The Engagement Aesthetic

INTERNATIONAL TEXTS IN CRITICAL MEDIA AESTHETICS

VOLUME #4

Founding Editor
Francisco J. Ricardo

Associate Editor
Jörgen Schäfer

Editorial Board
Rita Raley
John Cayley
George Fifield

The Engagement Aesthetic

Experiencing New Media Art through Critique

FRANCISCO J. RICARDO

BLOOMSBURY
LONDON • NEW DELHI • NEW YORK • SYDNEY

Bloomsbury Academic
An imprint of Bloomsbury Publishing Plc

50 Bedford Square	175 Fifth Avenue
London	New York
WC1B 3DP	NY 10010
UK	USA

www.bloomsbury.com

First published 2013

© Francisco J. Ricardo, 2013

All rights reserved. No part of this publication may be reproduced or transmitted in any form or by any means, electronic or mechanical, including photocopying, recording, or any information storage or retrieval system, without prior permission in writing from the publishers.

No responsibility for loss caused to any individual or organization acting on or refraining from action as a result of the material in this publication can be accepted by Bloomsbury Academic or the author.

Library of Congress Cataloging-in-Publication Data
Ricardo, Francisco J.
The engagement aesthetic : experiencing new media art through critique / by Francisco J. Ricardo.
pages cm
Includes bibliographical references.
ISBN 978-1-62356-134-5 (hardcover : alk. paper)– ISBN 978-1-62356-040-9 (pbk. : alk. paper) 1. New media art. I. Title.
NX456.5.N49R53 2013
776.01–dc23
2012044419

ISBN: HB: 978-1-6235-6134-5
PB: 978-1-6235-6040-9
ePUB: 978-1-6235-6928-0
ePDF: 978-1-6235-6961-7

Typeset by Fakenham Prepress Solutions, Fakenham, Norfolk, NR21 8NN
Printed and bound in the United States of America

CONTENTS

1 The engagement aesthetic—An introduction 1
2 Engagement as subjective system in electronic art 11
3 Transmodal engagement—Multiple media in singular works 29
4 Engagement as media metonymy—The aural as visual 49
5 Projective engagement—Transcending the modernist grid 57
6 Engagement from objecthood to processhood 73
7 Engagement in virtual and actual gallery space 87
8 Non-local engagement—The aura of the distributed moment 91
9 Engagement as spatial chronotope—Electronic art and the public sphere 113
10 Engagement across space and structure in post-architecture 129
11 Performative engagement—Dance with projective images 137
12 Engagement as performed intimacy—Depicting part-object desire, visually 151

13 Engagement as post-literary mechanism, an historical argument 161
14 Engagement as post-literary mechanism, from exposition to reflexivity 169
15 Engagement as comparative communication— Formalisms of digital text 183
16 Engagement across shifting beliefs: Shamanism, Turing, and ELIZA 201

Appendix 211
Notes 215
Bibliography 225
Index 229

CHAPTER ONE

The engagement aesthetic— An introduction

First, some notes on visual culture in connection with the title of this book, which is less about new art than how to experience it. The question that this book examines is how art or text created using electronic/mechanical media may resemble (or differ from) previous kinds of aesthetic encounters, and which aesthetic and literary criteria inform the character and structure of new works. These questions would not matter if we thought of new media as old media, that is, as the same, contemporary forms of art, literature, performance, and communication that we have always had, except utilizing new machinery and technology. But that feeling— new media as a "more efficient" version of old media—is not what electronic art and literature provide us. What confronts us in new media art and literature is not merely a "better" way to design, to see, to read, or to write. A pencil is more efficient than a chisel because it reduces the work required to make a mark, to write— yet with each, the creative effort in what is written is still entirely in the mind of the author. But in the new art and literary media that I am discussing here—a small sample of a growing category of creative systems variously called new media art, electronic literature, and other names—the aim is not to "produce" more efficiently, but to complicate the act of production itself, to transform it into a plural act, so that it emerges out of entirely new kinds of interactions and sources, perhaps between users and a work as in Rafael Lozano-Hemmer's public projections, or

between a viewer and a work as in Amaranth Borsuk's augmented reality literature, or between several media *within* one work, to include works that reflect their own structure, as we see in Andrew Neumann's electronic sculptures, the poetry generators of Nick Montfort, and the autonomous readers of John Cayley and Daniel Howe. In fact, the idea of a "work" is itself complicated by its appearance as a *practice*, such as by redefining architectural space, as does Paul Notzold's SMS-based art, or Mader, Stublić and Wiermann's spatial reconfigurations of existing buildings. The "when" and "where" of a work, too, is distributed into a pluralistic matrix of multiple "emergences" as in the work of Golan Levin, and Sheron Wray and Fleeta Siegel's interactive performances, or the electronic dance works of Jamie Jewett and Luke DuBois. None of these kinds of work is "already" finished, each has its own character, yet each is remade every time it is invoked, produced, viewed, or read. To experience such works is to look, read, think, and feel differently about art, literature, image, and text because the aesthetic focus is not on heightening our sense of an object or a work, but on what comes between us and the work—the act of engagement itself. It is an act that opens out to many possible directions.

And in order to explore some varieties of engagement as an aesthetic experience in depth, it is not necessary or possible to produce a compendium of electronic works of art and literature. The aim is, rather, on seeing, reading, thinking, and feeling—for these provide the three basic elements that viewers, readers, visitors of new media works have the power to produce: reflection, critique, and meaning. The essays here aim to foster at least one of these sensibilities, which is to say, to empower our experience and argue for the difference and integrity of a new aesthetic.

Reflection is the extended moment between perception and judgment, it occurs after seeing and before finally deciding that what has been seen is of *this* or *that* quality. Meaning is the extended moment after certain (positive) judgments that bring us back to reflection. To find something meaningful is to be able to reflect on it at length. Critique is the language by which perception comes to reflection, reflection arrives at judgment, and judgment ascends to meaning. Thus, critique is what I offer, it is the language of this book—reflection, judgment, and meaning are an opportunity, and a decision for each reader.

And so what is *critique*, in the sense meant, and as the method offered here? It is not an ideology, a school of thought, or an attempt to share my personal views on the work shown here. It is not a reduction of impressions down to a final verdict. It is the opposite of that, it is about conceptual integrity, about finding something behind and beyond the senses, beyond reading, beyond seeing. Judging work as good or bad, for example, is not critique; it is the *end* of any possible critique, it has a distancing effect. The judgment and the work are separate. But critique, when true to itself, is meditative, and therefore true to the art it considers. Strong critique is not synonymous with strong judgment; it is often the inverse of that. As a kind of truth, critique is not about secreting blunt and polarizing verdicts that either praise or dismiss creative work. Critique is a kind of *reasoning* that begins in sensory experience, and takes the work and the viewer somewhere new—beyond what the viewer may have initially seen. And in all of this, the point of departure is decreasingly textual and increasingly visual, because Western culture is now almost synonymous with the phenomenon of *the image*. The image is something so all-encompassing that it exists less as a specific kind of object than as an archetype; it speaks for what exists and makes claims about "what matters" as cultural reality because the production of imagery is of different kinds—and all are cultural products—to include the retinal image, the public image, the design image, the techno-scientific image, the fashion image, and the entertainment image. The once-pure connection between image and art (art being the institution where images were considered valuable because they had something unique, contemplative, and crucial to say to us about ourselves) has become thoroughly pervaded with and saturated by every other *non-art* creation and use of images. It is not that art has expanded outward to all aspects of social life—we know this because there is no evidence that the museum or gallery has entered the common interest of most people—but rather that the emergence of post-printing, post-text technologies that began with the invention of photography have carried the creation and delivery of imagery far beyond the secluded realms of art, with its expensive large-format books, its pristine white walls, and its climate-controlled galleries. If the image now defines human connection by way of social media, the entertainment industry, and other forms of technological conveyance, then art has come along

with it, of necessity. Breaking rank with the guarded traditions of painting, sculpture, theater, or literature, the image has launched on a major reversal through the expansion of its own function. It is no longer about its uniqueness, and no longer connected exclusively to ideals of the beautiful, the perfect, or the sublime. Unleashed on all corners of society, the image is sullied and compromised—and made real—as it returns to art with a chronicle of what it has seen and what it can show us. And so it is that art now follows media.

Consequently, museums and publications devoted to art regard the image in its new feral contexts. The art image in contemporary work may still be framed and hanging on the gallery wall, but it now disregards that context and operates as a window to worlds that are far from where art *was*. The contemporary images we find most familiar are those centered in action on the streets, fashion runways, rooming houses, police stations, brothels, cafés and bars, prisons, hospitals, morgues, and cemeteries, skyscrapers under construction, hallways in buildings, etc. Each milieu is more intensely common and intimate to us than the "old image" in its usual art contexts—the portrait, the nature image, and the image of still life.

The question of why the image is no longer defined by its place in art can be answered simply: it is created by technologies aiming to place it *within* popular culture rather than *above* it; these new systems aim for perfect *convenience* rather than perfection of *craft*, and so, visual products are no longer largely developed in the remove of a studio or developing room. Cameras now produce, transfer, and transmit images with contextual immediacy—at the moment and location of capture. Today's image-taking workflow is thus culturally embedded in a social setting: *seeing* leads to instantaneous *capture*; capture leads to instantaneous *transmission*, which in turn leads easily to instantaneous social *response* through equally mediated forms, as the image is again recycled back into the cultural stream.

Since we don't speak of art without reference to the image, and since we don't think of the image without reference to a medium, much contemporary art has become defined by its *methods* for appropriating or inventing visual work. What counts as *aesthetic* in what we see, therefore, is no longer based on affinity or preference alone. As technology entered artistic production, art became less exclusively concerned with producing objects, and turned

increasingly to the artistic obsession with production processes. And as we cannot apply questions of beauty to *processes* in the way that we could do with *objects*, endless variations of new criteria—or *scarcity* of criteria—have come to determine the artistic merit of art; if the process for creating it is unstable, the stability of consensual definitions (such as what constitutes a "masterpiece") is also undermined. Since art and technology have become codependent, *how* can we see and appreciate new kinds of art no longer based on conventional, object-based practices like painting? In fact, much of this new art isn't merely made *with* technological media, it exists only *through* the activation of such media, something that has been true since the first film. Film, unlike the photograph, can be experienced only while a (filmic) medium is recreating and projecting it. The evident conclusion here is that, if film is an art form (although categorical claims for arthood are, I think, deeply problematic—some films are aesthetically concerned, others not), then it is the first form of electronic art—it is art lacking the self-assurance of a standalone *object* and experienced only through a *process*. Regarding the art of film, as with the electronic, we can know that seeing a process rather than seeing *through* a process is unique in art history, and resembles the aesthetic of music and dance for which the audience must remain engaged differently.

To repeat the obvious, many forms of the (now electronically created) image have emerged outside of their place in art contexts and institutions, in fact, the primary production of images is independent of educational, publishing, news, business, or scientific institutions, even though these sources commission many of them. But as images continue to be created by all, with limitless abandon, and with unconstrained distribution, the standing of artistic convention and institutional art may continue to recede from the authoritative back to the nostalgic.

Connecting the cultural eruption of the image with electronic media, something extraordinary happens—this forest of symbol-creation systems also incinerates the clean boundaries that hold between technology, science, and art. All are now converging into a buzzing mélange of optical production. This also holds between what could be called "enterprises of image manufacture" such as the game, fashion, and entertainment businesses collectively known as the culture industry. For example, if we read between the lines of

all that has been written about the art of contemporary and technological media—however loosely one might define this—we find several fields or disciplines being strangely argued as "central" to digital art, others strangely absent from their indispensable relation to it. In the former kind of association—the extraneous—the recent connection between "digital" and "game" in the connotative space of artistic discussion can lead one to view these terms as synonymous with each other—evidence if nothing else of claims made without regard to history, since *art* and *game* are not only different words, they are different universes. But, with the exception of Fluxus and some experiments (e.g. *the exquisite corpse*), art's history has evolved quite distinctly from that of games. Art has experienced an unprecedented opening-up of its traditions, and in the digital sphere (which art historians have neglected), art has become more immaterial, more dynamic, without being contradictory, and more internally self-transformed without becoming displaced or ahistorical than non-electronic art. Yet for their part, digital art critics, too, have often neglected their own connection to art history, with the result that one world has remained unable to comment on the other intelligently. To be sure, what art history could share with electronic art is less an appreciation of physical materiality than an array of methodologies that can explore and explain varieties of style as they evolve through form. Lacking this, the cyber side of artistic criticism puzzles over lingering questions, such as what defines digital, electronic, or new media art in the first place without reviewing how modern art has grappled with questions of media aesthetics since the adoption of new expressive forms like photography, collage, film, and installation art.

I am not the first to assert that a *new* approach to address what is meant by digital or electronic or new media art is needed. It is a kind of criticism that attends not to surface or *sensory* questions like, "What does it look like?" or "Is it computer based?" but to conceptual probes about its hybrid origins, the reasoning and intent of some of its artists in choosing this creative direction, and how its processes may cause "art" or an aesthetic experience to emerge. These are, I think, considerably more interesting questions.

As its title suggests, this book's primary interest turns to several problems in how we think about—the aesthetic aspects of—works of art produced using new and electronic media, with relevance to earlier kinds of work. By "earlier" I don't mean *traditions* of art

alone, I also mean *industries* of art, as I will define shortly. The chief role of the artist is to create art; the patron and the collector sustain it; and the curator convenes and conveys it. All of these specialists have a role in the historical completion of the work, but the critic, theorist, or historian will elevate it, making it relevant to a time and audience other than the artist's own. But since, historically speaking, creation is continual, whereas understanding must follow what has been presented to the world, there is a temporal gap between what is made and what is understood. So the natural response is for public taste to apply older standards and criteria to newer work. Of course, as each epoch of art brings different aims to its viewers, one should first interpret works through *contemporary* sensibilities rather than older ones. It makes little sense, for example, to read modern abstraction in painting with a Renaissance eye. Likewise, the sculpture of the nineteenth century, still centered on appreciation of the chiseled image, offers little to the viewer encountering minimalist work from the 1960s, with its emphasis on fabricated symmetry and space-age materials over figurative representation. And if the artist creates work for the *now* while the public views that work through *tradition*, the critic must connect one age with the other not merely by expressing judgments but by making arguments about how to see the new in the now.

As I have just mentioned, the departure of contemporary sculpture from the rubble of its legacy did not come with the advantage that the contemporary sculptural reading could be extended to new forms in space. Instead, a decidedly traditional— not to say Romantic—sensibility has to this day prevailed as a centerpiece of sculptural interpretation. It is as if the modern pelican were judged as the reptilian pterosaur from which it emerged. If the universe of art evolves through media transitions like the animal kingdom evolves through genetic ones, the extinction of any specific form says nothing about the question of life itself, which for art is the ontological question. And so, to see something like Richard Serra's *Tilted Arc*—that lengthy slab of steel that cut across a public plaza in the 1980s—with a Romantic's eye is to force a chapter of contemporary sculpture into a kind of prehistoric misreading. What interested Serra is not merely the *object*, namely the enormous metallic partition that he placed across the pedestrian flow, but more importantly, the *process* that is the experience of one's immediate encounter with it,

the phenomenological commitment of its physical order—an order that has taken the place of normal aesthetic convention, of seeing alone—and for this reason he imagined this enormous barrier of steel cutting the federal plaza on which it was placed as imposing a new way of thinking about oneself, an object, and the space surrounding both as three continuous variables, such that

> The viewer becomes aware of himself and of his movement through the plaza. As he moves, the sculpture changes. Contraction and expansion of the sculpture result from the viewer's movement. Step by step the perception not only of the sculpture but of the entire environment changes.[1]

Need we really state that this aesthetic articulation (where the problem of shifting positions in projected space becomes *the* experience of the work) is totally alien to earlier kinds of sculpture?

When, in history, a kind of art emerges that has something new to say, three reactions are possible. One can accept the new art, one can ignore it, or one can attack it. There are many possible permutations. Sometimes it can be accepted, and then ignored, as happened with Suprematist painting, the De Stijl artists, and most Abstract Expressionists. It can be largely ignored, as happened with Minimalism, which was primarily of interest only to critics and curators. It can be accepted but later attacked, as happened with Op Art, Pop Art, and even much of Andy Warhol. Or it can be attacked before being accepted—this is what happened to Marcel Duchamp's readymades and related constructions. And sometimes, if art is taken as a visual but not meditative form, it is attacked—sometimes destroyed—and only then ignored.

As the best-known case of artistic decommissioning of the last century, *Tilted Arc* was ordered demolished on the grounds that it made no sense as a sculpture for one federal bureaucrat who waged war against it—it is the *new* rather than the archaic that can be made extinct. Its destruction is a case of the troubling triumph of conventional expectations of art over open engagement. It is a view of art that is resistant to or unaware of engagement inherent in works where *process* is more important than the *object* itself. It signals an outmoded obsession with seeing art as a static form, seeing a work as a fixed point of expression, relating to everything as a sculptural constant—that is the enemy of new art.

THE ENGAGEMENT AESTHETIC—AN INTRODUCTION 9

If viewers of the 1980s (not so long ago) could not engage with *Tilted Arc* as legitimate art, how can a more contemporary art-viewing public be brought to engage with digital and new media as aesthetically legitimate? However we define new media—something I identify as media born outside of the traditions of material arts that include photography, sculpture, drawing, painting—my point is that we are not encountering work revolving around the idea of *viewing*, of a spectorial aesthetic alone, but an additional engagement aesthetic—or many—that defines the new. And so it is to a detailed critique of this expansive artistic experience and process that I turn next, by examining different works, positions, and analytic methods from which I hope new interpretive and critical attitudes may emerge. Each side of this critique, from formal, to psychological, to linguistic, provides a different facet of this overall engagement aesthetic.

As I mentioned, the book is not historical, although it contains retrospective references; it is not defending or attacking a theory, although it is speculative and theoretical in character. There are some constant positions, however. One is my disappointment with the nearly systematic way in which art historians have ignored or overlooked the artists, the art and literature, and the aesthetic issues described here merely because they were related to technological production in some way. Some artists like Manfred Mohr have been producing work since the early 1960s. In an October 1967 missive from ARTFORUM's editor, Philip Leider, to art historian Matthew Baigell, Leider rejects a manuscript on electronic artist Charles Csuri, adding that "I cant [sic] imagine ARTFORUM ever doing a special issue on electronics or computers in art, but one never knows."[2] ARTFORUM denied computer-related art at a time when it championed the work of Sol LeWitt, Donald Judd, and other artists whose art was constructed by others, out of instructions, and with high-tech materials never forged by human hands. In any historical record, elitism and duplicity are sometimes indistinguishable.

And so, the forms of engagement aesthetic to which I refer throughout this book have largely escaped art history and criticism. As I show, however, Rosalind Krauss has come closest to extending conceptual and contemporary art criticism with the aims of rigorous new media art as I present here, and so her earlier writings provide an occasional bridge in this book, which nonetheless avoids

art history's canonical strictures. Another consistent position of the book is the defense of meditative suspension of judgment in the encounter with electronic art of any kind. I argue for immediacy of *feeling*, rather than of *verdict*, and this distinction is for me the point of separation between "better" and "worse" in art. When *all* electronic art is dismissed, as I later quote a major name in computer games, I have to ask why such dismissal is so quick, accompanied as it is, with the claim that computer games are themselves a legitimate form of art. I don't enter the debate as to whether computer games are art or not, because the question is not posed correctly: art emerges in expressive works, not in categorical abstractions or media. Additionally, if we can not exclude from the category of art the astonishing kinds of things that museums have chosen to exhibit lately, then we have also lost the ability to deny any claims by anyone to call art whatever they wish—and this includes commercial videogames. We can, however, proceed through critique, which is why I wrote this book. We could, for example, simply ask: Is there in claims for the arthood of anything a reasoned *engagement with an aesthetic*? If so, what is it? Or does the claim for arthood resemble more a reach for association with the *status* of art, perhaps as an attack against existing art practices? This book is entirely devoted to exploring the first two (and most complex) of these three questions, the last one belongs to the realm of individual inquiry thereafter.

Each chapter is a separate essay that appears to focus on specific works. That's not the main purpose for the writing presented here. I discuss works only as specific points in a grid of critique that is not viewable as a weave of loose ideas, or as a tightly reductive framework, or even as a theory. It is an endorsement of the belief that we should be open to new work, not because it is "new" but because it comes at us from a different world, one where image, text, and even communication itself (as the final chapter's statistical analysis suggests) is, at the level of deep structure, radically different from conventional expectations, and that perhaps if our view of electronic art and literature were as dynamic as the work itself, we might be more contemplative of *process* as an aesthetic necessity.

CHAPTER TWO

Engagement as subjective system in electronic art

Perception provides me with a 'field of presence' in the broad sense, extending in two dimensions: the here-there dimension and the past-present-future dimension. The second elucidates the first. I 'hold', I 'have' the distant object without any explicit positing of the spatial perspective (apparent size and shape) as I still 'have in hand' the immediate past without any distortion and without any interposed 'recollection'. If we want to talk about synthesis, it will be, as Husserl says, a 'transition-synthesis', which does not link disparate perspectives, but brings about the 'passage' from one to the other.[1]

– M. MERLEAU-PONTY

Of all the kinds of engagement that we can experience in the new art and literary work of electronic media, the first deals with a changed attitude about what images do for us. In electronic art, images are promoted from their conventional function as optical phenomena to devices for critiquing perception. I open with this complex epigram by Maurice Merleau-Ponty because his axiom,

and the essays in this book, together take the same point of departure. It states that, if there is more than a singular way of perceiving something, then, inevitably, perception becomes a kind of critique. And since electronic media are forms of perception, they contain the evidence and method of their own critique. Let us begin with Merleau-Ponty, who describes two kinds of seeing: spatial ("here-there") and temporal ("past-present-future"). Later, my argument will embrace several others.

The thesis that proposes a means for thinking about the kind of artistic work I'm describing here begins with this kind of "transcendental perception." It amounts to the conviction that there is a visual kind of experience, however fleeting, when three subsequent actions take place and become an aesthetic possibility, a kind of engagement that is extended and contemplative rather than immediate and conclusive. First, a moment emerges when *perception* no longer seems dependent on simple acts of *observing*; second, when perception begins to promote a sense or belief that feels like a seed of *understanding*, and third, when this idea or feeling that one has begun to understand something then itself becomes a reach back into the thing one is looking at as a kind of new perception, and this continual return is a basis for *contemplation*. But contemplation is a starting point in this book, not merely an aim. That potential is suggested in the quote above by the appearance of a personal verb: to *hold*, rather than to understand (this is not equivalent to *judging*). When artistic perception turns toward a kind of holding, the aesthetic in process moves from one of contemplation to one of complex engagement.

Contemplation has been the historically predominant goal of art. The term contemplation, which today seems antiquated and haughty, designates the activity of "thinking-about" prior to— and toward the development of—a *judgment*. By implication, the presumed greatness of a work of art or literature correlates with the length of this contemplative moment between observation and judgment. In great works like the *Mona Lisa*, judgment is almost indefinitely held back by contemplation. But in electronic art—at least the cases I'm probing here—this internal line from contemplation to judgment is made circular, oscillating, reflective, because the works I'm discussing (and there are many like these) are ones whose nature is always unstable; their structure becomes part of their content, and together this assembly fluctuates in

continual change. Since neither contemplation nor judgment, if we accept these terms, impart a sense of completion, they cannot individually portray a suitable statement or aesthetic of new media art. This art's circular rabbit-hole of structure-content melding and continual perception and holding is best understood as one of *engagement*. Engagement signifies a continual state, a relationship of progressive moments that persist without repeating.

And so, as contextualized by Merleau-Ponty in the opening thoughts above, there are two ways to take in Edmund Husserl's notion of a *transition-synthesis*—a passage from one perspective to another—as one variant of engagement. One way corresponds to transition-synthesis as a *concept*, an idea or notion "out there" like a geometric hypothesis; the other takes transition-synthesis as an *experience*, a moment when this principle becomes subjective and immediate to the observer. In the first case, a transition-synthesis is captured by the mechanism of language, it is articulated as a kind of universal observation that is external to the body, which is to say, it is *chronicled*; the second is by sensation, as something intimate, *felt*. A cinematic metaphor provides the analogy for framing the concept-experience spectrum visually in a work of art: in watching a film, the eye converges on psychological meaning around a very mechanical paradox—the whole emerges only through a series of momentary impressions, each overtaken by the next; a film's identity is constructed through an array of frames that lead to scenes. There is no single moment that encapsulates the entire meaning of a film. If the work is to bring the viewer into a here/there and before/after transition-synthesis, however, it cannot exclusively comprise a never-ending chain of sensations pouring from torrential change, since the viewer would not attain a stable perspective on the overall work. As change must oscillate with non-change, the term *synthesis* suggests transitions of *perspective* combining transformation with stasis, and as an opening example of the engagement aesthetic that transcends mere looking, the instrumental art of Andrew Neumann deploys two such transitions, specifically, of time, and of space.

As rationale for the radical character of so much contemporary art, Husserl's transition-synthesis points to something especially evident in the kineticism of mechanized and digital works, that is to say, in works where a series of perceptual shifts occurs as the work undergoes change. I refer to this not just in a *physical*

sense, for Alexander Calder's dangling mobile fins could easily fall within crude ideas of *shift*. But Calder's is a kind of "static shift"—the content (the propeller-like components) of the work changes while the overall structure does not. The perceptual shift in Calder—stationary objects that become rotating ones—can be described as a before-after change that is limited to one of motion, not to ontology, and the change in question is optical, but not one concerning alteration in the nature, essence, or being of the work. It merely rotates, albeit interestingly. But more fundamentally, how does one characterize artworks that bear a different kind of ontological structure-as-content shift of the kind I discussed above? One indication, as I will explore next, is whether description of changes in a dynamic work requires *different language* to describe each such change.

That is, works that convey change but which do not convey a transition-synthesis are those whose *structure* and core *perspective* remains static, despite a succession of flow or imagery. In this case, movement is not essence; it is a characteristic of an essence, so movement by itself is not enough to comprise the essence of a work of art, and it is that essence that must be altered. Thus movement or change alone is not the essential part of any work, any more than the movement of a celluloid strip is essential to the film being projected on a screen—the strip's movement is necessary to the medium, but not essential to the content.

Many artists working in new media relate this type of unidirectional transition of flow to interactive works by expanding the painterly metaphor of a canvas sustaining color fields in dynamic behavior to objects in motion. It is a metaphor; the principal ingredient is a background onto which visual activity is apparently projected, variations of events on the backdrop being the basis of new media works. Some artists, like Neumann, work with ideas of transition-synthesis by converting an expanded structure into expanded perspective. Consider how the more linguistically conjectural work, *Text Rain*, projects onto a wall a downpour of letters and words—crucially, in fact, a poem—rather than mere colors and shapes in a repetitious flow.[2] In this work the canvas metaphor has grown beyond two dimensions, capturing and reflecting the body of the viewer standing before it. As the work rehearses a poem line by line, each letter of every word descends delicately until any of its projected boundaries collides with some part of the

FIGURE 1 *Camille Utterback and Romy Achituv,* Text Rain, 2000. *Interactive Computer Installation, size variable, video projection. Detail.*

viewer's body, also projected into the same representative space of the work on the wall. But even so, fully integrating the viewer into such a flowing experience still does not produce the meaning-preserving circularity implied in Husserl's transition-synthesis. Work in constant motion, discarding old states for new ones, but not reinforcing a cohesive spirit with a structure that is indistinguishable from its content, lacks the fulcrum necessary to such a moment.

Transitions of Time

Of course, one would be tempted to reduce much of new media art to temporal flow, like film.[3] Indeed, works of agitation and flow do follow aesthetic patterns in their own right, but the archetypal notion of a *torrent*, though compelling aesthetically, is not a very complete metaphor for depicting the transition-synthesis: *structure*

as distinct from *content* remains unchanged. Interacting with surging forces always implies *departing* from some original state of things and setting toward another that has not yet developed. Moving from an existent now to a potential later, such experiences convey less a balance between motion and stasis than of persistent procession. The viewer, continually awash in new modes, hues, and layers, nonetheless fails to detect any actual cadence or completion. But a transition-synthesis, anchored on the stability of memory as the basis for one's impression of change, demands a point of reference. And since the absence of a temporal fix renders such awareness impossible, memory and perception are indefinable without reference to one another. Perception alone is not enough.

> Perception is never a mere contact of the mind with the object present; it is impregnated with memory-images which complete it as they interpret it.[4]

Bergson defines the dominant relationship between memory and perception, that momentary break between what *was* experienced and what is *being* experienced, as something temporal, linear, and metaphoric with cinematic projection, something whose principal meaning-making process concerns relative motion. Subjectively, as the capturing element of perception shifts, the recording sense of memory remains stationary, each fueling a kinetic contrast that forms both the original impression and all recollections of it. So, Bergson maps their consolidation in a two-dimensional way, representing memory along the horizontal axis, and perception along the vertical. Each impression thus captured from the event stream incorporates into something like a static collection, an archive of impressions, or a totality of recollections.

> If I represent by a cone SAB the totality of the recollections accumulated in my memory, the base AB, situated in the past, remains motionless, while the summit S, which indicates at all times my present, moves forward unceasingly, and unceasingly also touches the moving plane P of my actual representation of the universe.[5]

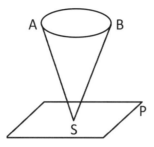

FIGURE 2

As perception and memory converge toward each other, a third process, meaning-making, begins to fill the juncture of the points. Between them, the depths of memory and the surface of perception define a space, outlined conically so as to emphasize its progressive nature, where primary observations evolve into full concepts. Drawing from the immediately acquired as well as from the previously established and memorized, initial perceptions oscillate between both poles, eventually resolving toward a final conceptual form congruent with, and incorporated into, what already dwells in memory.

Let us refer once more to the diagram we traced above. At S is the present perception which I have of my body, that is to say, of a certain sensory-motor equilibrium. Over the surface of the base AB are spread, we may say, my recollections in their totality. Within the cone so determined the general idea oscillates continually between the summit S and the base AB. In S it would take the clearly defined form of a bodily attitude or of an uttered word; at AB it would wear the aspect, no less defined, of the thousand individual images into which its fragile unity would break up.[6]

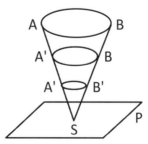

FIGURE 3

The first implication of this perceptual process is the heightened role that time plays. Not only does concept-formation through this memory model reflect a decisive break between present and past, where memory is to past events what perception is to present ones, but additionally, in this framework, what at any moment comprises perception or memory is precisely that: perception *or* memory. Both cannot emerge simultaneously. In the course of ordinary experience, this seems a rational assumption, what I see at first now is what I will remember later, recognition being the process linking one operation with the other. But the invisibility of this transition-synthesis is necessary to life experience so that one can assimilate and accommodate, that is, *learn*, seamlessly.[7] This instinctual invisibility underscores precisely what distinguishes the minimal, postminimal, and formal aspects of work in Neumann's perceptual sculptures from normal visual experience, where, in seamlessness, feedback and memory embrace so interdependently that it is unnatural to grasp any work in temporal seriality or linearity. In a visual work, things beheld come together gradually and with contemplation, but the sense of perception feeding memory or vice versa is not palpable. All that is felt is the sensation of *observing* and perhaps subsequently the *a-ha* that accompanies what is thought to be the *idea* of the work. There is a perceptual all-or-nothing that does not allow the privilege either of presentation or mechanism in beholding the work. In this perceptual mode of gradual familiarization, final judgment is what one keeps; all intermediate processing is opaque.

As an aesthetic framework, any such model that connects perception with memory will do so through the bridge of temporality. What comes first is absorbed purely through perception, where it is not yet memory, and then it passes into memory, where it is no longer perception. In Bergson's diagram, this temporal membrane is clear-cut: the isometrically laid-out plane represents a moving, shifting event stream with S as the point of subjectively focused individual awareness acquiring new information over time. And memory as a process is possible because perceptual input that occurs at one point in time is superseded by subsequent, different input at later moments, and displaced earlier impressions are retained. From the perspective of this model, one significant feature of minimalism is its atemporal and antisubjective nature. It denies the possibility of selective perception of its "subsequentness" by

forcing all reading of a work as something utterly without idiosyncrasy or irregularity. From a relentless sense of equivalence and symmetry, the same perceptual experience results, regardless of the angle or position of the observer, and impedes the possibility of encountering a work in a subjective, comparative, or relative-to-others way.

To experience the minimalist aesthetic is to experience separation. The unadorned symmetries of the box, minimalism's canonical geometry, bring the viewer all the intimacy of a numeric equation. The *subject* in this world is an option, and not one accommodated by the work. With its mute and featureless character, the possibility of *subjectivity*—the notion of a central and special position for the viewer—in minimalist art would remain out of reach, indefinitely suspended, were it not for Neumann's turn, a subjectivity-adding correction produced without altering the constants of minimalism (i.e., emphasis on formal qualities; the use of fabrication over evidence of the human hand; repeating, symmetric, or serial regularity of structure and placement). Neumann expands these constants by actually *embedding* subjectivity directly into the work while still employing a rather utilitarian minimalist vernacular. Rather than altering the formal circumstances that deny subjectivity, such as by *contamination*, that is, introducing symmetry-destroying

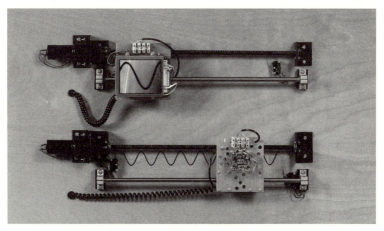

FIGURE 4 *Andrew Neumann*, Phase Cancellation with Sine Wave, 2005. *Digital photo, LCD screens, solid-state video. 30″ × 40″ × 5″.*

eccentricities that can make one observer's perception of the work different from another's, Neumann moves in the opposite direction, by a kind of *purification* and thus reinforcement of the perceptual experience, in this case, by repeating the act of depiction-observation *twice* in the same work. In a structural view, if a work of art exists to illustrate anything, it can be understood as comprising elements that reinforce the unique rhetoric underlying its chosen form and appearance. Interpretation is always selective. The requirement is about choice, a process that moves from a view of the presented elements that appear to support the function of the work as a visually constructed statement or question, and gradually converges upon emphatic particulars that substantiate an assumed and preferred meaning.

This is all attained through the self-referentiality of cameras trained on the work itself, and these cameras, akin to the subjective perceptual points in Bergson's diagram, are integrated into the work without implying which, directly presented or electronically viewable, is the "real" focal object. They are in relative motion over a plane on which are screwed, nailed, painted, or hung pure shapes such as sine waves or working tools such as Phillips screws. Thus, simultaneously visible to human observers are the material elements embedded onto a panel; the hovering camera-eyes of the work watching itself; and finally, the optic perception of these camera-eyes themselves reflecting the objects over which they are moving onto small active-matrix displays. The Bergsonian perceptual model is rendered in a manner that is entirely minimalist and also temporal, because the work conveys its own subjectivity, which, in addition to its panel elements, it reports openly and continuously. In this process, the work makes explicit in the fullest sense the transition-synthesis whose condition of formal inner coherence we found elusive in other art conveying visual transition.

I want to return to the tension between perception and memory, and a critique of how Neumann engages it. One cognitive instinct in our encounter with any artwork is a kind of a commitment to definition, to reaching some interpretation of the work. Of course, such interpretive notions are dependent on moments of recognition, where the objectively presented and perceived, which is obvious to every observer, and the subjectively recalled, which is obvious only to oneself, blend into reflection. What is observed always stands objectively before us; only *what is doing the looking* can be

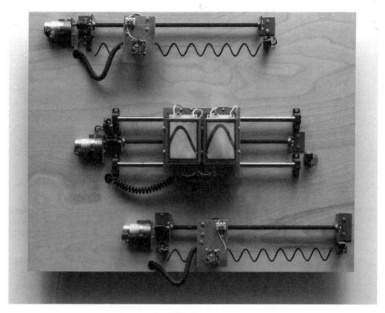

FIGURE 5 *Andrew Neumann*, Dual Asynchronous Sine Waves, *2001.* Wood, video, motors. 24" × 32" × 8".

properly termed subjective. And this difference is the evidence that corroborates how a work possesses subjectivity, for in each work that self-observes there is the creation quite literally of a mediated replica which, because it observes itself, is not a replica of the work, but, instead, of the observer. And we might also note that in this dual subjectivity, the viewer's and the machine's, the forces driving recognition are twofold: mechanistic, borne in the work (as we see it moving, observing itself) and conceptual, borne in the viewer (as we struggle to define the focal object in the work).

The recognition of a present object is effected by *movements* when it proceeds from the object, by *representations* when it issues from the subject.[8] (emphasis mine)

Transitions of Space

Neumann's work arranges out of a minimal set of recurring materials whose construction compares to the sparse but multi-perspectival sculpture that Anthony Caro developed during the 1960s. The panels and rails through which Neumann articulates a sense of depth and with which he provokes re-examination of images compare directly with the characteristic space-establishing planks and shafts of Caro's work just after he abandoned his figurative phase. In both artists, these elements project and reinforce the boundaries of the reconfigurable image; both alter the experience of perceptible motion. The strategy by which Neumann's statement claims this allusion, however, is distinct from that of Caro's. In the decade from the landmark 1962 up to the 1970s, Caro innovatively redefined sculptural projection by eliminating the plinth and placing the work in the real space of the viewer. But this is insufficient as a comprehensive description of Caro's strategy and its effect, because his effect is more than sculptural. It is innovatively perceptual, using the motion of the viewer around a sculptural object as an aesthetic operation for redefining the work itself. This happens simply: standing at each possible vantage point in relation to a Caro sculpture, one finds oneself before essentially a new work—no angle of view is similar to the previous one. With a minimal palette of steel planks, beams and rails, Caro achieves the improbable production of an experience of multiple works constrained as one physical object, the multiplicity of experiences emerges from changes in the observer's angle of view. In his panel works, however, Neumann establishes and maintains, by almost ironic contrast, the constant stability of formal qualities in a work. The irony is that such constancy is reinforced by two forms of observation, the viewer's role is technologically accompanied by artefactual self-observation in autonomous motion built into the work and entirely independent of the spectator's physical position. Caro's work is completely stationary, yet the spectator experiences a state of perceptual multiplicity. In Neumann's world, this strategy is inverted; the spectator need not move, as the work enacts a shift in perspective and impression through an oscillating series of state changes.

The preference for horizontal arrangement that is the typical orientation of both artists, Caro consistently placing his works

on the floor, Neumann's work consistently transposed onto the vertical plane of the wall but equally dispersed across a wider-than-tall landscape, operates centrally as ground to both artists, and in each case it is a ground whose chief contribution lies in its inconspicuousness. More than visual resemblance, however, is at play in the relationship between the work of Caro and Neumann. The production of changes in observer position demonstrates that the chief theme of that relationship is a progressive one, promoting *movement amidst stable objects* into a fully autonomous aesthetic operation. As with Neumann's roving eye, the rewards for the observer who moves and views the work from alternative angles are also evident in Caro. The reward of movement here is insinuated not only by the changing position of the observer, but also by the play of vectorial tension built into the work, which could be discussed separately.[9]

My point here is that the presence of sculptural objects is secondary to the idea of transition-synthesis, a progression of perspectives. The aesthetic emphasis for Caro and Neumann is less formal than conceptual. For each artist, the main perceptual grammar transcends the physical language of balustrades, sections, rails, meshes, or grids recruited and visually regulated for particular effect. It is, rather, a substrate, it is the power of the vector to signify and proclaim the fact of distance as a consequence of motion. This *here-there* antecedent to motion and perception is born in the viewer's quest for a point of reference. For each artist, the plane against which vectors project becomes the work's central statement around the same two-body problem, namely, that of locating the boundaries both of the work and of the viewer and then converging upon a signifying essence by the viewer's engagement with the work within a depth of field lying somewhere between both. The ballet of vectors that is *Hopscotch* (1962) is a geometric manifestation as far at the edge between motion and stasis as is possible to conceive symbolically. Likewise, the operation of spectatorship epitomized in *Early One Morning* (1962) evokes the process in comparison with Neumann's treatment of the same subject.

For here Caro fashions an upright panel into an irrefutable backdrop, arranging rails as reference points and a higher central cross beam assembly whose horizontality is tracked by the observer's eye. Seen in functional retrospective, this cross element setup recalls the scan of Neumann's camera through first-person

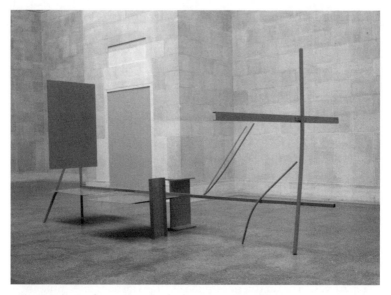

FIGURE 6 Anthony Caro, Early One Morning, *1962.*
Steel & aluminum, painted red, 114" × 244" × 143"/290 × 620 × 333 cm.
© *Barford Sculptures Ltd. Photography: John Riddy.*

experience. In Caro's sculpture, all perspective is established by a shaft projecting from the rear panel to the T-cross beam almost 20 feet away. As visual rhetoric, all of these elements are canonical to Neumann's work, for instance, in *Industrial Fan Panel* (2002) which sets the scene with a similar backdrop, similarly providing a railing system and sense of depth, only in Neumann's case the latter works in reverse, for, rather than using distance as a telescopic element as Caro does, Neumann uses proximity microscopically in order to intimately magnify mounted images and objects. In this relationship, Caro can serve as the ultimate metaphorical reduction of Neumann, while Neumann transposes Caro's multipositional perspective to a more contemporary technological octave.

Openly nonfigurative works like *Early One Morning* preclude any sense of interpretive closure, and, less abstractly, also for perceptual resolution, that is, for arriving at safe assumptions as to the location from which to determine one's role as the ideal viewer. Such is the visual richness in Caro's sweeping stylistic vocabulary that one cannot justifiably summarize this work in a

ENGAGEMENT AS SUBJECTIVE SYSTEM IN ELECTRONIC ART 25

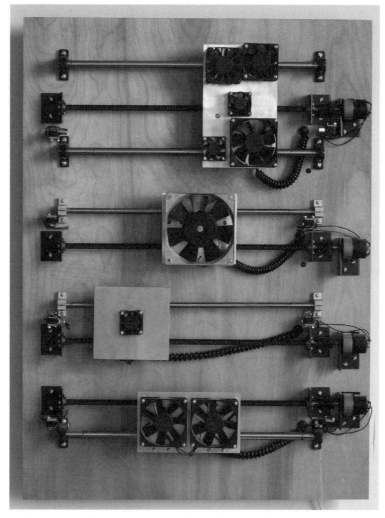

FIGURE 7 *Andrew Neumann,* Industrial Fan Panel, *2002. Plywood, LCD screens, video camera, misc. electronics. 32" × 48" × 6".*

single photograph. As mentioned earlier, here again, each viewer position, no matter how near the next, renders a distinct representation built from a new proportion between near elements and distant ones. Such transitions of space are adopted in an opposing

way in Neumann, in whose works, conversely, no camera repositioning can produce an image of retinal rail works that conveys a reading in opposition to any other. The spatial transitions happen internally as each successive vantage point is generated, recorded, and reported via the ubiquitous display panel, such is the coherence of his neo-minimalistic articulation. Reducing further, to utter functionalism, the comparison between the kind of panelization evident in both artists, we arrive at Caro's *Aroma* (1966), again, a simple latticed panel with rails, and Neumann's *Screw* (2005). Of less interest here is the contrast between backdrop and foreground elements in both works than the intensification of a pattern emblazoned in material form as a result of that contrast, and the rich emphasis of perspective pluralism from such minimal structuration.

This contrast suggests that a secondary strategy of focal reduction underlies these works. The visual rhetoric at play here is reducible to the one cogent statement that such simplicity of sculptural composition underscores *one* formal feature in each work. In Caro's *Aroma*, it is the trellis; in Neumann's *Screw*, it is the spiral. In both cases, the case for this objective is made through physical means, rather than through implicit suggestion, the method, for instance, that both choose to impart depth. And the simplification of material,

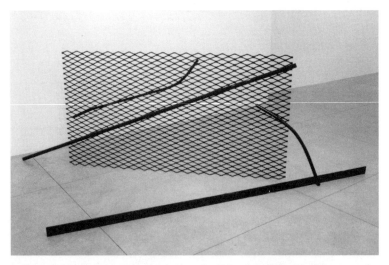

FIGURE 8 *Anthony Caro*, Aroma, 1966. Steel, polished and lacquered blue, 38" × 116" × 58". Courtesy Mitchell-Innes & Nash.

the sublimation of the supporting casts into almost extraneous elements, makes clear the importance of that coherence in the works, as if everything existed for the purpose of conveying the allure of a singular quality over what is supplied with secondary context.

Materially, Neumann entrenches his works in the abiding use of industrial elements such as video displays, wires, and motors always overlaid on the natural surface of a smoothed and carefully chosen plywood panel. It would have been possible, reasonable, and in fact simpler to mount any of his sculptures on a metal alloy base and thereby coherently and fully extend the industrial character of the work. All contrasts pose questions and here, with robotics over pine paneling, we might logically ask, why this choice? Isn't wood out of place in a work made of forged energy-conducting materials?[10]

That wood should be the chosen platform for this highly synchronized gathering of electrokinetic components speaks to the importance of grounding the electronic aesthetic within an organic narrative, rather than vice versa. The aesthetic relevance of this organicity is obvious: it translates the idea or process under analysis

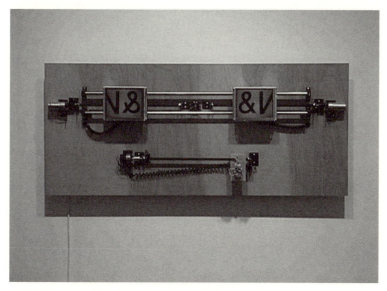

FIGURE 9 *Andrew Neumann*, Pan and Scan, *2002.*
Plywood, LCD screens, video camera, misc. electronics. 32" × 48" × 6".

from something that is abstract and decontextualized into a world where it is recast as a tangible form entirely on its own terms. So while each of Neumann's works addresses a rationalized or geometric abstraction (e.g. a phase cancellation with sine wave), its transposition into—and our subsequent understanding of it as—an autonomous aesthetic act is what is on offer. For only through this reassignment, this reification, can we see that something abstract like *pan and scan*, because it is presented in a work of the same name and illustrated in the act of panning and scanning itself, exists not merely as a cinematic technique but also as an independent object. The transfer from the universal to the particular, from the act to the thing, traverses a spectrum between two poles, it is a statement that can only be conveyed through oppositions. In Neumann's case this statement lies between the dynamic abstraction of a process and its static base in the concreteness of a natural material. However long the meditative span of our engagement with his work, it lies in conversation between these two worlds.

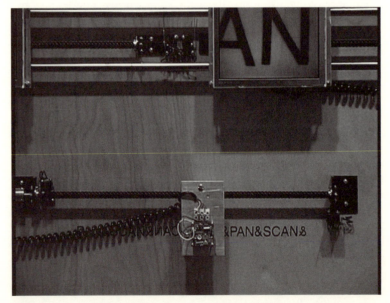

FIGURE 10 *Andrew Neumann*, Pan and Scan, 2002. *Plywood, LCD screens, video camera, misc. electronics. 32" × 48" × 6". Detail.*

CHAPTER THREE

Transmodal engagement—Multiple media in singular works

I. The Private Image

So much of what we want from art relates to a wish for subjective, personal meaning, not *meaning* in objective terms, as in knowing the significance of a vocabulary term, but meaning as a kind of continuous internal conversation with an image—and few art forms know this more poignantly than photography. When an artist exhibits or publishes a photograph, the act of exhibiting it anticipates an infinity of gazes which will connect with it. It is a rapport based not only on production of the work, but on its exhibition as well. That is part of what makes it art—it must, in some way, become perceptible.

But what of the *private* photograph, that image taken only with the intent of chronicling a personal moment to a single person? This confidential image stands as the opposite of the art photograph; the dialogue or source of meaning in the personal object plays out in what emerges between the image and one's own private associations. The private image is always an utterance in one's "private language" in the sense meant by Wittgenstein, in whose *Philosophical Investigations* it is clear that meaning functions only in a subjective way: "[t]he words of this language are to refer to

what can be known only to the speaker; to his immediate, private, sensations. So another cannot understand the language" (§243).

As a public product, however, the photographic work of art initiates a conversation with history and with what transcends the personal (indeed, the world speaks back, but the image is frozen and impervious to judgment). Also, however, there is a third kind of photo-image, which we may call "migratory" to refer to photographs that begin as private objects and are later incorporated into artworks. A relationship with someone is a relationship with an experience—the experience that ties that person to oneself. But the photograph rather centers on the *memory* of its subject, and also therefore maps a complex relationship to the different materials of memory: images, impressions, music, moods. Contemporary art criticism which calls photography an indexical art, a photograph is *indexical* when it points to something rather than merely resembling it—is a claim that can be seen as a line, a path of interpretation leading from the direct perception of the image to a sense that the image has, by way of some context, something to say *about something*, and so its *visibility* is secondary to whatever it *implies*. But it's an implication beyond concrete *reference* in the way that a clock's hands are an index to the passing of time. It is one of *evocation*. The distinction is really about the poetic power of photography; a clock alludes primarily to *time*, not to *aging*; photographs can do both equally well. There is in our experience of the photograph, then, another way in which it can be understood, as a pointer to what lies beyond anything temporal; it centers on the process of memory-making itself. The photograph, when we speak of any meaning within it, is an index to association, to memory, and to everything that it points to its future as a possible world of meaning.

The photograph is the first art medium in which its subject is not fictive; what is photographed always preexists and predates the photographic image itself. And so, the photograph is never complete without conveying the aura of presence of the situation being shot. This belongs not merely to the spirit of the dilapidated rooms of a Francesca Woodman image, but categorically to the medium itself; its condition, namely that the artist must *be* in that space in order to acquire the image in the first place, is true of all representational photography, and the viewer is compelled to confront the image's multiple presences—the presence of place,

of what populates it, and of the photographer—with the corresponding feeling of communion.

The personal photograph points to meaning of a private nature. Not merely *uninterested* in evoking associations with a gazing world, this type of object *wants* to exclude public inspection. The art photograph, however, aspires for commentary on its quality of capture, of *signification*, not merely of its *imagery*, and so, in its exhilaration as a work of art, it presents a kind of image determined to foster commentary by "outsiders"—viewers unconnected to the image in space or time, but tied to it by a willingness to negotiate meaning with it through contemplation. In this, the art photograph's relationship to memory is more productively vague and more inclusive than the personal photo, whose meaning derives from the personally familiar.

Beside the object's final *destination*—a gallery wall and collector's portfolio versus a family album—the aforementioned distinction might seem the major one by which to separate the art photograph from its confidential equivalent. But what distinguishes these two kinds of images—contrasts based on different takes on what "the familiar" means—is quite unstable, because what is unfamiliar can just as soon become entirely familiar, and vice versa. What is recognized but cannot be possessed—like the image of a celebrity—will bear a kind of familiarity that is very distinct from a personal possession, like a curio in one's living room, and yet both may seem legitimately familiar. This distinction could be seen as the geometrical contrast that separates the linear from the radial; the privately familiar—the photo image that has meaning for two people—suggests the kind of relationship between two points that defines a straight line between them. The private photograph is a dialogue, not a collective conversation, it suggests a relationship, and, as with all relationships, the associations to meaning may be private to one of the persons or shared between both. With this (linear) kind of familiarity comes the need to read the image in the context of something privately shared, it bears traces of a language of social intimacy. But the public photograph, which includes the photographic work of art, implies a different geometry of relation; its reception and interpretation by a large social sphere conforms to the notion of a central point with interpretive lines radiating from it out to the many contexts, moments, and associations in which it is viewed.

This applies not only to the art photograph, but to all public photographs, many of which exist purely for spectacle value. In reading an image as art, however, there is something that can only be called subjective *meaning*, of which spectacle is the opposite. The possibility of "meaning" in this emotive and personal sense depends on a conversion of interpretation from public to private. To meditate on an art image is to make it private; the image is made private by the emergence of a dialogue between two things—the viewer and the image—rather than a conversation among many viewers. As a personal object, the image acquires a power for me that others may not see or have, what is familiar to me can be invisible to others. To meditate on an art photograph is to make it personal, to transform the public and recognizable of what it gives everyone into the private and familiar of what I take from it.

How then does one set apart the nature of these two kinds of photographic images when one claims to be a work of art—a claim that the other, private, kind of image has no interest in asserting? A sculptural object embodies decisions about materials and techniques that are "more special" or at least unusual than those normally available to consumer culture (that "specialty," as it were, distinguishes artists from others). But a photograph can be produced as much by a trained artist as by anyone with a mobile phone; in its publication in a book or prominent destination on a gallery wall, each can be placed next to the other. Few who are not artists create sculptures; almost everyone, however, takes photographs. Artists understand that creating implies an act for the world; the work is always potentially destined to become the possession of someone else.

So, the promotion of any object up to the status of art depends on the intention that it be presented and interpreted as such, even if that intention might not have determined *why* the photograph was originally taken. Nor might the presentation of the photograph as a work of art have been the photographer's first intention—the work might have been appropriated for that end, as many artists have done. And so, as to the private photograph, what potential relation to the world might *this* kind of object possess? This is a question for migratory photographs, those whose origins are private but which, in their accommodation into works of art, have now entered the public sphere, and this is reflected in one work by Lyn Winter. Photographically derived, but permeated by

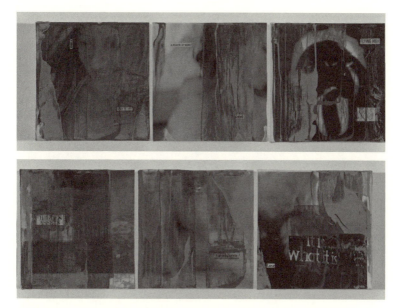

FIGURE 11 *Lyn Winter,* I LOVE YOU LOVE ME LOVE, *2009. 8" × 48" (six 8" × 8" panels). Photo collage, acrylic varnish on canvas with audio by iPod shuffle and headphones.* © *Lyn Winter. Courtesy of the artist.*

other media traces, the work is a series of six photocollage panels commemorating the hazy contours of an erstwhile romance.

Resembling a quasi-storyboard, Winter's work presents elements of a relationship, so that a kind of story is evoked, though never explained. It is a meditative reverie obscured by tones of dreamy vagueness not unlike those which marked Robert Rauschenberg's pictorial but private language. Winter's work has commandeered each of six private photographs into a series of panels that provide for the artist a means of remembering the space between what the depicted relationship *was*, as became evident in hindsight, and what, in its own day, it *seemed to be*. Rich in emotive tone, each panel plays on a juxtaposition of materials and media, to include the presence of photographs, the sparseness of collage-like adhesions of magazine text clippings, and tone strokes of cyan, red, and yellow paint applied in broad swipes across each panel. In the palette of the initial panels, the paint, as if representing both

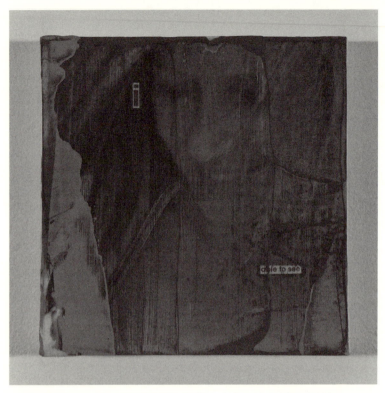

FIGURE 12 Lyn Winter, I LOVE YOU LOVE ME LOVE, 2009, panel 1.

visual complexity and emotional opacity, is minimally applied. But since the images prove difficult to discern, the paint, seemingly disconnected from their composition in the panel, undermines the seeming placidity of each underlying image, playing out the kind of fruitful effect that visual distortion in dreams provides—affective amplification resulting from the uncanny tension between the distance of cryptic images and the immediacy of their presence for the dreamer.

The basis of all literary and film history is the intractable complexity of character tension. For four acts, before the explosive fifth, Shakespeare immerses us deeply in the drowning ambivalence of Hamlet, his suspicions torn by contradictory messages

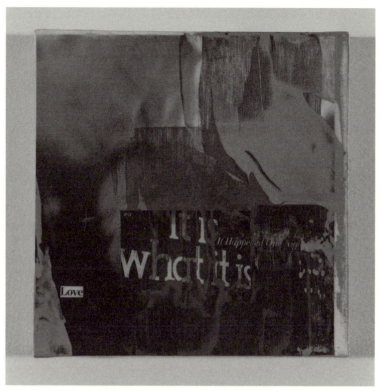

FIGURE 13 *Lyn Winter,* I LOVE YOU LOVE ME LOVE, *2009, panel 6.*

from both the world of the visible and that of the ghostly afterlife. In Winter's world, too, there is a sense of protagonism borne of the second life—from the private sphere to that of the work of art—that her images assume. In the memorializing function of photography, a medium whose exactitude to reproduction funnels our attention obsessively to the matter of the *detail*, the portrait becomes simultaneously the richest and most enigmatic statement of emotional presence—who is present to whom? Who, as viewing audience, are we meant to have been, in the original incarnation of these images? Since their initial objective was private, are we to understand ourselves as the very subjects of the photograph, as how they, in having captured these images, would have seen and

intended to remember themselves? Or are these scenes even more private than that, so private that they were destined instead for a closed album in the closed bureau drawer of a closed room? The enzymatic energy of a connection is indisputable, yet the target of its devotion is completely unclear, and not merely because of the blurry indistinguishability of the composition. Given that the extreme close-up is a direct reference to the physical intimacy of the relationship, but in its use, the fullness of the photographic image is lost, we must go beyond the visible to appreciate that relationships are often defined precisely by how the witting suspension of distance transforms into a chronic inability to take perspective, until there is only pure affect and little reflection.

But as we feel for a narrative train in this work, its image panels are accompanied by a musical recording – a reflection, a celebration, or a dirge. And, now there is text, as well: each panel vignette bears two epigrams:

Panel 1	I	able to see
Panel 2	A STATE OF MIND	love
Panel 3	FLYING HIGH	You
Panel 4	HIDDEN ASSETS	love
Panel 5	me	LAPPING IT UP
Panel 6	it is what it is	It Happened One Night Love

Three of the six panels contain the word *love*, as does the title of the song that plays through the iPod that accompanies the work; *I Love You Love Me Love*, by the English glam rocker Gary Glitter. As the first single to go platinum in the UK, this song fueled a nationwide ersatz romance, a multitudinous love projection among British teenagers of Winter's generation for Glitter—or more precisely, for the archetypal love object image that he embodied. And it is this "relationship" between a real and loving subject and a distorted love object that the playback of this song signifies in Winter's work, which, after all, documents in the open but not in a wholly legible manner the truth of one romance navigating itself through the complex dance and faint imbalance of incongruent identities—of a youthful lover and the older object of her affections. Glitter's lyrics are audible in the song accompanying the work:

We're still together after all that we've been through
They tried to tell you I was not the boy for you
They didn't like my hair the clothes I love to wear
They didn't realise that I was strong enough for two

I love you love you love me too love
I love you love me love;
I love you love my only true love
I love you love me love.

The things they said about the two of us were lies
I know they couldn't see the love light in your eyes
They said I wouldn't dare to show how much I care
They didn't know that we were just two angels in disguise

I love you love ...

So here we are alone
we made it on our own
and though they tried they can't deny the way I really showed 'em:

I love you love ...

The work brings four modalities of expression—photography, painting, music, and text—into a single structure. Yet the experience of the work is unified; there is not an obvious painterly feeling over the photographic, nor does the presence of a song constrain the visual reading; all four media forms become part of a singular aura, all four speak with the assurance of their own tradition, and together they suggest how the work, structured in this multiplicity, undermines attempts at describing the work through media-specific interpretations. But the painterly fields in the panels recall Abstract Expressionism's meditations, as does the photograph and the song that plays over the entire work—each perceptual mode provokes the same rich sensory stimulation without any overt evidence of narrative. This happens because of the substitution underlying the way the work is made: the narrative process is replaced by an interplay of methods for portraying it; distinct media thrust our attention from one modality to the next,

so that each dimension—the painterly, the textual, the sonic, and the photographic—exists in its own register, from auditory to abstract—as in the work's paint strokes—and from concrete—as in the work's photo images—to poetic—in the work's text and lyrics. Each medium presents on a physically independent plane, but within each, the mode of engagement between self and medium transports visual experience to a new feeling of the whole that cannot be attributed to or located within any medium, origin, or structure.

In this way, Winter's integral approach depends on our vacillation between the different mode of engagement that each medium provokes. Since we cannot experience the work *as* separate media, we have to take in the whole, which mirrors the emotive and overpowering character of the artist's own experience of the intense relationship memorialized here.

Here, then, is a transmodal work, and the importance of recognizing the new way of approaching such a work becomes evident in the more contentious case I present next. However, the crossing of modalities—in Winter's work, visual and auditory, contained by a single aesthetic statement (but allowing the experience of the message in one mode, of another in a second mode, or of both together)—impels us to attend not to the behavior or structure of a single medium, but instead to converge on what lies above any expressive mechanism: a new response where the insinuated distance between the externality of media and the intimacy of reflection aims for fragile balances between art and life.

A work of art that is transmodal, possessed of that conversation between modalities of representation conveyed by a conflux of media, makes its interpretive quality distinct from works that merely dazzle through *techné*, parading artistic skills at manipulating media. The main problem for the artist is to present something *integrated* rather than merely composed of separate media. The main challenge for the critic is to notice this and to explain it as a whole. One criterion—and its question—relates to the artist's realization of a kind of *productive aggregation* of media: does the viewer's participation, as prompted through digital, electronic, or technological operations, generate new experience if it merely reflects what is already observable through any *single* medium? Or is a new kind of feeling for the work, perceptible as a

larger, single experience, usefully conveyed through its layering of different media?

Used in a work of art as a documentation method, for example, photography is relegated to the *informative*; only when it transforms documentation by its insistence on a new reality in which I might *see myself seeing differently*—through new visual media, I become a different observer, and a different subject—do the photographic conditions of the artwork become original, novel, radical. Photographically, we experience this "I as a new viewer" through the lens of Francesca Woodman, Cindy Sherman, or Barbara Probst. That one must find this in new media comes directly from Walter Benjamin's reasons for suspecting the nature of the technologically born *work of art* as potentially annihilating the contemplative *conditions of art*. Of the film, his claim that "The spectator's process of association in view of these images is indeed interrupted by their constant, sudden change" (Benjamin, 1969) is a critique not against change but against *suddenness of change*. A minimal, and essential, time of concentration is not attained because it is controlled by the work's succession of images, rather than the viewer's succession of thoughts. With Woodman, Sherman, or Probst, photography's method transforms from documentation of world (as was claimed of original photography) to construction of world, a move that, due to instinctive reliance on the realistic exactitude of the photo image, we are not inclined to feel is entirely fictive. Thus there is in this quasi-realism a vague tension between derivation and fabrication, and this tension extends to the observer, whose own position is caught between a process of correspondence and recognition and one of fantasy and confabulation. But the necessity of establishing the truth behind the photographic image is important to the observer. For if the image is documentary, mimetically reflective, photography operates as something from "our world," our reality. But if it reflects something constructed, fictive, then photography is alien, uncanny, "from another side." It is the need to know which role the photograph before us is playing that determines who we are when we see it, because we are constructed by what we believe.

Benjamin wasn't worried about what happens to the photograph or any medium. His concern was what happened in *us* as viewers confronted by art made and delivered through the phonograph and movie projector—the "new media" of his day. And to explore a

technical medium and its effect on aesthetic sensibility, his argument goes in various directions, reflecting several significant oppositions. One of these is between the conditions of artistic production, in which something of the creator's experience is embedded in the experience of the work's viewer or listener (the art-as-ritual argument), and those of mass reproduction through technology in which these two experiences are set too distantly from each other in space and time (the technical-reproduction argument). In another, the distance between the observer and the observed is too instantaneous, preventing the contemplative act from emerging. So Benjamin suggests not merely that visual technology reproduces the image, but that the rate of reproduction is anti-aesthetic because contemplation's nemesis is any process of interruption. Of course, this opposition is logical only for the kind of contemplation that *preceded* the rise of technological media for aesthetic means. This is the kind he imagines when he says that "[t]he painting invites the spectator to contemplation; before it the spectator can abandon himself to his associations." We should note that for Benjamin, the word "contemplation" has two unrelated meanings: *thoughtful reflection removed from sensory experience*, as he hints in this quote where it is obvious that if "the spectator can abandon himself to his associations," he is not operating in the sensory here-and-now; and, conversely, an act of *explicit looking*, as in his later discussion of architecture, whose lack of tactile affordance presents special problems ("For the tasks which face the human apparatus of perception at the turning points of history cannot be solved by optical means, that is, by contemplation, alone. They are mastered gradually by habit, under the guidance of tactile appropriation." (Benjamin, 1969)). Here again he introduces another dialectical high-art/low-art premise around the act of absorption: whereas in the contemplative work of art, the viewer is absorbed, architecture, whose functional priority makes it less an object of contemplation than one of distraction, is *absorbed by* the public:

> Distraction and concentration form polar opposites which may be stated as follows: A man who concentrates before a work of art is absorbed by it. He enters into this work of art the way legend tells of the Chinese painter when he viewed his finished painting. In contrast, the distracted mass absorbs the work of art. This is most obvious with regard to buildings. Architecture

has always represented the prototype of a work of art the reception of which is consummated by a collectivity in a state of distraction (Benjamin, 1969).

Here is a critique of technology revolving around antagonism to introspection, to time for thought and for extended observation of a work of art. Benjamin wants to address the missing time of contemplation, the time that has been compressed into nothingness by the continual roll of impressions, those captured in the real time of the scene and played back at the same rate of speed by the subsequent kinoprojection which the filmic mechanism is best at producing. While the time of a scene is played back to the audience at the same speed—characters, would, for example, need to be seen to speak, gesture, and move at a realistic pace—there is of course a significant temporal jump between the date of the work's recording and its subsequent cinematic performance for an audience. Thus, the simultaneity of impressions projected for the audience is the same as in the original scene, and even with intensive editing, the aesthetic impression is that dialogue and action happen at the same speed both in recording and playback. Of course, the fact that the audience observes a ten-year story unfold within a two-hour film doesn't happen because the dialogue, for example, is accelerated but rather because the narrative world admits cuts between events. And *this* is central to Benjamin's critique, that in visual technology, the jumps *have now become the structure of the narrative*, not just compressing time, but also squeezing out the spaces of possible contemplation that emerge and occur precisely and exclusively in the interstitial gaps between milestone events. More importantly, even the temporal gap between recording and playback—a gap that film required—has been eliminated in the mechanism of video, film's subsequent stage of technological development, a gap that has been replaced by the complete simultaneity of live-action feed-through.

Incidentally, film is not the origin of this operation of two scenes playing simultaneously; Rosalind Krauss provides two other examples of this practice. Invoking the idea of the archetypal Medium in its ESP sense, the possessed interlocutor between the human world and that of disembodied spirits, as well as Freud's pioneering technique of eliciting and interpreting dreams in connection with simultaneous events in the patient's life, Krauss

points to the same word, "medium," in precisely these terms, approaching what she terms "temporal concurrence"—events happening in synchrony in two venues at once, being connected or channeled through the work of a medium. And she finds this association to be a good rationale for video's capacity for "the simultaneous reception and projection of an image." All three examples—that of extrasensory perception, of dream interpretation, and of the real-time feedback of video—perform with equal reliance on the human body, which is "therefore as it were centered between two machines that are the opening and closing of a parenthesis. The first of these is the camera; the second is the monitor, which re-projects the performer's image with the immediacy of a mirror."[11] This body-centering in simultaneous capture and playback—surely the very antithesis of Benjamin's conditions for aesthetic contemplation—has, however become co-opted into a work that heightens our understanding of that compression. It is the early video work by Richard Serra called *Boomerang*, in which the artist makes a video recording of colleague and artist Nancy Holt as she speaks into a microphone. She can hear herself through headphones, but these echo her utterances only after a short delay, which displaces her experience by doing the opposite of Benjamin's critique—the aural medium *inserts* a continual, contemplative interval between what is spoken and what is heard—even though the effect is one of almost total distraction. Holt observes this: "Sometimes, I find I can't quite say a word because I hear a first part come back and I forget the second part, or my head is stimulated in a new direction by the first half of the word."

> Because the audio delay keeps hypostatizing her words, she has great difficulty coinciding with herself as a subject. It is a situation, she says, that "puts a distance between the words and their apprehension – their comprehension," a situation that is "like a mirror-reflection ... so that I am surrounded by me and my mind surrounds me ... there is no escape." The prison Holt both describes and enacts, from which there is no escape, could be called the prison of a collapsed present, that is, a present time which is completely severed from a sense of its own past. Through that distracted reverberation of a single word – and even word – fragment – there forms an image of what it is like to be totally cut-off from history, even, in this case, the immediate

history of the sentence one has just spoken. Another word for that history from which Holt feels herself to be disconnected is "text."[12]

What all of this points out is how a compression of aesthetic experience happens in the juxtaposition of real and virtual space, compressed even further by the act of real-time interaction. Like a relentless involution toward the center of a black hole, the singularity occurs at the point of performance. Without this act, Benjamin's procession of "images interrupted by sudden, constant change" produces mere disorientation. Only with it, however, can the conditions of narrative arise, best exemplified in dance performance, an expressive form that Benjamin does not consider. We could imagine dance as work done by professional dancers in a space distinctly set apart from that occupied by an observing audience. But historically, this division is predated by its opposition: dance was an activity engaging one and all. In this earlier context, dance retains a quality that is lost in the modern version—it is *participatory*. Observation and presence are co-reinforced in a singular chain of sensations, an integrated experience.

When I taught art theory, something happened one day that proved the notion of an engagement aesthetic—borne of media and the idea of art always created in a continuous present—as opposed to a stable, predetermined work of art with a single origin in time. It emerged when one of the graduate students in my department presented work for the all-important crit that accompanies art school rituals of semester completion. As is customary in crits, students present work for review to faculty, which includes some outside scholars and artists. One such visitor here was a scholar knowledgeable in art of the past century, but not of the equally significant history of electronic art and literature. This lapse proved important in critiquing work at our department—and our era—since both fuse digital media with photography, film, video, printmaking, performance, and sculpture. Of course, it isn't surprising that electronic art—often plural and complex in construction—is not prevalent in contemporary art history, which classifies art in terms of the categories that arose over time as each of its practices self-differentiated. The effort of historians in bringing each of these new lines of inquiry into a contemporary canon requires fierce acts of demarcation; since each new tradition

must be distinguished from any prior one and its media, creating a canon is about *differentiation*. Thus, art critique favors singular art practices, and underrates those that are hybrid in nature, fusing or incorporating *several* traditions.

Let's return to our crit. On display was an installation by Evelyn Eastmond, whose work consisted of a large suspended light box, a screen, divided into 24 translucent panels encasing coiled Mylar strips; these in turn refracted an adagio of formless, shifting colors that emitted from a digital projector above and behind the hanging armature. Moving gently, the palette of whirling colors rear-projected against the screen was indirectly determined by viewers, who could text words or phrases to a phone number displayed on a laptop computer positioned near the light box. The work employed software for the modal conversion of words into colors. Each word or phrase received by the work would be associated with an array of colors that at times seemed obvious ("Devil" producing red hues; "Ocean," aqua ones) but when the text did not convey visual reference, the projected color palette became more interpretive.

FIGURE 14 *Evelyn Eastmond,* Interactive Light Sculpture, *2010. Japanese Mylar LightBox Java, Google Voice, COLOURLovers API, mylar, wood, vellum. Detail. Image courtesy of the artist.*

The work unites three separate media traditions. First, the suspended light box is an unmistakably sculptural object. Second, the abstract use of projected light references the tradition of abstract light and video works dating at least as far back as Anthony McCall's *Line Describing a Cone* and subsequent projective works like *You and I, Horizontal, III 2007* of which I say more shortly. And third, the use of SMS text messages to induce changes in a projected work is from the convention called *cell phone art*, but which falls into the much broader field of electronic literature. In a critique of this unique structure, we can engage the work subtractively—following separate sculptural, filmic, and interactive analyses—or in the same way as it is experienced—as a special whole. The latter approach requires us to bypass the tradition of each medium comprising the work. By entering it as something beyond specific histories, one experiences it as something new; it is post-historical because it is post-medium. And the viewing process should attend to the work, rather than to its component parts.

Viewing this electronic work with distaste, our visiting modernist dismissed it precisely *because* of its hybridity, rendering the work

FIGURE 15 *Evelyn Eastmond*, Interactive Light Sculpture, *2010. Japanese Mylar LightBox Java, Google Voice, COLOURLovers API, mylar, wood, vellum. Image courtesy of the artist.*

unstable, as neither of one tradition nor of another. For her, its very interactivity (via viewer-contributed text messages) rendered it inadvisable in "serious" settings. Anyone, she admonished, could text profanities to the work and debase its artistic significance. No doubt, all interactive art, electronic or otherwise—as well as all public art—exposes itself to misuse. Less relevant than such judgments, however, is the larger question of whether any aesthetic line between intention of *art* and that of *world* is as valid for appreciating electronic art as it has always been for conventional art. Of course, one can "enter" a painting, but the engagement is of a unilateral kind, it doesn't change the work. It is effectively half-engagement. The aesthetic of electronic art such as Eastmond's, which blends media with interaction, realizes a much broader kind of engagement, and not only because it is interactive.

But in this afternoon's drama, our visiting historian's dismissals took aim less at the formal qualities of the assemblage than at a viewing experience whose interactive function had now become "the special complicity that that work extorts from the beholder," (Fried, 1968) as Michael Fried wrote decades earlier, of minimalism. It is a complicity that destroys the stability of the work because it is reconfigured with each encounter; it becomes an essentially different image with each textual conveyance; it changes with use, with *total engagement*. Fried's attack was misguided, and had the ironic effect of legitimizing minimalism in art critique. Likewise, our visiting scholar's complaints of the work's non-seriousness and the perils of its potential profanity were sustained, and after nearly a half hour of invective, a *call to action* emerged from many in the room, who, having been convinced of profanity as the work's aesthetic, then proceeded, mobile phones in hand, to produce a barrage of text messages to the system in response to her derision—many of which attacked her personally. The texted rejoinders functioned in effect as two kinds of demonstration. One was instrumental, a demonstration of the system's use; its interactivity being held up in exception to the scholar's judgment of the work along lines that speciously insisted on placing it in a conventional category as a *static* model of installation. This was a numbness to the act of emergence with the work, a feeling that what made it new—its engagement with beholders—is precisely what diminished its value. The other kind of demonstration became an affirmation of social action as artistic ingredient, a collective show

of feeling opposing critical traditionalism, and bearing witness to an antiquated orthodoxy before a gathering of artists whose work was itself founded on a broader notion of engagement, and whose own commitment to new art directions, therefore, had since traced many daring departures from old-world stances. In an artwork, the act of speaking back to the viewer constitutes an extension of aesthetic experience that raises it from the circumstances of *sentiment* to those involving *language*. And as it was true and essential for Wittgenstein to assert foundationally that "the meaning of a word is its use in the language," it is true and essential that to this new generation, a work of art is what emerges in *use*, so that, although contemplation remains an aesthetic aspiration for all artists, *use* alone, and what emerges from it each time—as in the collapsed present that speaks back to Nancy Holt in *Boomerang*—forms the guiding criterion for validity in a work. The tools may be technological, but the actual medium is engagement. Because use is the genesis for meaning, no normative judgment *other than use* can validate its aesthetic. So here, the lopsidedness of critiquing work that prompts viewers to speak back to it was the first retreat from the aesthetics of non-engagement that has circumscribed much—though not all—modernist art. Eastmond's crit may not be far from what it might have been like to review Vito Acconci's *Seedbed*: the aesthetic in each is framed by the conversational co-performance that defines the work's potential. Each work is not a statement of the responsiveness of a work of art, but of its *presence* as a dimension contingent on ours. And that presence, in Acconci, Winter, or Eastmond, to mark three entirely separate lines of effort, is the basis of use that language's engagement, in transmodal works of art, compels in order to create meaning.

CHAPTER FOUR

Engagement as media metonymy—The aural as visual

As a starting point for imagining the innovative success that is possible using one expressive medium as another—a sort of transmodal shift—we have only to think of one artist, for whom a city has given itself in curious fascination. I say "given itself" because it is beyond rare for three major art venues in one city to *simultaneously* exhibit the work of a single artist. Even in New York City, that metropolis whose many art spaces might accommodate such a possibility—and recently has—there is more to read into this confluence than assertive artistic promotion, but rather, this triple action must be taken as a full embrace of something about what the artist's work represents, as a compass on curatorial and art sensibility at large. The reference to a transmodal shift of media I make is because the protagonist of this interest, Christian Marclay, is not a visual artist by conventional definition; while he has created photographic and video documentation, his original medium is not visual at all. It is perhaps not even a medium as much as a practice, which is where the crux of urban attention lies and points to what we might briefly examine in that extraordinary co-optation.

If a work of art functions to engage us with both its uniqueness and familiarity, it is because of a kind of "circle-making" closure where what its aesthetic frame *excludes* is what cues the viewer on

what is to be read *back into* the work. More obvious for Marclay's practice, what is included within the frame of an object is its content, while what is excluded is often determined by limitations inherent in the chosen medium. This terminus enables an experience of crucial duality between what is perceived and what is felt, what is sensed and what is imagined. It is a boundary that Marclay, as maven of the phonograph more than any other mechanism, navigates. His principal strategy could be called the *metonymic filibuster*, it is designed to take part of a work for the whole, thus suspending the full performance of what its original expressive medium provides. The tactical move is twofold, involving first a partial or incomplete selection of aural or visual work amenable to sensory reception via the photograph or phonograph, and then impeding its reception by perturbing its playback or display. The array of expressive media subjected to these operations is itself a study in pluralism.

First in this procession of media is photography, at the Paula Cooper Gallery, where the recent Marclay solo show named *Fourth of July* featured a series of large-format torn color photographs of an eponymous parade in New York City which the artist photographed in 2005. The display set comprised seven portraits—although we never see any of the subjects in complete rostrum view—of members of a marching band, for the photos were torn into various shapes, each of which prevents us from observing but a fragment of the action. In the photographic medium, the image is always the center of reception, but when its physical reduction by tearing is so severe that its function as a sign of the world is negated, we put equal focus on the boundary, the frame, so that the shape of the image, its fragmentation, is in dialogue with what is captured photographically. Denying the holism of a scene upon which the eye depends, these works operate as anti-portraits, or at best, as scenes of scenes, visual *subsampling*, a term whose exploitation Marclay's musical vocabulary also understands.

Thus to imagine that this collection is a photographic show is to misread the larger aesthetic operating here; it is one in whose structure the medium is presented in staged engagement with something outside of it, and this engagement—here, both physical and retinal—identifies a reading bridging two distinct worlds. The fact that, as a logical step after collage, this selection of, bridging across, and playing through media is now a prevalent artistic

FIGURE 16 *Christian Marclay*, Untitled *(from the series* Fourth of July), 2005. C-print 32" × 31½" (81.3 × 80 cm.) Framed: 38 ¾ × 38¼" (98.4 × 97.2 cm.). © Christian Marclay. Courtesy Paula Cooper Gallery, New York.

practice for artists, sets it apart from most legacies of art making that precede it.

Similarly, there is *Festival*, a Marclay mid-career retrospective staged at the Whitney Museum. Looking as much as art school classroom as rehearsal space at an experimental theater company, the Whitney show presented a textbook case of how to structure the engagement aesthetic between form and frame. Enclosed video and exhibition spaces melded into a larger common area that was itself

reconfigurable into quarters by enormous black curtains, selectively drawn closed during live performances by musicians playing Marclay-made instruments. In this open plan, inscribed through the entire span of one wall painted as a massive blackboard was an array of musical staff lines with chalk holders allowing visitors to "compose" what the performers might wish to read. A pyrrhic gesture, since the wall is not positioned so that players could easily see it, but no less crucial to the exhibition's engagement aesthetic: the symbolic overlay of players using Marclay's instruments, performing to the visitors, ostensibly interpreting their "compositional cues"—all of this crossed the worlds of language, music inscription, and reader response to the exhibit-as-medium.

The third deployment of Marclay work in New York City, part of the *Haunted* exhibition at the Guggenheim Museum, was in the company of a larger undertaking organized around the theme, increasingly topical, of part-whole relations investigating how a medium that captures only a portion of experience—itself modulated through artistic voice—can reconstitute larger memory and meaning. While the principal medium for *Haunted* was photographic, space was made at the top floors of the museum for three video works whose identity was about memory. The thematic concern of the *Haunted* show, which I would term the "conceptual afterimage" where photographic media use the past as an aesthetic function (rather than just one of information retrieval), is very much Marclay's own, as when, in his contribution to the show, the single-channel video work entitled *Looking for Love*, he creates juxtapositions of memory in the LP records and similar analog media, juxtapositions that are immediately set off to destroy memory or undermine the conventional aesthetic experience for which they were created. And this, he accomplishes by literally going against the grain of the medium's own structure and materials of reproduction: a video close-up of a phonograph needle is dragged over the grooves of a record, so that "looking for love" means looking for where the word "love" was sung.

One reading for both shows, the Marclay festival at the Whitney and the Guggenheim's *Haunted*, could circle around the interface between the potentials of aesthetic perception and the production of sensory triggers for them. In the case of the *Haunted* exhibition, the production is photographic; with Marclay it is aural. Each line of production is thus anchored to departures from the particular

FIGURE 17 *Christian Marclay*, Looking for Love, *2008. DVD, 32 Minutes. Edition of 5.* © *Christian Marclay. Courtesy Paula Cooper Gallery, New York.*

character of specific media—the camera and the phonograph. But this interface reading between reception and production—the notion of memory as the target of media production, whose sounds or images evoke references to the problematic past and our inability to reproduce it clearly—is only a possibility for the total phenomenon of this larger relationship between self and media, a relationship that has come to dictate preponderant conditions of art today in which new media choices—Serra's cor-ten steel ellipses, Jessica Stockholder's retail plastics, Thomas Hirschhorn's low-grade material enclosures, Ilya Kabakov's dreamy closet-like rooms, Rachel Whiteread's blocks of architectural forms without faces, Tracy Emin's squalid *mise-en-scènes*, Damien Hirst's taxidermy of the grotesque, Matthew Barney's post-pagan carnival performances—all reflect an engagement between the status of art and the presence of the self, each contingent and seeming separate but with an ineffable connection to the other. More germane to this phenomenon is a different departure from the convention

whose historical reliance on the figurative and representational became tied to production practices that both artist and audience understood. That art until the late nineteenth century was judged on bases of taste meant that subjective and objective—that the experience of art and the quality of art—were determined together and simultaneously. It meant that art was a signifier of society because it was a matter of universal consensus, although this occluded an asymmetry that has augmented out toward all of contemporary art, because, like two circles that never overlap, the production of the work was entirely dependent on the artist, while the production of interpretation lay completely with the viewer. Today, this equation is no longer fixed.

This change has not merely affected art; it has by and large become the principal mode of experiencing of it, both via artistic production and the assumptions of viewerly response. The independence of these production-reception spheres is gone; they are no longer distinct or even sequential. Instead, they now emerge together; execution and context become dependent no less on audience than artist. And interpretation is no longer a matter of consensus—since the earliest Cubist work, or the subsequent articulations of abstraction variously adonized from Picasso to Rauschenberg, such work challenges the academic categorization of genres like landscape, still life, or portraiture. These historically elaborated categories have lost ontological weight, and the eye, schooled or unschooled, is equally confounded. Another factor emerges from the problems of boundary in works whose space or time can no longer be determined. And a third factor, which should be called aesthetic nominalism, points to the new practice of built-in measures against reproducibility of the work, so that it is performed uniquely each time. These are frequently present in a dual mode of existence, as indications, templates, or instructions for execution on one hand, and as specific but ever-unique instantiations in distinct occasions on the other.

The results of these divagations from the cogency of convention have been given simple names, perhaps "pluralism" being the most common, though least informative. If, as we know, it is clear that, in this variety, a century of art has gradually challenged sensory expectations against conventional modes of experience and historical categorization, it is also true that, together, the many varieties of this challenge alter the act of reception from

something passively convenient to that which, in order to complete the work, must engage it in new ways. Artistic sensibility predicted that, in order for this to happen—for the viewer to enter the space of production—standards of aesthetic convention had to be sacrificed. It is not that *aesthetics* has been expunged from modern and contemporary art, but that it has become redefined, the familiar mode of its experience—summarized as judgment from perception—is now less crucial to the experience of a work. Key now is the sense of, and commitment to, activating its world as constructed, as presented, and as possible at *this* moment more or less independently of any other, so that in order for the work to exist, it must exist *now*, without necessarily any reference to a history or a future. As this *now* is constructed from the overlap of the duality of production/construction and reception/interpretation, artist and audience collude in the contract of art making. The final outcome generates new experience connected less to disembodied universals like beauty or truth than to the immediate confirmation of one's own being by engagement with the work's statement. Replacing the old universals feeds new forms of artistic action that could group under an engagement aesthetic.

It is no longer possible to manage memory without managing media. We must again revisit the question of where memory happens. With the revived age of enlightenment that accompanied the Freudian psychological model, the principle of "repressed energy" has moved from its earlier center in narratives of religion, and later even fluid dynamics, to ones based on the function of the mind itself. Here, the problems of memory are exposed; it is meaning-laden but structurally flawed. In the mind, memory is woven into other memory, where associations are not accidental, and are instead motivated by subconscious processes. Incompleteness is augmented by imagination, and recall is not merely informational but reflective, serving as description of the thinker. An aesthetic line connects this phenomenon—Freud's principal insight—with one that Marclay evokes in an unrelenting part-whole engagement within and against emotive associations with the media of memory and recollection.

CHAPTER FIVE

Projective engagement—Transcending the modernist grid

Almost everyone seems convinced that life a hundred years ago was simpler than it is today. The relentless rise and prominence of industry and technology is blamed for complex existence buckling under mountains of details and rules that seemed blissfully absent from earlier times. But if there is one thing that became *less* convoluted in the twentieth century, it is the architecture that arose there, and which influenced all the design styles that came to be characterized as modernist. For a variety of reasons, including cost, new buildings abandoned the ornamental quality that typified nineteenth-century structures, and with the evolution of plated glass and steel-reinforced concrete, the new century turned to a minimal style that revolved around, and resembled, the simplest of forms: the grid. What ornament was to art and architecture of the nineteenth century, with its flowery complications and interwoven excesses, the grid, with its austere uniformity, became for the twentieth. Tempting in its economical simplicity, the grid eventually entered the dimension of painting and sculpture, and there, became a tradition unto itself. By the 1970s, therefore, this tradition had become well established, and Rosalind Krauss wrote the preeminent critique of the grid as the singular structure most emblematic of modern art. So, as the grid became the symbol of

skyscrapers with their windows arranged like the cells of a spreadsheet, it has also been adopted into major artistic movements, from Suprematism, to De Stijl, to Minimalism.

But the story doesn't end there, because what the grid initiates with its symmetry and its abstract purity, the circle extends, in a form that approaches a Western mandala, something stressing *radiality* from its center. The circle's compositional integration is a mirror, a simile for the universe as an expansive principle where, as with the mandala, any notion of a center is subservient to the form's overall order.

But in order to understand the circle, we must consider the allure of its predecessor, the grid. In its latticed form, the grid is a pattern whose mystical overtones modern art criticism doesn't deny, for two crucial reasons. Reason one: the first artists to employ grids spoke to the transcendental ontology of its creative form—we note Krauss's acknowledgment, that "Mondrian and Malevich are not discussing canvas or pigment or graphite or any other form of matter. They are talking about Being or Mind or Spirit."[1] Second—and more forcefully—it is in the grid's transcendence that the idea of symmetry finds a way *out* of form and into an interpretive rabbit hole of possible pathways—as again Krauss affirms: "The grid's mythic power is that it makes us able to think we are dealing with materialism (or sometimes science, or logic) while at the same time it provides us with a release into belief (or illusion, or fiction)."[2] Thus, in its embrace of this visual archetype, the art historical record is clear: the grid signals modernity's engagement with formalism.

And so, again and again, in the drawings, paintings, and prints of Marcel Duchamp, Piet Mondrian, Georges Vantongerloo, Ellsworth Kelly, Donald Judd, Kenneth Noland, Sol LeWitt, Robert Ryman, Agnes Martin, Chuck Close, to cite ten artists in the twentieth century, there was a marked and persistent return to the grid, exploiting its seductive significance and archetypal purity. Unmistakably, this procession traced its lineage through the mainstays of the modern and contemporary canon. Of course, a grid painted by hand, declaring the commitment of artistic reduction to repetitious formalism, conveys the same attention to its form as can a machine-programmed grid, realized through the iterations of algorithmic generation. So, even though the grid is, as Krauss notes, a shape somehow dependent on the obviousness of

a material support and the presence of labor for its transcendence, it is nonetheless an abstract form, and it fascinated many digital artists. In the grid, this equivalence between conventional and programmed ways of producing art renders its bias against the computer as an art medium inexplicable. Art history has commemorated its favored paint and print artists, while denying the same in the work of others who used computers to make art based on that same grid. But, despite being ignored by art historians, the artists who used electronic media to investigate the grid did so in a manner that used it less as an immutable altar (as did the Minimalists) than as a catapult for new formulations. Working at the same time as their famous counterparts who used physical

FIGURE 18 *Vera Molnar, Untitled, 1971–4. Plotter drawing, ink on paper. Computer: IBM; Plotter: Benson. 40½" × 40" framed. From the Anne and Michael Spalter Collection.*

media, these electronic artists, to include Vera Molnar, Edward Zajec, Kenneth Knowlton, Jean-Pierre Hébert, Georg Nees, Roman Verostko, and others, took the grid into individual and radically reconfigured terrain.

Thus, of particular (and historically overlooked) relevance is the means by which new-media artists have offered up new directions after the abstract geometry of the grid reached its repetitive exhaustion. An array of new possibilities emerged. In one, as Edward Zajec's or Ken Knowlton's work captured, the grid undergoes a partial shift from within, so that its structure remains unchanged, while revealing the beginnings of a new core undermining its own perfect symmetry.

FIGURE 19 *Kenneth Knowlton,* Untitled, *1972. Silkscreen after plotter drawing. From the Art Ex Machina portfolio 197/200. From the Anne and Michael Spalter Collection.*

In another, the grid retains its emblematic uniformity, but this has been splayed out like a rainbow over successive curvatures, a transformation that is the signature of Mark Wilson's sweeping work.

FIGURE 20 *Mark Wilson.* SKEW FF10, *1984. Rives Offset rag paper, with a Tektronix 4663 plotter using pigmented inks and an IBM PC* 43⅛" × 27" *framed. From the Anne and Michael Spalter Collection.*

In yet another move, the grid is exploded altogether, its structure remaining as an echo, almost as if it followed a creative big bang—this is evident in the delicate work of Jean-Pierre Hébert or Roman Verostko.

Of course, it is folly to imagine the grid as a modern structure; what I am arguing for is its ubiquity as a design archetype. Perhaps its debut as a meme begins obliquely, in the book, where text is arranged in regular galley margins and read in a singular direction page by page. It is not only an X-Y grid of letters, but as a mountain of paper, it is also an X-Y-Z grid of bulked-up signifiers. There is nowhere to go but *out*, and the explosion to which I referred earlier has occurred in literary art as well, in the tradition of authors from the early Futurists through concrete poets in work that assumes visual dimensions while preserving its textual legibility.[3] So, while Verostko, Hébert, and those other post-grid visual artists known as the Algorists explore *form* as the point of departure from the grid, we might imagine both shape *and* text as simultaneous catapults from the grid. This emerges, for instance, in the work of Henry Mandell, whose strategy is the adoption of texts—essays, poems, or even quantitative data—into visual abstractions which nonetheless evoke the spirit of their original context. The meditative aims of Abstract Expressionists like Mark Rothko re-emerge similarly in

FIGURE 21 *Roman Verostko, Untitled, 1990. Plotter drawing, ink on paper, 31¾" × 43¼", framed. From the Anne and Michael Spalter Collection.*

Mandell's landscapes—the viewer's attention oscillates between a sense of the text (a sense that is without direct reference, since the text can no longer be discerned) and the originality of the shape. The mystery of the text's meaning lies not only in its illegibility, but in a story of extraordinary origins. In *Tamahagane*, for example, Mandell references seven centuries of masterful production of Samurai swords borne of Tamahagane steel's organic purity, as he stretches and folds the vectors of a text on the subject in the same way as the masters forged their own material.

FIGURE 22 *Henry Mandell.* Tamahagane, *2011. Ultrachrome archival pigment on canvas, 44 × 126″. Image courtesy of the artist.*

Tamahagane, the first canvas painted with digital media to enter the permanent collection of Boston's Museum of Fine Arts, is a historic predecessor on several levels of *Soundings*, one of a series of works composed from text and information about climate change as it has been recorded over five hundred years, explaining Mandell's semiotic transformation from the symbolic level of text to the iconic one of image, as for him, *Soundings 5C*'s shape is doubly evocative: "of high altitude weather balloons whose soundings of the atmosphere inform specialists of its health and well being."[4] And to this, he began with "the unformed idea of producing a vital vessel in which to contain an essence of life."[5]

In any case, as the grid has been transposed, it is frequently also into circular form. That transposition is necessary to bring fresh artistic energy to an overused essence. Today, grid composition is no longer innovative, and, since material support itself is, in a technological epoch, no longer a precondition of creative production, we find how, in much electronic art, this new shape has borrowed the distant abstraction of its earlier rectilinear variety,

FIGURE 23 Henry Mandell. Soundings 5C, 2012. *Ultrachrome archival pigment on paper 57 × 22". Image courtesy of the artist.*

but has learned how to transcend it. The circle's trigonometric correspondence with the engineering of the cathode ray tube, the computer monitor, and many kinds of projection, lathing, and impression systems raises the status of that shape and renders it as the *new grid*, the palette and co-ordinate system for contemporary electronic art. Of course, non-digital art, too, has long used the circle's fertile promise—we could in fact draw a second historical timeline from Duchamp's first filmed rotoreliefs in action up to Anthony McCall's projections, where the viewer changes from an

FIGURE 24 *Anthony McCall, You and I, Horizontal, III, 2007. Installation view at Sean Kelly Gallery, New York, 2007. Solid light installation, 32-minute cycle in two parts. Computer, QuickTime movie file, two video projectors, two haze machines. Dimensions variable. Courtesy the artist and Sean Kelly Gallery, New York.* © *2007 Anthony McCall. Installation at the Serpentine Gallery, London (30 November 2007–3 February 2008). Photograph* © *Sylvain Deleu.*

image to sculpture by *entering* and disrupting the work with his own body. Incidentally, McCall also illustrates that electronic art need not be digital.

Rather, the insistent abstraction of the circle, for example, characterizes the analog signal, in works like John Whitney's *Permutations*, a series of short films illustrating the dance of dots in a progression of circular rearrangements over the spatial void of a CRT screen. But to reach the height of an art machine's play with the archetype of circularity awaited the work of one of its quietest pioneers, Desmond Paul Henry. Henry used the targeting systems and sights of bomber planes to construct mechanical drawing machines powered by their electrical servo motors. This resulted in a kind of spirograph on steroids, a complex arrangement of gear trains and cogs. In its original use, the sight mechanism calculated a parallax that anticipated the impact point of a bomb from a

certain altitude and speed. Thus, a bombardier entered information on height, bomb weight, velocity and direction into the (analog) computer, which then calculated the bomb's release point for best accuracy. Henry's adaptation added a means by which the mechanism would trace a succession of partial curves and mark them on paper. Each machine-generated drawing took from 45 minutes to three hours to complete. The process, while manual and mechanical,[6] also incorporated chance in the final drawing.[7] What emerges is the eye's inescapable pursuit of the lines through their radial orbits, a trace which the grid forbids.

The turn from ornament to grid was not the only change in the art of the last one hundred years. Much modernist art from the twentieth century is a gradual departure from academic perfection of the image and a portrayal of the psychology, even the *trauma*,

FIGURE 25 *Desmond Paul Henry,* Radar Beam Sweep, *1962. No. 053. Black and orange biro on smooth, white card, hand embellishments: vertical and horizontal lines in ink. Executed using Drawing Machine One. 19cm × 26cm. Exhibited at Henry's Solo Exhibition at Manchester's Central Reference Library, 1964.*

FIGURE 26 *Desmond Paul Henry,* Tractatus 6.2322 (Wittgenstein) no. 069, 1967. *White Indian ink in tube pen on black cartridge paper. Hand embellishments: some white highlighting in Indian ink and sweeping lines in bronze-colored marker pen. Executed using Drawing Machine Three. 72cm × 50cm. Picture submitted for inclusion in* Cybernetic Serendipity, *1968.*

behind it. The project begins just before Impressionism culminates in forms of abstraction, where a physical object and its represented image are no longer connected. But what arose from the ashes of Abstract Expressionism is different. *That* postmodern art is characterized by a return to the real, drawing from societal conditions the materials for aesthetic production. So how feasible is an artistic union between the detached perfection of the circle on one hand and contemporary art's connection with the real, imperfect world on the other? How can a form like the circle be used in *this* world in conditions of photorealism, of motion, and of what a technological art form can bring to them? This is the question that Anne Spalter's digital projective work considers, and in so doing, resolves a missing vector between the creative lineages of the grid and the circle. The end result, it turns out, is not founded on material supports, but rather on the technology of filmic realism, computationally modulated.

Spalter's approach begins with architectural observations, capturing a succession of events over time using a very constrained cinematic grammar, namely the linear pan, the zoom, and the steady shot of urban settings. Before us lies the transposition of the world from its natural Cartesian perspective as our eyes see it—horizontal motion across the x axis and vertical, running up and down—to one whose co-ordinate system is *radial*, using a fragment of the visual field as a slice that weaves into itself around a circle. This doesn't merely yield a polarized fugue of somewhat recognizable scenes and objects. It also resolves a long-standing problem of how to unify the abstract promise of the circle with the pragmatic and embodied realism of cosmopolitan life. It brings together the quasi-tessellated rabbit-hole of immersive order that we encounter in artists from M. C. Escher to Andreas Gursky, with the visual stimulation of a filmic setting, recalling from other traditions in the twentieth century— for example, in literature—the turn away from formalism and toward realism; William S. Burroughs, Jack Kerouac, and Hunter S. Thompson come to mind. But Spalter's visual assemblages also propose a new trope that starts in Duchamp's *Anemic Cinema*, with its classic rotorelief mechanism, up to the mathematical symmetry that Benoit Mandelbrot discovered in the structure of natural forms from small scale to large, so that a video shot of a highway, in Spalter's mutations, reveals an uncanny similarity not to an object

FIGURE 27 *Anne Morgan Spalter,* Circular Highway, *2011. Video projection. 00:13.*

but to an entire *range* of them, to include at one moment, the floret seeds in a dandelion that in turn explode to the multidirectional obduracy of a star.

FIGURE 28 *Anne Morgan Spalter,* Circular Highway, *2011. Video projection. 00:23.*

And as this shape expands, its inner membrane dissolves, so that the points transform into spokes where separation between inner and outer form yields to that of an open nexus.

FIGURE 29 *Anne Morgan Spalter,* Circular Highway, *2011. Video projection. 00:26.*

In turn, this image's radial augmentation again returns to the star, but now as its negative, a space *between* points, and pointed to by them:

FIGURE 30 *Anne Morgan Spalter,* Circular Highway, *2011. Video projection. 00:30.*

FIGURE 31 *Anne Morgan Spalter, "Sky of Dubai," 2012. 3-minute looping 1080p HD digital video. Shown on Digital View 96" × 54" panel wall. Image courtesy of the artist.*

Spalter's eye for submitting horizontal linearity to applied movement in a single continual direction produces a chain of transformations that resolves, as I have said, not toward a single image but rather to the presence of a *principle of translation*, sometimes imposed directly over urbanscapes, as in *Sky of Dubai*, which was shot from a helicopter as a portrait of that city's skyscrapers. It is one whose essence is both abstract and *in* the world of physical phenomena. This is the intersection, between the worldly and the pure, that mandala makers understood, as they gave us fleeting visual monuments as aphorisms of contemplation that would use *form* as a way to move toward everything that lies *beyond* form. And it is the same meditative process into which Spalter's transcendent motion draws us, and whose form of engagement reveals images as evolutionary, rather than static, phenomena.

CHAPTER SIX

Engagement from objecthood to processhood

Not long ago, a colleague pointed out a paper sign tacked on a wall of the classroom where I taught theory. Its handwriting read, "Can computer games be art"? Optimistically, he suggested that the answer has been confirmed by internet discussions. I was less convinced.

For a long time, museums, galleries, historians, and critics were the only authority for determining the aesthetic status of something (its monetary value was and is determined by art auction or private sale). But the question of whether something is or is not art can no longer be dismissed by merely asking whether it resides in a museum or gallery exhibit. New art has rarely emerged through these institutions, much more often it has been excluded by them. Infamously, Marcel Duchamp's first readymade, *Fountain*, was included in a gallery exhibit, although the show's curators placed the urinal in a separate room. It was included but not shown, it was therefore excluded. While *Fountain* changed modern art, neither that exhibit nor its organizers are important to art history. As far as the record goes, they are neither included nor shown.

The question of art status, of course, resembles an earlier chapter in modern art when, in the early 1920s, Alfred Stieglitz struggled to legitimate photography within the gallery system and wrote to the man who most infamously undermined that system—Duchamp himself—to ask whether a photograph can possess the status of art. The consequence of this for new media art is something I have

considered elsewhere.¹ Here we see Stieglitz, working as more than an artist, and for 15 years managing a gallery devoted "to advance photography as applied to pictorial expression," continually assembling and promoting exemplars for a growing canon of photographic art. Yet here he, Stieglitz, becomes the ironic outsider posing the categorical art question about the product of a revolutionary medium—photography.

Stieglitz, unlike Duchamp, did not come to photography through an art school education. His artistic development followed another trajectory. Mechanical engineering, his primary field, was central to his development of the photographic medium. Regardless of the engineer in him, something coalesced in Stieglitz such that mechanical precision progressed through artisanal perfection and arrived finally at mature consciousness of the photograph's aesthetic promise. At that point, Stieglitz's own attitude changed; photography became less the medium to be perfected than the art form to be cultivated. This isn't unique to Stieglitz or even to photography; the progression from instrumental craft to legitimate art form is the same one that Stanley Cavell's philosophy locates in the origins of another medium: film. As it was with Stieglitz's interrogation of photography, it is also true for Cavell's questions of film's aesthetic, whose genesis he finds, with Panofsky's own and in opposition to Bazin's, that it was not "an artistic urge that gave rise to the discovery and gradual perfection of a new technique; it was a technical invention that gave rise to the discovery and gradual perfection of a new art."² That is, the processual art always evolved from the objective medium.

The more intricate the machinery of an expressive medium, the less dependent it is on art institutions to legitimize it as an art form. Film, much more dependent on complex technology than is photography, has never been defined by the gallery system. It is a medium capable of thriving within as well as outside it. As film became "the movies," it grew into a commercial empire not through the institutions of art but of entertainment. And thus, each world—art and entertainment—has adopted its own relationship to it: if we can consider *films* as an art form, we can also speak of *movies* as entertaining for its viewers, and profitable for its producers. The commercial film has evolved to serve the industry whose adjective describes it. The presumable integrity and depth of art and artist that emerges from images of solitude and sacrifice

stood against the shallowness of commercial film's evolution in the 1930s as a product of a draconian studio system—each emerged from a very different kind of studio. The artist created the demand for his work, but commercial film is led by the expectations of a general audience, which drives the demand for popular entertainment. In this sense, the term "mass market," and not just the word "commercial," is also an inverse of high art. Not without irony, this distance from the masses allows high art to become profitable without losing claims to integrity, since now many works of art, contemporary as well as classical, fetch auction prices exceeding the production costs of many commercial films. This speaks to the contrast between *creation* and *production*, one that we will visit shortly.

The comparative view of fiscal relations with which I have opened here is the beginning of several contradictions about the computer game. It is fundamentally an entertainment apparatus. Historically, photograph and film have seen a family of critics arise, writers balanced by complex positions, names that include Panofsky, Bazin, Metz, and Cavell, and promoters like Stieglitz—exploring the problem of each medium's own legitimacy as art. Games are only now developing that lineage, although the legitimacy of any art form always depends on the solidity of the critique that engages it. However, arguments for games as art are expressed through sheer declaration, an authority akin to the sort of baptismal claim that allowed King Henry VIII to annul his own marriage by creating the religion that permitted it. This does not lessen the integrity of the game in itself, but knee-jerk endorsements deny the role that history can and must play in determining the status of any expressive form as art—not as commerce. Indeed, proponents of photography and film emerged shortly after the medium had already been developed and explored principally as an optical device. Any claim that photography and film were from the outset motorized by an aesthetic program is patently untrue. Their development traced, in Panofsky's view, a "technical invention that gave rise to the discovery and gradual perfection of a new art"—not vice versa. But the massive system that games have populated—the global entertainment empire—was already in place at their birth; it followed commercial film's own invention of that industry—largely by itself. This is the same industry that replaced an existing culturally integrated entertainment institution—theater.

It is an industry that, even further back in time, did not exist at all during photography's infancy, which is precisely why Stieglitz created the Little Galleries of the Photo-Secession, a name whose agenda we would do well to reflect upon. The overlap of distinct stages of culture industry with the evolution of a technical art form's products, then, is the question to probe, rather than whether any such form, by commercial emancipation, can claim arthood through institutional relationship.

Which brings up one of the more often-cited apologias for the art status of the computer game, the essay *Games, the New Lively Art*.[3] The position taken there champions games as art on normative grounds. Its author relates the experience of attending two panel discussions at a conference. In the first panel, we are told, the discussion was "sluggish and pretentious"—and, it seems, amenable to telepathy: "I knew exactly what they were going to say before they opened their mouths." By contrast, the discussants in the second panel "were struggling to find words and concepts to express fresh discoveries about their media; they were working on the very edge of the technology, stretching it to its limits, and having to produce work which would fascinate an increasingly jaded marketplace." We don't know what was sluggish, pretentious, and predictable about the first discussion; no quote of this account is given. The article identifies the disfavored speakers not as theorists but as digital *artists*. The second group, we are told, comprises game designers. Now, it seems to me that claims for the art status of any medium ought to be made in a manner that integrates, rather than rejects, the experience of its artists. But if, as the contrast between digital artists and designers implied, creativity marks the accelerated pace of the designer, how should we understand the common frustrations of game designers whose creative work is constrained, controlled, or curtailed by constraints of game industry structure rather than being properly free?[4]

Jenkins's essay, whose title alludes to a 1924 defense of popular culture as an art form, references cultural critic Gilbert Seldes's *The Seven Lively Arts*. Seldes wanted to present not a defense of the moving picture as *art*, but rather to "establish the picture as a definitely accepted form of *entertainment*" (emphasis mine).[5] "Lively art" here must be read synonymously with the latter term; the defense was important by itself, it did not seek to relocate

the moving picture into the legitimizing context of galleries or museums. In fact, art and entertainment differ less over legitimacy than *topicality*—art aspires for timeless relevance; entertainment aspires to be relevant *today*. So, an art medium like painting is organized in genres—landscape, portrait, abstract, still life—that are transcendent, academic, and not from the fashionable trends and tides of cultural taste. An entertainment form, however, is always a direct echo of the contemporary *moment*; it is a frame from a cultural skein reflecting the self-determination of a society, not of an artist, a genre, or a medium. Seldes's essay should be read through our evolved understanding of the film medium not as art but as entertainment, since its archaic proclamations of artistic merit, such as that "the drama film is almost always wrong, the slap-stick almost always right"[6] are not credible except as portrayal, however legitimate, of a bygone time. It sided with the relevance of its day, not with timeless concerns.

Jenkins's essay also asserts that "games have been embraced by a public that has otherwise been unimpressed by much of what passes for digital art." The premise is that a very *particular* public—one which expresses disdain of new-media art—has decided what can become art within the digital medium, while excluding whole-cloth the products of any currently evolving practice. The next passage is more striking: "contemporary efforts to create interactive narrative through modernist hypertext or avant-garde installation art seem lifeless and pretentious alongside the creativity and exploration, the sense of fun and wonder, that game designers bring to their craft."

But which specific works are "lifeless and pretentious"? Which ones might be "*passing*" for digital art? Might the presumed impostors be the raster-based creations of early artists like Charles Csuri or Manfred Mohr, or Desmond Paul Henry? Or perhaps, more recently, the two-dimensional screen-based work of Mark Napier? Or the interactive poetry of Stephanie Strickland? Or the participatory projections of Camille Utterback? Or works whose input *is* the live conversation of the internet, like Pentametron, or real-time data sculptures like Mark Hansen and Ben Rubin's *Listening Post*? Or the kinetic-semantic installations of David Rokeby or Jeffrey Shaw? Or the conceptual work of Caleb Larsen? These are but the most obvious names in a plurality of contemporary traditions whose art status has not been dismissed but rather

FIGURE 32 Desmond Paul Henry, Androbulus, 1962. White India ink technical tube pen on black cartridge paper; hand embellishments. Drawing Machine Two, 15.35" × 20.47". From the Anne and Michael Spalter Collection.

critiqued, theorized, and, because of that deliberation, secured in the evolving canon of digital media art. Nevertheless, games are, for Jenkins, not merely superior to such art, but to all arts, as the essay quotes another apologist who, describing important characteristics of the computer game, nonetheless adopts a competitive view of aesthetic merit in which games excel at art better than art does:

> Because the videogame must move, it cannot offer the lapidary balance of composition that we value in painting; on the other hand, because it can move, it is a way to experience architecture, and more than that to create it, in a way which photographs or drawings can never compete [sic].[7]

This broadside comes from a book on videogames and entertainment, not art, but the presumption is that the first can eclipse the second if we believe that visual motion is a superior aesthetic criterion to any other. The method is obvious: raise the aesthetic status of computer games by diminishing art's. But with Jenkins there is also a critique of how the institutions of art have excluded digital works. Some reference to the historical works of Ken Knowlton, Manfred Mohr, Charles Csuri and so many others who worked in the 1960s and 70s would have made evident the time span—numerous decades—before any expressive medium attains the maturity necessary to be co-opted into the museum. In 2010, London's Victoria and Albert Museum hosted such an exhibition of digital art, which included the seminal work of these early artists and more contemporary examples. Perhaps Jenkins faults not art but an outdated stereotype of its tradition—and in this, he may be right. But the premise that reducing electronic art and dismissing its artists raises the status of videogames is harmful.

The crafting of videogames involves aesthetic elements, but these must fit within other engineering priorities which are another kind of demanding craft. If we think that we know art by merely thinking it out, without real inquiry into the difficult process of the artist, it is easy to conflate artistic craft with computational craft. As Hal Barwood explained to readers of *Game Developer* magazine in February 2002, "Art is what people accomplish when they don't quite know what to do, when the lines on the road map are faint, when the formula is vague, when the product of their labors is new

FIGURE 33 *Manfred Mohr, p-300b, 1980. Plotter drawing, ink on paper, 27½" × 27½", framed. From the Anne and Michael Spalter Collection.*

and unique." Art exists, in other words, on the cutting edge and that was where games had remained for most of their history. This portrayal resembles an outsider's idea of what serious artists do. It overlooks, for instance, the role of already-developed artistic skill and craft as it is brought to bear on new work.

In art programs and studios, art is its own goal. It is what happens when people *do* know what to do; it is not a side effect of frivolity. Beyond approaching a prosecution of art, Barwood's last quote seems a wish-fulfillment to invert the outsider role of games vis-à-vis art by summarily recasting the past century of art as somehow belonging at the center of game activity's motives. Again we could feel the annoyance of comprehensive characterizations

about art, devoid of reference, nuance, or balance, dropped into a discussion of games that should not be absorbing itself in self-demeaning and specious competitions about the "better" art. These are biases, not rigorous notions of the burden of art making in any medium—or across media.

Yet a third, unstated implication of that position—but the most decisive—is worthy of consideration. It relates not to the institutionality of the work of art, to include the computer game, but rather to its objecthood. Generically speaking, the presence of the object has been a major constituent of the value function attached to any artwork. The appreciable mastery of the aesthetic object combines with the conditions of its being, namely as a *unique* or one of a small series, and this puts into play a tension between the extended history of visual art, of which this work is a member, and the irreplaceability of the singular object, which is controlled by its owner. Through this tension, the desirability of the work derives from two separate but integrated roles—spectatorship and ownership. This is the historiographic model of art value that has been contested by conceptual art in the twentieth century, art assembled from low-grade materials, art whose works are intentionally non-unique, and art whose objecthood is denied by immaterial conditions of being. What has *not* happened yet is the freedom of such art from another aspect: its exchange value. There are instructive ironies about art's commodity status at a time when an artist like Lawrence Weiner can assert that "the work of art need not be built," but where the statement, itself part of a work, remains subject to the same commercial and licensing proscriptions as any other artwork.

But the most characteristic inference we may draw from this is that art history rarely mentions but continually relies on every work's exchange value. Membership in the annals of visual history, for a work that cannot be sold, is especially difficult, since, however indirectly, its value also relates to its provenance. The uniqueness of the object, in other words, becomes more interesting as the number of owners of the work increases, the implication being that the work possesses *some* value that endures through a lengthy succession of exchange agreements. There is no issue here, except as an inversion of the situation with the computer game, whose commercial character is more akin to the literary work—rather than existing as a unique work with successive collectors, the game

and book are released in the form of many identical copies, one for every possible owner, so that the value of those works accrues not through their uniqueness but through their *non-uniqueness*, their multiplicity, for any book or game that has sold millions of copies becomes valuable for a company, and a culture, not a collector. Exchange value, it seems, has a role to play in determining aesthetic value regardless of whether a work's distribution is unique or innumerable.

This brings us to massively multiplayer games created *around* their distribution model, with aesthetic decisions falling under those of profit maximization. It is difficult to advocate for any abstract status of an object created and produced principally to sell as many copies as possible, as are many slickly packaged games based on sequels, sports stars, or big studio feature-movie-based computer games. If this is the kind of production that, to counter-quote Jenkins, "passes for digital art," while other art is not, then there is a smoke-screen here. The game can produce and sell one copy for every person who wants one, and as it does so, it gains in monetary value. The value of a work of art derives from the opposite—its rarity. To hold a Pissarro means that others cannot have it. One category—games—thrives on the reproduction of its experience; the other—art—from the uniqueness of its presence. Electronic art is between the two—another reason that game critics and contemporary art historians should be considering the new. Games are valued by the richness on interactivity, which is to say, engagement. Art's richness is its aesthetic history. Electronic art's bridge is, as I have already argued, an engagement aesthetic.

And while we might think that books—including literary masterpieces—conform to the videogame's pattern of mass reproduction, there is one important difference relating to integrity of creation. There are countless works of literature—one thinks immediately of Solzhenitsyn's *The Gulag Archipelago*—created under conditions where sales and profit could not possibly have been motivating forces. Although crafted in the grueling conditions that artists know too well, once published, these works would come to assume a new incarnation based on mass reproduction, and through it, capture a world audience. This chrysalis, through which it makes sense to produce a maximum number of copies, does not detract from the art status of any such work: all that it tells us is that a work like Solzhenitsyn's is *created* in one reality and *produced* in

another. But games of the arch-commercial kind I mentioned earlier are not of that ilk. Their *creation* is beholden from the outset to conditions of maximal commercial *production* to such a degree that the first of these modes is functionally indistinguishable from the second. Creation in this collapsed creation/production sphere is controlled, budgets are made, resources are assigned, marketing plans are written, and timelines control every stage of the game so as to guarantee a punctual release and the anticipated profit margin. This mill has frustrated creative workers in game companies, film and design studios, and publishing companies. As this is not the reality of the artist, the critical crossroad is inevitably encountered when creative individuals who work for such companies must decide whether to follow the path of the game artist, perhaps forged from previous art school education, or of the game designer, an employee of a corporate environment's conduit of creation in the cubicle. One of the articles I critiqued above portrays that reality, neglecting how their own steady employment in a commercial system of that size also allowed them to be less tentative about their craft. Perhaps designers are less theoretical not because they disdain theory but because they must operate under the utilitarian/temporal constraints of commerce, rather than the discursive/meditative spaces of art. And the distinction ought also to be made between the corporate game designer and the independent creator. For the latter, game studies and theory comprise an ever-important dimension—we can see in individualists like Jesper Juul or Gonzalo Frasca examples of the autonomous designer-theorist. But even as regards the corporate sphere, there is no objection to this line of work, which is like that of the graphic designer or stage designer for any theater company. Integrity and constraints are endemic to every profession. What is problematic is the presumed elevation of that kind of practice over another in the name of *art*, particularly when history's trajectory has run so polemically opposed to it and when an argument is more fully opinionated than fully informed.

And so, this distinction between creation and production, obfuscated in discussions of the computer game, is at the crux of conceptual artists' jamming of the commercial aspects of art, who in the 1960s and 1970s purified the value of art by creating works out of ephemeral materials defeating resale, reproducibility, and the auction system in general. This is not lost on electronic artists. The creation, for example, of digital poetry as a non-object points

to a similar substitution in new-media art: one in which process becomes *the* object.

An example of this arose with Nick Montfort, the MIT scholar of electronic literature whose series collectively titled *ppg256* is a case of constrained poetic practice in digital media. Each *ppg256* software poetry generator is a Perl-based program whose source code is exactly 256 characters long and which produces an endless procession of verses rigorously consistent in form, meter, and occasionally rhythm. The invocation of each program is the first part of the performative act, the second being the output produced in real time. In a recent conversation at a café, Montfort stressed that *ppg256* does not—and should not—store its output. There is no object to print or archive, there is only potential literature signified by the code and the process as aesthetic statement. The line between process and product is thus totally eliminated. He produced his mobile phone and, connecting to his remote server, invoked one of the *ppg256* programs, which composed poetic stanzas in a continuous, unending stream. This production illustrated how the *potential* aesthetic work referenced by the *code* became *real* in the *process*. We might, as we would have done with the works of any of the Fluxus artists, regard *ppg256* as not only a game but also as play, and as art—in other words, something that is no less art within and beyond the literary.

The *ppg256* generators are closed poetic systems, they generate poetry in real time to specific meter constraints using a meta-dictionary, a system of rules that composes real English words. An open version of this, one whose input draws from the most open source of all—internet chatter—is comparably illustrated by Pentametron.[8] This site hosts a program which scans real-time tweets and joins those written in iambic pentameter on the basis of their rhyme. Each invocation of the program produces a 14-line sonnet that is both Shakespearean in form and contemporary in character:

To speak of it as poetry without play is to reduce it to an old, insufficient category, as does the question on the wall with which I opened this chapter. For play here is to be understood synonymously not with the place of expression in any institution, or with the specific vocation that the creator engages, or even the status of an object, but with *process alone*, something that remains ubiquitous to all media forms and genres of digital creativity.

Pentametron

With algorithms subtle and discrete
I seek iambic writings to retweet.

RT @cheetahcouture *about 11 hours ago*	I'm always thinkin of a master plan
RT @kelticatheo *about 12 hours ago*	Hope I improve tomorrow even more!
RT @SneakerHead_pop *about 12 hours ago*	I wonder what the future has in store
RT @Desirous_Dreams *about 12 hours ago*	I am already getting birthday spam! :D
RT @DOPAMINEonDOPE *about 12 hours ago*	That shouldn't even be a issue. Damn.
RT @Jacobpincus *about 12 hours ago*	Dilemma City Population: Me
RT @Kyraa_Jam_Is_On *about 12 hours ago*	I'm fina be the rawest mama gee.
RT @WhoYouAreJay *about 13 hours ago*	I'm jelly over that proposal tho
RT @xxSlimnessxx *about 13 hours ago*	On baked potato number two! Hello!
RT @_TMBxxx *about 13 hours ago*	tomorrow is a big exciting day !!!!
RT @X_NoneLikeVARIA *about 13 hours ago*	That shower was amazing by the way
RT @SkyHigh_xX *about 13 hours ago*	I'm staking money to the perfect height....
RT @BrockDuCoin *about 13 hours ago*	I really wanna start a twitter fight
RT @MelyVill18 *about 14 hours ago*	Believe in people that believe in you.

◀ ● ● ● ● ● ● ● ● ● ● ● ● ● ● ▶ ?

made by moonmilk.com

FIGURE 34 *Pentametron output, captured 31 July 2012*

And, as with play, art, too, is being increasingly presented as process and outside physical institutions, principally the gallery, which as the next chapter demonstrates, is itself is becoming virtual.

FIGURE 35 *Nick Montfort invoking* ppg256 *via mobile device.*

CHAPTER SEVEN

Engagement in virtual and actual gallery space

To work in the world of art is to embrace few strict rules, even in a forest of ideologies. One of the apparent constants, however, could be articulated by an equation, or more accurately, an equivalence relation that sustains between the ideas of *art* as one term, and *freedom* as the other. The artist is free to create openly, the collector is free to gather or dispose of a collection freely, the viewer is free to engage, interpret, or dismiss work. There is, however, one region of the art world where this equivalence is more problematic, less value-free, in fact, less *free*, than elsewhere. It happens in the role of the curator.

Much has been made, correctly, I think, of the blows to apparent neutrality that curatorial activity implies. The sequence of work that underlies the exhibition sets into motion not merely the procession of examples aligned within a singular theme—usually perceptual or by school of practice—but by necessity, also the universe of assumptions that the curator reads into this motorcade. Such assumptions, always inferred because they are never articulated, color every constructive dimension within the challenge of erecting a show, down to the selection of wall colors, with the added complication that presentation and representation occur in different discursive worlds. For, what is presented in one space, namely, the gallery, museum or other venue for exhibition, is typically critiqued in another, normally, the newspaper, journal, or other venue for discussion.

Embroiled in this asymmetry, one new-media affordance provides a third kind of venue in the form of the virtual gallery. A recent survey of such software[1] brings several thoughts and questions to mind. To begin with, we might ask why a virtual gallery makes sense, given that the very non-physical status of the virtual world and its "objects on display" makes feasible the reduction of gallery experience to an array of URLs with descriptive captions. In this minimal possibility, the gallery would be entirely replaced by its function as the basis for a show, something that is in turn the product of curatorial statement. But these virtual galleries do not merely (re)present work in digital space, they reproduce the gallery itself as an object of reception. Why, then, is it necessary to envision artwork in a simulated gallery?

To be sure, the display of a single work, sculptural, filmic, or painterly is an experience already fraught with loss in translation from the physical to the virtual. We know that when a work—even a sculptural one—is brought into the digital screen, several facts take place. It retains all of its recognizable features as a medium; the work does not fail to register as an instance of sculpture, for example. To the inverse extent, however, that the notion of a work's *medium* is preserved, its *materiality* is entirely lost within digital mediation. Gone is the weft in the canvas, the nick in the marble, in fact all evidence of the work as a process and its evolution toward becoming a product disappears. Here, while we can see the work—often with greater clarity—we can no longer touch it with our eyes.

But this transformation, because it is shared by all digital reflections of material objects, can be neither an endorsement nor indictment of the virtual gallery situation, and is therefore not part of the rationale for such a mechanism as the virtual gallery. The answer lies elsewhere, for the experience of an exhibit revolves not around the *presence* of images but rather their *adjacency* within a singular spatial context. The theatrical contribution of a gallery simulation is necessary not to the individual integrity of work but to the curatorial operation that accompanies the collective property of *works* in a show. Beyond being possessed of its autonomous character, every artwork suggests itself in this plural connotation as well. The walls and spaces that provide the reinforcing ground for the ad hoc collection make the sense of a curated show possible, a supporting reality that lends more to each work than critics of

"the gallery system" can account for, even with the rather stilted simulated space of the virtual gallery, one of the software genres that replaces architecture with interface design. The question is whether the work is replaced by anything that converts it into its own simulacrum, for it seems to me that something is lost when we choose to replace the verb "to exhibit" with the verb "to display."

CHAPTER EIGHT

Non-local engagement—
The aura of the distributed moment

> *Let us compare the screen on which a film unfolds with the canvas of a painting. The painting invites the spectator to contemplation; before it the spectator can abandon himself to his associations. Before the movie frame he cannot do so. No sooner has his eye grasped a scene than it is already changed. It cannot be arrested.*
> WALTER BENJAMIN, THE WORK OF ART IN THE AGE OF MECHANICAL REPRODUCTION

From a lonely and troubled perch in Nazi Germany, Walter Benjamin, introvert, Jew, and intensely sensitive man of letters, emerged to become the greatest literary critic of that country, and, next to Karl Marx, the most cited name in modern critique. Perhaps his unconventional erudition revealed a larger landscape of past and future, because with nearly mystical prescience, he pitted prevailing nineteenth-century Romantic sensibilities against the brutal modernism of the twentieth: technology, and after his posthumous rediscovery, any humanities scholarship that read him never turned back.

Once Walter Benjamin's thinking became the canonical portal between the worlds of what could be called post-Romantic modernism and postmodernism's romance with the dual destiny of technology as both creative medium and aesthetic object, his position in theories of new-media art seemed suddenly embraced in the most universalistic and unproblematic way possible. By and by, scholarship came to acknowledge that all of his major writings from 1919 to 1931[1] culminate in the essay from which I take the epigraph above, one which has been read as a kind of biblical ontology of electronic media in relation to artistic production. And by extension, this essay consequently locates Benjamin at the ubiquitous beginning of all major discussions of visual interpretation in the age, after his own, of *electronic*, not just mechanical, reproduction. How can one argue, for example, against the propitiating presence that accompanies the primal act of art making, a force that, in its archaic form, conjoined for Benjamin soul and work into the ontological singularity, the aesthetic event horizon, the nucleus of creativity's very power of transformation signaled by and caught within the emanation of its *aura*?

One might imagine that Benjamin was, of course, not endorsing art in any universal sense; that he was, instead, only evoking the fearsome rise of its primal desecration by the incursion of machinery into what cannot be produced by and contained within it. In that sense alone, but sufficiently it seems, his most famous essay staked not so much a position on the role of technology than a *logic*, ultimately reducible to the axiomatic inequality that *creative production is nullified by technical reproduction*. I provide the adverb here, "ultimately", in reference to Benjamin's allegiance to Marxism and its teleology, pointing as it does, like a polemical time machine to the notion that social forces will churn conflict into transformation, coalescing like an alchemical *solve et coagula* on the way to a final post-historical cadence: an endless moment of fulfilled ideals, of purity of knowledge, and of utopian existence in a classless society.

Despite this dreamy culmination, it is ironic that the post-historical Marxist imagination that inspired Benjamin relies on reasoning of a specifically *temporal* kind. This logic, introduced in the second section of this 1935 essay—and most relevant to what technological art can imply today—is evident in the argument that it is the temporal separation between the creation of a work

and the moment of its reception—*not* the advent or manner of its reproducibility—that provides the basis for its aesthetic legitimacy. In other words, in the authentic work of art, creation, purpose, production, and experience are to emerge simultaneously, Thus, works re-created (which is to say, *created anew*) by recording devices are ineligible for the same status as original art, since Benjamin connects temporality to aesthetic legitimacy: "[e]ven the most perfect reproduction of a work of art is lacking in one element: its presence in time and space, its unique existence at the place where it happens to be. This unique existence of the work of art determined the history to which it was subject throughout the time of its existence" (Benjamin, 1969). The existence of the work is validated through a Geist-like spirit of presence addressed as its *aura*, a special kind of creation in whose specific conditions production and reproduction are mutually exclusive. Whatever else can be read from this essay, the possibility of *simultaneous* creation and reproduction of art are inimical for Benjamin, and so, much new media scholarship, incorporating his thinking whole cloth, has often and unwittingly absorbed those very assumptions.

We could see how Benjamin would not wish to argue the mutual exclusion of creation and reproduction with too much bluntness. Rather, he would want to allow the argument to unfold gradually—gradually enough that it seems to turn on *originality*, rather than temporality. So he opens the second paragraph of that second section, with seeming consistency, claiming that "[t]he presence of the original is the prerequisite to the concept of authenticity." And this originality is not the ontologically unconditional originality that we might imagine as the initial moment of creation in every artistic work. Rather, as with elsewhere in Benjamin, it is a qualified and rather specific kind of originality that excludes creation except by manual or organic means, so that "[t]he whole sphere of authenticity is outside technical—and, of course, not only technical—reproducibility." Again, it is worth remembering that machinery is not, in his argument, the reason for de-legitimizations of art, it is, rather, the temporal distance between creation to experience, so that when the "cathedral leaves its locale to be received in the studio of a lover of art; the choral production, performed in an auditorium or in the open air, resounds in the drawing room," the aura of its creative moment is also left behind, separating the artistic *essence* from the audience's *sense*.

Thus are production and reproduction poised in antithesis, the work of art, anchored in a singular time and place of creation, is torn from that past by processes that impart only its *appearance*, not its soul. To accept this account of art in the contemporary moment of technology's integration with all manner of social process is to read it not as an early critique of technologically mediated art but as its final epitaph. *All* art undergoing reproduction, we are led to infer, loses the ineffable legitimacy that originality, which is to say, *creation in a moment of time to which direct experience had access*, bestows. But would we not today speak of the work of art in the age of reproduction *mechanisms*, which is to say the artwork within the work of algorithms? What is the direct experience of an algorithmic work if not one distributed and equal across time and space?

When in the early 1970s Alan Sondheim wrote of the pluralism of the art of that decade,[2] and when Dick Higgins wrote of the same regarding the art of a decade earlier,[3] the foundation was laid for a time when creative production took new, multitudinous steps toward the idea of the distributed work of art. First, the new art emerged from a pluralism of media; next this pluralist practice led to the work of art as something simultaneously created in multiple places and times. So the pluralism of that time evolved into a profusion of media and practices resisting the labels that art criticism could make so apparent in previous chapters of art history. Today, for example, there is no strong prevalence of "label art," no longer do we read of an Abstract Expressionism, a Pop Art, an Op Art, an Agitprop, or a Minimalism, there is rather the numerosity of methods and media, of departures from the idea of a single work born of a single moment out toward compound art born in an emergent manner, in several ways, with multiple inputs and forces, in what might best be called a distributed moment. It is not that the aura is nowhere, but rather that, like the algorithm, it is everywhere.

These developments, while intriguing, have not really surprised anyone who might have witnessed the displacement and evolution of singular narratives out to a range of new media forms and practices in the last 20 years. The rise of what we might call "narrative across media"—the distributed moment where art is no longer a singular act—represents the point where production and reproduction, the unique and distributed, the momentary and the evolutionary, contribute equally in the power of the creative act that

was for Benjamin located in a singular but transcendental source, one that conflated the idea of art's origins with the original in art.

And so the distributed moment in electronic art is a turning point from Benjamin, who has often been read, as I have said, with unreserved acceptance. The idea of an art aura is not one we need to accept in its initial 1935 spirit, but neither need we deny it outright because of the unusual nature of art in networked and postmodern times. Benjamin's reference to an authentic art as a singular phenomenon—created once, experienced once—could be contrasted with the technological problem of art now experienced many times, to his critique of the phonograph and the cinematic projection. But art *conceived/created* pluralistically from the outset? This is much harder to dismiss as inauthentic.

And there is no shortage of possibilities for art of this type, since so many electronic devices foster creativity through networked genesis. This conceptual distribution of the creative act, for example, in media technology's own capabilities with mobility of

FIGURE 36 *Golan Levin*, Dialtones, A Telesymphony, *2001. Detail, pre-performance mobile phone ringtone programming ["instruments tuning?"].*

signals, is one that the mobile phone addresses. Correspondingly, this is the formulation evoked in one installation by Golan Levin, one of the most important electronic artists of the last two decades. A case of this dispersal, simultaneous in time, Levin's work derives from the live idea of a symphonic concert that Benjamin would have found utterly legitimate. In *Dialtones, A Telesymphony*, the audience in a performance hall gathers to experience the usual kind of musical composition that one might see in a chamber work in a recital hall anywhere in the world. But here, there are no visible musical instruments. In fact, these come with the audience, whose mobile phones, prior to the performance, were individually configured with specific ringtones, each comprising one part of the musical work, so that in the simultaneous aggregate, any melody or harmonic grouping can be activated by the stage performers—essentially in the role of conductors. That is, their computer systems dial the programmed phones in a sequence that (b)rings the work to life through a distributed simultaneity that has many points of origin and playback.

FIGURE 37 *Golan Levin*, Dialtones, A Telesymphony, *2001. Installation View. Image courtesy of the artist.*

This work illustrates one of several possible permutations of the pluralism to which I referred earlier. In one form, as Levin's work explores, the distributed moment emerges through the co-ordinated participation of numerous media devices and persons gathered in the same time and place. In another possibility, the opposite variation is possible, and Christian Nold's series of *Emotion Maps* addresses it.[4] In the *Paris Emotion Map*, for instance, a group of participants agrees to wear a bio-mapping system that continuously records emotional state, time of day, and geographical location. After some urban wandering, the participants write a series of annotations for the experiences associated with the most salient physiological responses recorded by the mapping system. These annotations, each pinpointed on a map to the location where their experiences took place, become an art document, an existential palimpsest of collective experience, extended over several weeks, and unified into a narrative whose authorship is a pluralistic summation of media and moments. Nearly 200 geo-impressions were recorded, ranging from the mundane to the startling:

accident, but not dead

Mosque – suprising

Tents of a group of African people were all eating together in the street. The atmosphere was like a squat

Still in the 11 arrondissement – I always thought I was going into the 20th

Little white statue – Garazette – all painted white. Lots of work material round here

Almost got run over – I was hungry

beautiful white lilac tree

followed a big black cat

very good smell of the blossoming trees

THE ENGAGEMENT AESTHETIC

FIGURE 38 East Paris Emotion Map, *2008*. *Christian Nold. Poster*

FIGURE 39 East Paris Emotion Map, 2008. Christian Nold. Annotation detail.

on a grave was written respect the dead, don't steal the flowers

discovered a new grave with a statue of a pelican

But how far in spacetime could this kind of art process that I am calling the distributed moment—the single creative act simultaneously realized through plural media forms—extend? Can the immediacy of presence be sufficiently extended in time as to be indistinguishable from *absence*? Can a work of art created through this kind of distributed moment speak with a possible *future* version of itself? In geographical distribution, this is not difficult; Stephen Wilson's *The Telepresent* provides one early example. A small box built from low-grade materials, it was an early foray into the (then) novel notion of sending images from the source of capture out through the Web, something that Steve Mann replicated in scores of provocative "broadcasts" of his real-time experiences interacting with people around urban spaces.

In both cases, and in many examples since then, a localized experienced was transmitted to a dispersed audience, so that the aesthetic moment was spatially interspersed while simultaneously retaining its temporal immediacy as a form of real-time portraiture. But in the same manner as the spatial axis can be extended, the temporal can as well, and speaking to posterity is the function

of another kind of time machine. The minimalist aesthetic that frames Caleb Larsen's box, provocatively titled *A Tool to Deceive and Slaughter*, is at its core a proverbial contradiction to Walter Benjamin's contention that the aura—and aesthetic legitimacy—of an artwork is site-specific, born in the moment and place where its performance is experienced, so that subsequent "removals" or playback of the performance are removals from the authentic encounter that engendered it. How Larsen's work embodies this contradiction—the idea that a work need not be present to a physical viewer and yet be performing an artistic process—is a study in inside/outside oppositions: the *object* conveys one message through its physical solipsism of the black cube and its reflective symmetry: resistance to interaction by any visitor (or owner), while the work's *process* opposes that seclusion, given that inside the box, an Arduino chipset is programmed to do something approaching what any gallery curator could dream of: advertise and sell itself.[5] With its persistent internet connection—one wire is all that can be seen to emanate from the cube—the nondescript Plexiglas container pings a remote server to decide whether it is time for the

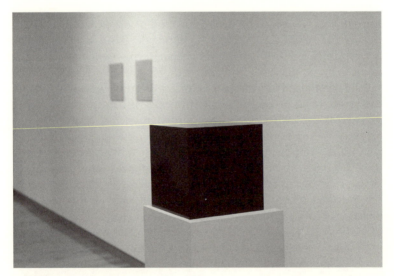

FIGURE 40 *Caleb Larsen,* A Tool to Deceive and Slaughter, *2009. Perpetual online auction, internet connection, custom programming and hardware, acrylic cube. Image courtesy of the artist.*

work to be put up for sale, and if so, its embedded system manages an auction of itself on eBay. The contract of the work stipulates two principal conditions for the collector: the successful bidder must keep the work connected to the internet so as to allow the work to re-auction itself at a later time—hence the work interacts with a future condition of itself—and, second, when the work puts itself for auction again and chooses a new buyer, the present owner *must* sell the work (and retain the profits). The work migrates to another owner only when its resale value grows.

Larsen's work is a case of the conceptual transmodal, a term that I apply elsewhere in this book to artworks that appear to be medium-specific or single-purpose but which are not. Here, the work's sculptural presence—static, silent, monochromatic, and symmetrically without narrative—is its most visible and yet its most trivial component. Looking exactly like so many plastic cubes, the work's material objecthood occludes its true function, which is *not* to be where it is, and to quite literally raise its own face value. As becomes clear, the work operates in the vitreous space of the Web, maintaining a price-based commercial dialogue with everyone who does *not* possess it, so that the triad of its ultimate presence, meaning, and value are determined only through an internal algorithm's prolonged zeal for a remote kind of out-of-body experience.

Responding to the growing commoditization of art, Larsen's work is more than an ironic riff on the idea of art-collecting as wealth-building; the artistic message and rationale for the work's exchange value becomes its only function. It has value as a work of art because of what makes it unique: the ability to change its own price. In this compression, the idea of arthood as an autonomous part of a work's value is eliminated; its aesthetic self is now completely equivalent with its commercial self. And as it continually self-presents to an external world, seeking its own highest resale price, it delivers something new—to art as a market, it offers the idea of a work guaranteed to increase in value; to art as an object, it presents a work that chooses its owner, rather than vice versa. In both aspects, the work calls its own shots, even as it is physically *here* but functionally elsewhere, even in time.

What has taken place in art that engages with nonlocal place and time marks a precipice, an irreconcilable turn in relation to ideas about the "modern" in what Benjamin delineates. His line

in the sand argues that those "situations into which the product of mechanical reproduction can be brought may not touch the actual work of art, yet the quality of its presence is always depreciated" (Benjamin, 1969). The problem is not merely that this "rule" dissociating the "actual" original work from its subsequent reproduction predates the form of many new—and networked—forms of art that are simultaneously original *and* distributed/reproduced. It is also that for Benjamin and for modernist sensibility in general, the distributed moment detracts from what is most fundamental to the work: its presence. It is not because presence is presumed missing from electronic art, but rather that its presence is complex. This "distributed presence" includes much that is not evident in the idea of physical presence, to include the notion of transfer of value as related to physical elements of a work. In Larsen's work, for example, such transfer is determined by the creative algorithm as it selects the next owner (i.e. the auction's winning bidder), and who, by extending the work's provenance (by appending a new owner onto the work's history), validates its physical reality. And the distributed moment of a work of art also implies the distribution of roles for participants involved in it. While in twentieth-century performance, there is much art where visitors also act as artists, in Larsen's work, every owner assumes the new role of *auctioneer*, not choosing the winning bid, but handling the sale at the appropriate time. The role of ownership, too, becomes extended into one of transaction, or perhaps even rental, since each collector must relinquish custody of the work once it finds its next owner. All of these separate roles, identities, and moments are *deposited in the artwork* by virtue of its distributed nature, and they act as evidence of an augmented, more complex aura, rather than intimating its absence.

Two examples, one from the world of live performance and another from that of documentary film, and an overly brief and structural view of an electronic medium—the computer game—should round out this discussion of the distributed moment in the sense that I am intending, namely as an extension of its original concept of narrative distributed through media forms that can best express an episodic side to certain artworks, with no single medium possessing the entire tale. As is now obvious, the specific notion that I am putting forward relates to the distribution less of *narrative*, as in a fable or known story of the sort we know in commercial form—from *Mario Brothers* to *Star Wars*—than of experientially

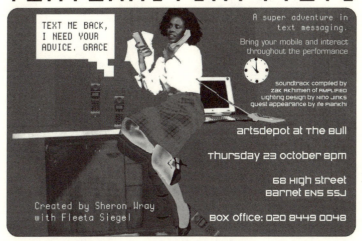

FIGURE 41 *Sheron Wray and Fleeta Siegel,* Texterritory v.2.3, 2008. *Event announcement, London.*

shared *meaning*. The story collectively produced in these examples is never totally fictional; it is rather one that recruits significant elements of the contemporary voice from an audience, and as such, has only one aspect of preconception that we might call 'story': its *structure*. The work as story and distributed moment appears less as the franchise of the corporate story-product than as a mirror of action whose audience participates in an aesthetic contract by co-opting the work's own structure and speaking back to it. And because of this, the audience is itself constructed by this art. And by construction, I point specifically to that component of the work that directs it, acting as the moral imperative of the work—as it has always been in social history in any case—the normative principle of the algorithm (in electronic art) or set of instructions (in contemporary art) for realizing the work.

The dramatic role of the algorithm is demonstrated in the example of *Texterritory*, a work that fuses nonlinear story, partially predetermined and partially real-time, requiring the audience as a pluralistic collective to direct the actions of a Hamlet-like stage character, immersed—not to say, *paralyzed*—as she confronts several moral dilemmas. As originally presented on stage, the

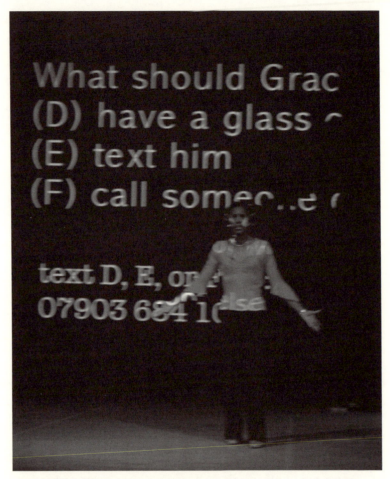

FIGURE 42 *Sheron Wray and Fleeta Siegel,* Texterritory v.2.3, 2008. *Performance view.*

protagonist, Grace Campbell, played by Sheron Wray, is a legal secretary whose anxieties intensify prior to being visited by a long-anticipated romantic suitor. The work's title alludes to the context in which the two had met—in a dark club several weeks before—and lacking opportunities for deeper personal interaction, their acquaintance emerged electronically, as they began "texting out their territory." But the fictional premise of the work—text

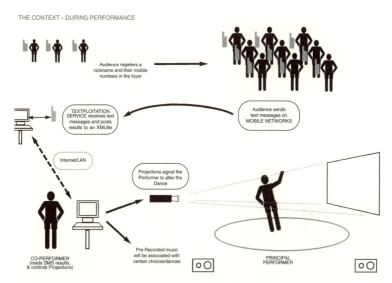

FIGURE 43 *Sheron Wray and Fleeta Siegel*, Texterritory, *2008. Diagram of the work.*

messaging between Grace and her friend—is realized externally by the audience, which is prompted to vote on successive actions that direct not just the performance, but its actual plot, and send those in text messages that are converted into real-time branches of action by Grace.

The distributed moment is less one where the collective determines the next move for the lone character of the work than one where the timing of action is always the dependent variable, the partnership in collaboration on actions—sometimes taken by the character, while at others, directed by the audience—is a reflection of work relying solely on a kind of reproduction of signal in order to produce its aura, and by so doing, becomes rhapsodic.

In 2010, this method was subsequently adopted for serious and more intimate exploration of mineral exploitation, when Grace visits Africa to "find herself." The theme of experiencing distance in order to discover something close to oneself is both familiar and strange, making the strange familiar, and the familiar strange. This synthesis recalls critic Viktor Shklovsky's observation in *Art and Technique* that art makes objects "unfamiliar" because "perception is an aesthetic end in itself and must be prolonged." Artists achieve

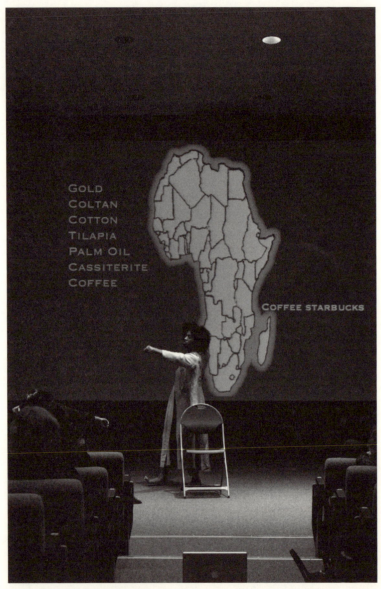

FIGURE 44 *Sheron Wray and Fleeta Siegel,* Texterritory, *2010. Performance view. Photo by Lisa Bates.*

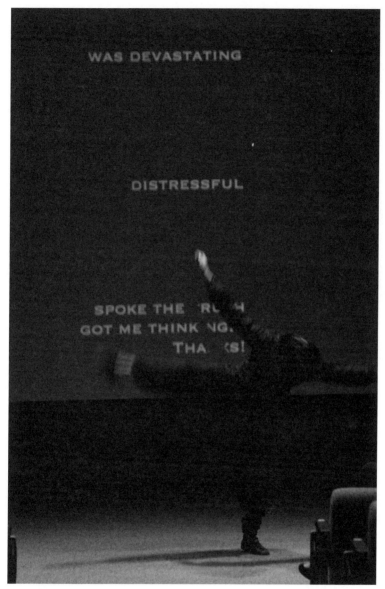

FIGURE 45 *Sheron Wray and Fleeta Siegel,* Texterritory dml, *2010. Performance view. Photo by Lisa Bates.*

this by contrasting prolonged perception with its opposite: the seduction of curiosity that keeps viewers engaged. This tension—attentiveness versus suspension—is the foundation of aesthetic engagement, whose culmination is the cathartic experience that "the strange" *is* what was familiar all along. For Grace in Africa, this realization comes as she learns of the war in the Congo, with the mineral coltan (columbite-tantalite) at the heart of it. Coltan is mined to manufacture capacitors for mobile phones and electronic equipment, and the strange/familiar epiphany unfolds once the audience finds itself implicated, every mobile phone owner having financed a piece of war. As they texted their realizations back to the performance, the responsive connections broaden (the term "Coffee Starbucks" shown in Figure 44 was texted by one viewer in response to questions about products sourced from Africa).

Any form of engagement fuses an internal experience with an external one. Thus for Wray and Siegel, it was important to extend the impressions felt within the work by Grace to the audience, extradiegetically, beyond the work. As a video plays in slow motion, showing the devastation of the war, Wray's stage movements reflect her angst to suffering—a requiem—and the audience is encouraged to text their sentiments and impressions, which are projected in the backdrop. Wray reflects that "it became a wailing wall."

Whether for lighthearted comedy or political awareness, the approach signals a relationship between artwork, artist, and audience that is conceptually centered, yet grounded in social consciousness. Sheron Wray recollects that

> [t]he active engagement of the audience was really a driving force behind developing Texterritory. I was really focusing on what physical presence actually is. When people observe they also have thoughts, opinions and feelings and I wanted this to be felt and made to act so that there is no doubt that their being there is of significance. In the time where we think we can all absorb performance on YouTube I felt compelled to press that lever to engage the audience's intelligence directly and yes challenge myself and other performers massive amounts. But that's art.[6]

Siegel and Wray's work embraces technology as a methodology whose purpose is to reach the viewer with ideas but to then

transform idea into action through reflection. This in some ways is an inversion on a body of earlier conceptual art which moved art from a separate "viewing/presentation space" into the real space of the viewer, but where that migration did not yet convert the viewer's contemplation into behavioral change. One thinks of Vito Acconci's *Proximity Piece* where the "audience" (essentially, viewers of the photographic evidence) can see the artist's closeness to oblivious strangers. Acconci's description best conveys the intention:

Vito Acconci

PROXIMITY PIECE

'Software,' The Jewish Museum, NY; Sep 10–Nov 8, 1970.

Activity; 52 days, varying times each day.

Standing near a person and intruding on his or her personal space.

During the exhibition, sometime each day, I wander through the museum and pick out, at random, a visitor to one of the exhibits:

I'm standing beside that person, I'm standing behind that person, closer than the accustomed distance—I crowd the person until he/she moves away (I crowd that person until he/she moves me out of the way).

(Attached to the wall, in the midst of the other exhibits, a 3" × 5" index-card notes the activity and describes it as above; the card might or might not be noticed by a viewer passing by.)

Acconci's pioneering work illustrated avenues through which conceptual art comprised primary engagement between artist (as planner) and (the idea of) art, occasionally co-opting the public. Conceptual art, however, was not centrally concerned with the transfer of decisions. Such an intertwined sort of engagement is

FIGURE 46 *Vito Acconci,* PROXIMITY PIECE, *1970. The Jewish Museum, NY; Sep 10–Nov 8, 1970. Activity; 52 days, varying times each day. Courtesy of the artist.*

in conceptual art more a mental/rational variable than an engine motorizing the art. But as regards decision delegation, the logic of the distributed moment has been debated at length in a creative medium that art history disregards: the electronic game. Much has been written on the question of temporality for the aesthetic validity of a game: Does the art emerge *before* a user's (or artist's) performance, or *during* it? On one side are *narratologists*, who find that any predetermined structure in a game is a key constituent of the larger narrative tradition that print epitomizes. On the other are the *ludologists*, who find in the freedom *between* predetermined waypoints in an interactive story the evidence of non-narrative, perhaps aligning with an aesthetic akin to the second law of thermodynamics, except that in place of the entropy that physical science sees as accreting in an isolated system in disequilibrium, the ludological enterprise finds increased indeterminacy and variety the more one plays the same game.

If this contrast explains the structure of *Texterritory*, it is because a story, as is universally understood, is never wholly located or comprised within a single work, device or expressive form. It distributes itself through a culturally wide range of media and expressive practices. Its structure is creative because it contains oscillations between predetermined and real-time/aleatory/improvised/chance/random elements. It reflects the brittleness or fluidity of each medium or form of agency through which the work navigates. And if it seems that the compression in time between the moment of original creation and that of reception has today not threatened the legitimacy of art, I do not want to conclude by implying that this post-Benjamin situation is due strictly to digital technology. My argument about the new work of art's collective aura is not meant to suggest a reliance on the *state of the art* in any form. The artwork's new condition, moving from a moment of originality that was seen as the aura out to a distributed moment, is determined by the structure of the work of art—that is, its underlying *algorithm*—not because the work exists before the algorithm, but because the algorithm exists before the work. The procedural, not the structural or medium-specific, has become the new foundation of this aesthetic, nature and function co-orchestrated. Thus can we see in the works I have discussed both a dispersal and a unification of time and space, of creation and reception, of

event and of place. And regarding place, consider one last example, entirely outside of digital technology.

Place, as the site for the transmedial expression of algorithm of meaning, brings to mind, particularly in connection to a city as rich as Berlin, Richard Kostelanetz's film, *A Berlin Lost*. Constructing a set of films around a single story—making it imprecise to imagine *one* specific core in the story—Kostelanetz produced the six films that bear the same name, each visually the same but each also recorded in a different language and with different narratives. In each work, we are taken through *Weissensee*, the Great Jewish Cemetery of Berlin, where much of what we are shown no longer exists. The medium of the film's text, if we could speak metaphorically of anything like a script, comes to us through the visual construal of place markers, including the gravestones that Kostelanetz's eye seems less to visit than to probe. Their inscriptions reflect connections through time and place that weave the fabric of Berlin's story as a cultural reserve, albeit not through images alone. For each of the six versions of *A Berlin Lost*, while visually identical, comprises entirely different soundtracks in English, German, French, Swedish, Spanish, and Hebrew; each comprising a distinct procession of ex-Berliners reflecting, in their own tongue and given to us *without* subtitles, on the time passages that accompanied life in the city's great period, the eight decades prior to 1940. This makes, I think, amply evident how distributed narrative constructs and frames an account, but also reclaims alternative truths by separating what constitutes it from any single medium. Instead, it is framed by a higher algorithmic, an order above narrative and medium. As such, it confirms and completes the aura's distributed moment.

CHAPTER NINE

Engagement as spatial chronotope—Electronic art and the public sphere

For better or worse, the term "social sphere" has most often been used in reference only to the politics of public presence, to include the way one looks, what one presents to the world, the insignias and status symbols that announce our position in a society.[1] The badge of the policeman, the sash of the prince, the tattoos of the goth, and the three-piece suit of the businessman all *create* and define the public sphere as the site where we can be read and constituted by norms of the collective. But, like the clothing of individuals, the skin of physical structures, too, has something to say about creating and reflecting the public sphere, and new-media art refracts this through its interventions on such structures. Two dynamic processes have been especially open to manipulation by electronic art: the staging of architecture as sculptural object, and the use of projective strategies for public gesture. Though both are complementary, the first, architecture as sculpture, emerges when physical structures become more than dwellings, and are used for reflection onto themselves over against means for other purposes. The second, public projection, works as a new branch of street performance, not for actors, but for media. Through these changes—architecture as sculpture and projection as statement—the feeling of novelty is more than mechanical; it compacts the

distance between human and machine, the latter increasingly assuming roles played by the former, but organizes both under new co-ordinate space that is neither entirely physical/real nor virtual/technological.

New media sculpture's use of architecture's physique converts the material into support for the visual through a kind of overlay that emerges naturally on the computer screen but not in three dimensions. For media artists Holger Mader, Alexander Stublić, and architect Heike Wiermann the perceptual superimposition of one geometric structure over another makes a contrasting statement of this kind. Here, the felt directness of stationary physical authority in a building or sculptural object is embedded into and within the dynamic projection of a moving grid, lattice, or framework, which in turn presents itself as objective in its own plane within three-dimensional virtual space. And although the projected imagery congeals into position and reconfigures the physical into what would seem a "physical+virtual" compound, addition is not the precise operator to summarize the conceptual result. We can see in the resulting image-object evidence for how the categorical nature of image sequences, namely animation, is distinct from that of event sequences, namely narrative; it is more accurately a progression of geometrical reconstructions whose logic destroys the order that a viewer expects when space and non-space collide. It is the corollary of this distinction that Mikhail Bakhtin, that imaginative genius of literary philosophy, found in the novel's relationship to temporal and spatial categories. The co-ordinate relationship for such study was what he termed the *chronotope*—a space-time pattern that is distinct for particular literary forms. The romance genre, for example, possessed a narrative pattern where the passing of time was an external and independent variable—events in such tales tended to descend on the protagonist with their own momentum, presented as a cascade and catapult for surprises. Here was the space-time characteristic that he called "adventure-time."[2] And so, another chronotope, that of *spatial engagement*, is particular to new media's use of subjective readings of architectural space.

It may be sufficiently clear by now that my use of "engagement" as an operative term for the experience of technologically created aesthetic experiences is both sweeping and ambiguous. That, of

course, mirrors the span of perceptual intentions in this kind of art. It is neither pictorial nor spatial, but both. It is neither stable nor dynamic, but both. It is neither centered exclusively on an object nor on a process, but promotes an experience that emphasizes each in oscillation. As as aesthetic phenomenon, this term cannot be reduced to what happens in the first minute of visual observation, nor in subsequent reflection about the use and role of technology in becoming one of our "extensions," as Marshall McLuhan claimed four decades ago. But from the perspective of artistic *reception*, critical traditions that begin by identifying the principal medium of a work are already inappropriate to this kind of art. When a critic needs to understand a work *as* a painterly object, or a sculptural, or a photographic or filmic one before proceeding with an analysis of what transpires in electronic art, the direction of the work's understanding will be set out prematurely by a bias toward medium, rather than with openness to how *aspects* of media are structurally in play in the construction of and interaction with such work. Perhaps the least we could do is to view the agglomeration of practices in electronic art under the metaphor of new kinds of equations.

As a case of this, the additive relationship between film (where object and process are projection-based) and architecture (in which the object is a structure but the initial process is a projection) transforms the object and its aesthetic result into something that is neither exclusively architectural nor filmic, but rather sculptural. Whereas architecture is a ground or backdrop for location, sculpture's function serves as the site's foreground, its spatial punctum of observation. By moving from the mode of standard relation to media such as architecture and film to a synthetic, additive, combinatorial one between and among them, the work of art recasts media in a new purpose, and this reconfiguration, which is transitional and often perplexing, is the moment of productive engagement in whose name the aesthetic I am describing arises.

This pattern is evident in *Folded Space*, a complex projection onto the Torre Pompéia in São Paulo, itself an asymmetrical brutalist structure. Its tension is undeniable—our protective expectations of architectural structures are denied by a work which, far from being nest-like in its acceptance of our habitation, exposes itself more as a closed puzzle, a place with small, odd windows, with floors and overpasses that seem more like something from

a computer game than a stable edifice. The only aspect of what could be called architectural comfort in this structure is its rectilinear design, with the solidity of its concrete skin rising in stoic verticality. And so, this is the target of aesthetic assault. Onto its surface the group Mader, Stublić, Wiermann—MSW—projected a simulation comprised of abstract structures that superimposes a kind of axial system in motion, continually rearranging itself, reclaiming the architectural as sculptural by denying the stability of its vertical space, one that now becomes *folded* space. As with earlier projections like *Façade* (a work originally designed for the Reykjavik headquarters building of Iceland's energy purveyor), a structure's otherwise understated postmodern regularity is rendered visually unstable. Typically, we take a projection as separate from its underlying surface; a film lit over a screen produces two referential worlds—screen and image—contributing to one pictorial illusion. But in MSW's work, the world of figure as image and ground as structure become part of the same thematic reference, each reflecting characteristics of the other.

And so, in *Folded Space*, as abstract geometric forms appear in patterned unison, they blend, meld, and transform into others equally rectilinear, with the unlikely flow of shifting desert sand. Depth against surface, figure against ground, edge against point, the primacy of spatial perception is subsumed under the polytonality of objects anchored in two separate co-ordinate systems within one singular space. This makes reference to Peter Eisenman's claim that the act of folding changes the traditional space of vision from something *effective*, meaning that it functions, frames, and shelters, into something *affective*: it conveys an excessive condition, something transcending reason, meaning, or function. This change can be more succinctly understood as a quasi-paradox, where image and object are juxtaposed, yet remain in tension in our quest for perceptual clarity. When we observe a fold in something, the registered image warps—its regularity is altered—as does that of the folded object itself, yet we cannot easily discern one crucial distinction: what, beyond the *visual* warp, is the extent of the actual *spatial* distortion? This meditative oscillation between image and object, beyond projected image alone, and raised to architectural scale, is the engagement aesthetic that MSW conveys in *Folded Space*, pluralizing one perceptual experience into several.

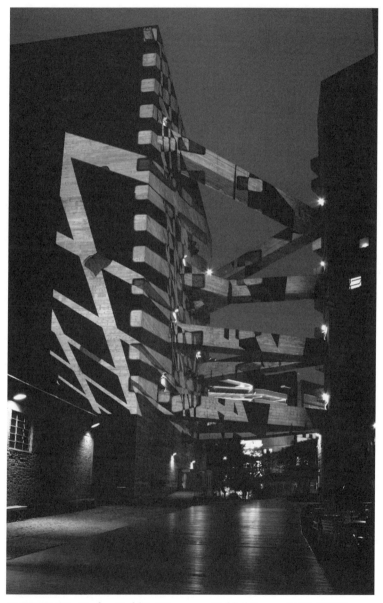

FIGURE 47 Mader, Stublić, Wiermann, Folded Space, 2008. SESC Pompéia, São Paulo. Electronic Projection. Photograph © 2008 MSW, courtesy of the artists.

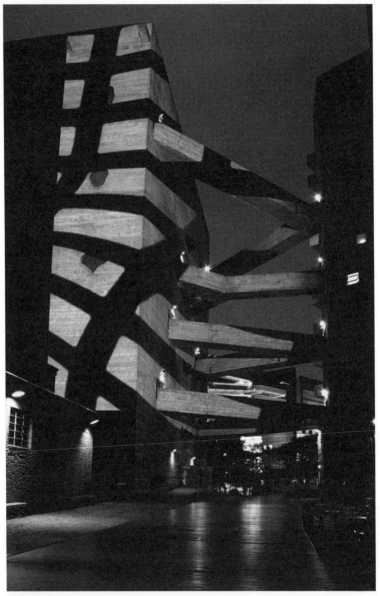

FIGURE 48 Mader, Stublić, Wiermann, Folded Space, 2008. SESC Pompéia, São Paulo. Electronic Projection. Photograph © 2008 MSW, courtesy of the artists.

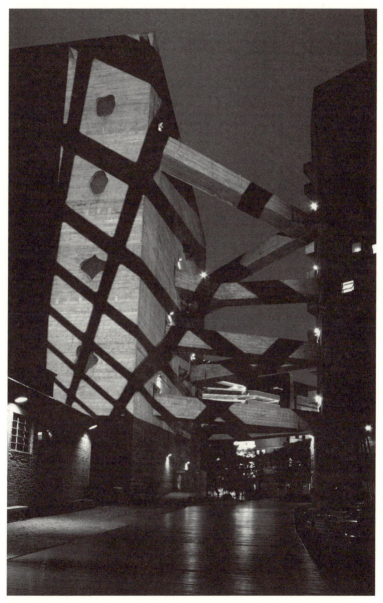

FIGURE 49 Mader, Stublić, Wiermann, Folded Space, 2008. SESC Pompéia, São Paulo. Electronic Projection. Photograph © 2008 MSW, courtesy of the artists.

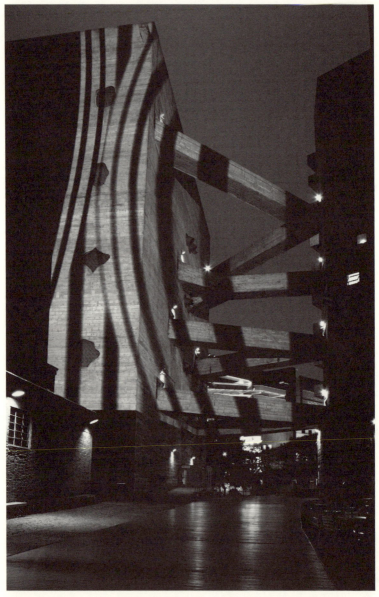

FIGURE 50 *Mader, Stublić, Wiermann, Folded Space, 2008. SESC Pompéia, São Paulo. Electronic Projection. Photograph © 2008 MSW, courtesy of the artists.*

And what if not over a *single* space? This redefinition of architecture away from static dimensions, was illustrated in *Expanded Space*, a more ambitious work by the artists, who, in 2009, took the occasion of the United Nations Climate Conference in Copenhagen as a platform for a deployment of distributed awareness, an engagement aesthetic of urban proportions. Centered in a suburb south of Copenhagen and calling attention to the theme of the conference, MSW projected similar moving patterns over Avedøre's power plant, selected because of its modernist design as well as its high capacity, biomass processing, and exemplary (94%) fuel reuse capabilities. Visible at night, *Expanded Space*'s dynamic geometry redefined the buildings of the station's structures, so that quasi-rectangular projections reinforced the quasi-rectangular design of the edifices while semi-conical projections suggested circular and even plume-like vapor diffusion tower forms over the same structures:

The images were additionally rendered mobile, having been synchronized with those appearing rear-projected onto the cab skin of several trucks that simultaneously traversed the city.

FIGURE 51 *Mader, Stublić, Wiermann,* Expanded Space, 2009. *UN Climate Conference, Copenhagen. Electronic Projection. Photograph © 2009 MSW, courtesy of the artists.*

FIGURE 52 Mader, Stublić, Wiermann, Expanded Space, 2009. UN Climate Conference, Copenhagen. Electronic Projection. Photograph © 2009 MSW, courtesy of the artists.

This is not to say that projective space, as distinct from real space, obviates the social dynamic and function of spatial use as traditionally determined in the polis, or notion of the state as a representative layer over collective presence in a boundaried space. Rather, the character of projective space, which is already naturally transformative over architecture, is of a kind with what the notion of a dynamic democratic presence represented from the outset. It is, for example, in the early political writing of Jürgen Habermas that full awareness of the public sphere (*Oeffentlichkeit*) emerges, both as theoretical source of critique and empirical support for social transformation.[3] As the historical roots of this term date back to the practices of the first democratic forum of ancient Greece, "public sphere" has been monopolized almost exclusively for political discourse. But it also operates elsewhere, in art contexts, perhaps more openly, in ways that distinguish themselves from relations of power between humans and institutions. Here it would differentiate, for example, between perceptual provocation and moral persuasion.

But the public sphere's immutable power, equally resonant with politics and with art despite their diverse agendas, lies in

its potential for *motorizing consciousness*. Using the idea of the public sphere as the main analytic bludgeon in a sweeping critique aimed directly at the crisis of modernity, Habermas rigorously expanded previous thinking, constrained, as it often was, by the often long-winded pirouettes necessary to reduce the manifold reality of contemporary conditions down to Marxist or protest polemics. Inspired but not constrained by such ideological biases— he famously owes much, for instance, to Horkheimer and Adorno's *Dialectic of Enlightenment*—Habermas's concept theory of the public sphere draws on more than history and philosophy; it sweeps through economics, architecture, and sociology of communication to expand the opposition first established between private sphere—the arena of domestic concerns—and public sphere up toward something more nuanced and complicated—and can therefore relate art's response to the encroachment of the public sphere in private life. And in new media, this opposition has grown into a mutual interpermeation, whereby the private self *assumes* a public sphere through the garb of a web persona from Facebook or MySpace, the bard of the blog, the prolocutor in the chat room, the doppelgänger in *Second Life*. What means *public sphere* when each of those two words has been so altered by its virtual translation? Simply put, Habermas's unspoken meta-contribution lies in first offering up an objective, workable, and sustainable distinction between the ideological and the critical, theretofore entirely conflated within Marxist discourse, and one might bear in mind the consequences for new media art criticism.

But this is not the only expanded alteration of importance to us. There are two other terms which have been observed operating in semantic equivalence in the work of Habermas, Horkheimer and Adorno: modernity and avant-garde.[4] Although they may serve the aims of critical political discourse as synonyms there, a difference among them bears retaining, particularly in the language of art, where they relate less through parity than through a kind of extension of one another. In particular, the complex conditions of modernity extend to relations of production that are directed by divergent lines of interest, lines that often remain faithful to conventions where monetary value is manipulated and accumulates most steadily. In the art world, the gladiatorial venue for this "conservative modernity" is the auction house, in which work from previous generations is traded as never before,

applying price scales exceeding those of the diamond industry. More recently, the same applies to new art as well. But the trade in avant-garde art is much more bipolar, tenuous, selective, than that of prior generations, so that the sentiments that motivate the rules for this new kind of extreme value exchange are not in balance with those which, operating in the same spatio-temporal conditions of modernity, have produced and championed the avant-garde. In fact, the nadir of the modernity versus avant-garde wedge can, uniquely in art and unlike any other industry or discipline, be identified as radiating from one person, in Clement Greenberg, whose value judgments polarized the art world in precisely this way. But for art, the real factor of interest relating modernity and avant-garde is no longer played out in differences between formal abstractions of judgment like those which Greenberg articulated, flatness, for example, intimately tied with painting or sculptural modes of production. This battleground has been supplanted by others, the near-political zone and debates of the increasingly expanded and variegated public sphere is one of them. It is in that particular theater that the sentiments of the avant-garde appear most poignantly, hold up a mirror to, and even clash with, the assumed framework of modernity in which the populace operates. Public art has come to challenge the public's understanding of the functions of art and of space.

Of course, the infamous case of this challenge, chronicled earlier in this book in the story of Richard Serra's *Tilted Arc*, serves as the icon of a polemic of the avant-garde within and against the assumptions of the public sphere. Serra's spatial rupture made explicit the subversive use of art and the susceptibility of space to artistic objectification; in perhaps his most explicit remark on the sculpture as a phenomenological function, Serra asserted that the sculpture changes in response to the viewer's movement (of course, this is not true—only *one's perception* of that sculpture is what changes). But this polemic of art and public sphere played out in the reconfiguring use of space—and in ferocious arguments in legal and critical circles—proved unequivocally tense, and art lost, for as we know, eight years after being erected in 1981, the sculpture was ordered destroyed. In its own arc of construction, "use," and destruction, this one work therefore responded both to the assumable notions of modernity—an unquestioning, uncritical avowal of art in almost anesthetic echoes of decorative art—whose

(literal and figurative) position ultimately realized a necessary and conscious attack on those assumptions for art, space, and style that defines avant-garde as the refutation, rather than the Habermasian synonym, of modernist assumption. Through *Tilted Arc*, historians, political functionaries and the public found that while art of modernity extends the current environmental conditions for contemporary adaptation, avant-garde art confronts and redirects them, the literal case of which became the *public sphere-as-experience* of the sculpture's plaza visitors. For when Serra stresses an engagement aesthetic, the explicit goal of transforming the viewer into the subject of the artwork ("space becomes the sum of successive perceptions of the place. The viewer becomes the subject"[5]), he also makes that viewer into a proxy *for* the public sphere. As the avant-garde will, to quote the formalist phrase, make the familiar strange, the previous absence of even the vaguest reflection on space, destination, goal, and time that each pedestrian could afford to not-experience in Federal Plaza became replaced by the hyper-consciousness of those aims that *Tilted Arc*, as art (or obstacle), brought to inescapable awareness.

While one's initial impression of avant-garde art comes to view as something abstract, formal, removed, and intellectually inscrutable, it is in the public sphere that what is an innocuous lout in this figure inexplicably becomes the threatening menace of corrupting value. Serra's anger found the crux of this turning point in the mind-numbing aesthetic judgments of political critics and pundits, whose diatribes for American freedom and democracy encountered no contradiction in their equally vociferous arguments for censorship of works which offended their own myopic sensibilities.[6] Moreover, as Serra's lawyers discovered, laws protecting copyright offered no protection on grounds of moral right of an artist to claim legal protection from distortion, defacement, or in this case, destruction, of a work once it is sold. A work, once sold, could be (and was) destroyed if the owner didn't like it. This is problematic enough when it applies to a single individual (such as when a Japanese bank president destroyed a Noguchi sculpture that was not deemed worthy of artistic interest) but when the owner is the public, the work of art speaks in the public sphere, and the de facto executor is the government employee, not the public. Conservative arguments, like those overbearing dismissals of Hilton Kramer, refused to acknowledge the responsibility that necessarily accompanies the

modes of deliberative engagement and expression that the public sphere has historically afforded the populace and upon which any democracy relies. Instead, the problem becomes restated as one of offensiveness to the public. What originates as the engagement aesthetic of Serra's wish to make the implicit explicit, to bring to public consciousness the perception of space in new sculpture, is distorted as an attack of artist against public. Consider this reading, for example:

> What proved to be so bitterly offensive to the community that "Tilted Arc" was commissioned to serve was its total lack of amenity indeed, its stated goal of provoking the most negative and disruptive response to the site the sculpture dominated with an arrogant disregard for the mental well-being and physical convenience of the people who were obliged to come into contact with the work in the course of their daily employment.[7]

What work of art is safe from the whim of a power broker unable to critically assess his own conservative sensibilities? How in fact can the public sphere operate at all when it can be censored, shut down, controlled by rules of order defined by any single group whose umbrage is first or most virulently provoked? And historically, the effect is amplified; the avant-garde in this kind of public sphere is afforded no bottom, no anchor.

If materially originated avant-garde art like *Tilted Arc* can find such little protection in the public sphere, what of art in the hyper-contemporary spaces of the virtual sphere, most of which is by definition avant-garde? Critiques that first looked at contemporary artists and works through the lens of their response to and relevance with ideological and counter-ideological statements ought to be extended in correspondence with the augmentation of the public sphere into virtual dimensions, particularly as this also-contemporary octave of the public sphere provides an empirical platform for dialogue on the same matters of substance that consumed the eighteenth-century salons of which Habermas wrote. There is no doubt but that the participatory characteristics of that environment are increasingly corroborated by empirical research that should also enter the discursive spaces of art criticism in contemporary engagement, because destruction of art is not in the interest of any public sphere unless that sphere is defined by

hierarchies. It is within art, in fact, that the public sphere can voice distinctly, uniquely, autonomously, single poles of oppositions that cannot be separated or stated apart from their mutual antagonism in the political forum alone. In its many provocations, contemporary art can and does address themes of money (or not), of violence (or not), of coercion (or not), of tradition (or not), of class and stratification (or not). Naturally, this capability for voicing one side in exclusion of the other predates new-media art, and is so clearly the prerogative of the artist that even within highly specific strategies of production—for example, text art—an entire oeuvre articulates either ideologically, as does that of Barbara Kruger, or not, as relates to that of Lawrence Weiner, or, alternatively, can ambiguously fringe the margin throughout, as does the work of Jenny Holzer.

This is not to disavow the real political character of much new-media art, which turns to the conventional uses of the public sphere—the examples of Kanarinka and Jane Marsching, among others, argues this explicitly. And, offered up less as an art-political than art-prophylactic intervention, Paul Notzold describes his aptly titled *TXTual Healing* as an SMS-enabled interactive street performance, as another case of spatial engagement whose own chronotope is more than imaginary. The inscription in Notzold's work is of three layers—viewer/author, artwork/image, and structure/ground—and as with *Tilted Arc*, alters a viewer's perception of space. But Notzold emphasizes the perception of one function: *spatial narrative*, a form of expression that Richard Serra's work denies us, except in a muffled way. Serra's is an abstraction that refuses to meet the viewer halfway, it retreats into form, and compels geometric curvature to speak for itself. But in *TXTual Healing*, as in Evelyn Eastmond's work, discussed elsewhere, the viewer *must* participate through dialogue, contriving a message to fit the context in which the work exists. In Notzold's work, the context, a building, displays projected speech bubbles that point to windows, so that viewers can transmit a speculative or provocative caption that can act as the utterances of people whom we do not see. The backdrop of a comic-book panel, devoid as it is of meaning in relation to the characters who occupy it, is inverted here into the only part of the work that is real (i.e., the actual building), while the characters are not merely imagined, they are *constituted* by the dialogue provided by SMS messages. And this in

turn opens the door to the aesthetic spatiality that is explored in the site-specific narrative art called locative media, such as *34 North 118 West*,[8] a work by Jeremy Hight,[9] Jeff Knowlton, and Naomi Spellman. Here, users listen to a story unfold using an electronic tablet as they navigate an urban landscape. Their location and speed of travel feeds into a system that selects which portion of a story will be heard and when. The shape of the story depends not on the performance of a storyteller, but on the listener's presence and location. Since, as we have seen, embedding narrative media in physical location transforms static space into a performing subject, the following two chapters consider that aspect of new media art that utilizes architecture as perceptual performance.

FIGURE 53 *Paul Notzold,* TXTual Healing, *2006. SMS-enabled interactive projection. http://www.txtualhealing.com/*

CHAPTER TEN

Engagement across space and structure in post-architecture

Disciplines thrive on dualities, and the architectural order resonates to one ethic, a sort of moral philosophy of the profession, more than any other, namely the endlessly quoted mantra that *form follows function*. The two nouns in this synergy are essentially invariants, set into action by the comparative verb between them, which may be changed for classical, modern, postmodern, or other design programs. This utterance, then, with the possibility of term replacement—we could see in Zaha Hadid's architecture how form *frees* function, or in Frank Gehry's how form *ignores* function—provides yet another example of the primordial Saussurean contrast between the view of language either through its synchronic—which is to say, temporal—change across time, or through its diachronic development, reflecting change within a single period or context. Mindful of the power of this conceptual grammar, Roland Barthes had three decades ago mapped it onto a sort of Cartesian X/Y matrix for modern culture, creating an analytic whose character was no longer exclusively limited to spoken language.[1] Rather it now showed relevance to quotidian contemporary life as comprised of *systems*—the fashion system, the car system, the furniture system—each encoding its signs as Ferdinand Saussure did language's. In the most condensed example, the food

system accommodates the scheme of the restaurant *menu*, whose rules define a proper meal (utterance) as a horizontal array of courses (parts of speech) in the culinary grammar where several meals are framed between appetizer and dessert and where each course is vertically substituted by an allowable synonym (e.g. fish, steak, or fowl in the middle courses). It is due to this perpendicularity between a comprehensive framework and the vernacular of a local variety—the semiotic language-speech (*langue-parole*) distinction—that architecture's form-function duality has sustained itself beyond jurisdictions of critical doubt.

Function is a given, an *a priori* condition born of the common spatial, monetary, and legal denominators that constitute any architectural project. Form, by contrast, emerges *a posteriori*, having navigated a relatively subjective path through a creative spectrum. With this partnership, the theoretical landscape of architecture would appear to be complete. Yet, as broad as this form-function dualism appears, it is actually myopic, it is partial to a small subset of the architectural establishment: *physically realized formations*. If architecture were only about the end phase, about optimal fabrication, there would only *be* fabrication—that is, effort without preponderant countervailing critique, distinctive manifestos, or contemporaneous but philosophically contrarian schools. All element of controversy would long ago have been factored away, for form and function gaze only at, and revolve around, construction, fabrication, completion, consummation of area, the *nisus formativus*. They do not accommodate the philosophy of the discipline: its region of critique.

There is, however, another predicate relation that more directly addresses architecture's complete ontology, namely, that between *space* and *structure*. That this association is more logically architectural is evident in its obvious commutative property, for in the claim that *space follows structure* the inverse also holds. And likewise, to say that space *enables* structure is true in reciprocal inversion, that structure enables space. And to claim that space *limits* structure, too, is well-founded when stated in its inverse. There is no tautology in any of these relations—space is decidedly *not* structure. In the catalytic power of design, one can contain the other—something that is not true in the semantics of the form-function pair. The linguistic symmetry of space-structure utterances is grammatically optimized speech for architectural thinking, but this duality is also

more generative because it is frankly more teleological. Specifically, it is more appropriate to speak of post-architecture, to include the virtual, in terms of space and structure because these terms simultaneously retain their conventional sense while also conveying new cognates and references that reflect dynamics of the "populated non-built" of cyberspace, which fabricates not over *real* estate but over *virtual* estate. Although *form* can address both physical and virtual worlds, it is nevertheless too indeterminate, applying equally and thus with too-vacuous reference to two, three, and n-dimensions, and even to characteristics of zero-dimensional things—as when we refer to the "form of an equation"—as well as to connotations of *partial organization*, without the sense of a whole, as when we refer to the "formal properties" of a thing. Yet—though for the opposite reason—*function* is also problematic, it is too narrow-minded. Understood as the objective motivating the environment's creation, this term is constrained by its reference to physical realization. In virtual architecture, *function* is no longer anchored in either geospatial co-ordinates or the actual capacity of a space in relation to its occupants. Increasingly, too, postmodern architecture has begun to use (or conflate) "function" to mean "form that looks functional" through its notion of reconfigurable space, the all-purpose structure, super-modular minimalism, and algotecture, all of which suggest a greater allegiance to virtuality's transcendence of physical constraint than to the quality of the habitat's experience for its residents. More anchored in form than function, therefore, these structures do not operate, do not *function*, out of regard for optimal conditions of use, but rather by projecting *dis*placement, perturbing functionalist imperatives and asserting architecture's impending reliance on new and different vernacular, with all that this word implies. I refer to bold new directions in space and materials—the *algotecture* of Kostas Terzidis, who has proposed ideas like a housing development that uses stochastic search to determine the location of its units,[2] the material rotations of Zvi Hecker (e.g. his 1989 Spiral Apartment House in Ramat Gan), or the floating asymmetric slices of Günther Domenig (e.g. Steinhaus, 2002).

The argument that these structures, as visual evidence, make is that as contemporary practices aspire for material transcendence, for literally working outside the box, the relevance of architectural function is transformed into a reference system for a new kind of

physics that refutes gravity, containment, and obviousness. One constraint, however, hinders this neo-functionalist flight: form and function matter through, and remain beholden to, the immediate priorities of human accommodation. But when, as happens in virtual space, a structure is allowed to transcend material limits of appearance in relation to physical use—because neither appearance nor use now operate in limited space—then the embodiment imperative is no longer the independent variable, the consumable factor, the last criterion of adequacy in determining the success of a design. And because of this escape from embodiment, we might rightly ask whether, in considering any domain where the pronouncement that *form follows function* loses relevance, we are still discussing architecture at all. As has long been argued within the critical establishment of the field, how else, if not by tying its functionality to physical construction, is this profession distinguishable from that of *design*? Soberly, Diane Ghirardo located this propensity not where we might expect—ensconced within Utopian programs like Buckminster Fuller's—but instead as recoil from economic adversity:

> ... when building opportunities dwindled in the United States in the 1970's, architects turned to drawings – not even designs of a different and better world, but instead a set of increasingly abstract, pretty (and marketable) renderings of their own or of antique works and recycled postclassical picturesque sites. Like much building of the decades just preceding, these aesthetic indulgences simply masquerade as architecture. They reveal architects in full retreat from any involvement with the actual world of buildings.[3]

This retreat points to the two key moments of the profession, the design moment, and subsequently, that of "involvement with the actual world of buildings." Since design is design for actual construction, architecture must "build" virtually before plans become transposed into physical space, and, while the initial design is fictive, the world into which it will be projectively realized is not; it is unequivocally physical. Several post-medium questions now bring us to the heart of the matter. What, then, of the nonphysical world? Can one have a veritable architecture, as opposed to *design of virtual things*, there? Imagining an architecture devoid of its

second moment, fully committed to *non*-involvement with the actual world: isn't this like unto the difference between fiction and nonfiction, rendered within corporeal dimension? If, for architecture, the diagram or plan provides the means, and materials become the tools, then by extension, the medium of the discipline is the environment itself.

Without its physical environment, which is then to say, without its medium, the discipline, albeit possessed of a *design* character, can only be *potentially architectural*. For, who could otherwise distinguish between design and potential (which is to say *unbuilt*) architecture? I should point out that we are not speaking here of the unbuilt architectural proposal that addresses itself to true physical co-ordinates and idiosyncrasies of any actual location. Although unbuilt, such a proposal is a necessity in practical construction, and thus remains empirical, just as hypothetical scenarios contrast with works of literary fiction by the presence or absence of worldly reference.

This major criterion of worldly reference—the empirical standard—defines the threshold of form and function in architecture. Where form is unbuilt and function is disconnected from material realization—each a condition of virtual space—there is an architecture without constraint or confinement, which is to say, without consciousness of limits, and thus without reality as praxis.

FIGURE 54 *Alan Sondheim,* Tora, *2012. Transformed virtual avatar and architecture.*

In all respects, save two, virtuality negates the limits that characterize architecture's methods, means, and materials. The two exceptions are space and structure, which remain compulsory parameters for virtual and actual domains, and arguably become aesthetically heightened in nonphysical environments, where endless examples of distended spatiality and structurality disconnected from physics become defining elements that blur all distinction between edifice and myth. And since edifice and myth can coexist functionally in virtual space, architecture migrates away from its category as a building practice and becomes another kind, both sculptural (when structures are foregrounded) and performative (when they are in the background).

And in the latter, as a performative practice, architecture unites with spatial experiments, like those of Alan Sondheim, whose bodies have now *become* a kind of architecture itself. These beings, as avatars, are what he terms thwarted architecture:

> With these images I was representing the internal workings of distorted avatars, including the 'mouth parts' so that words might appear to be mumbled or stuttered; these were presented against a changing virtual architectural background that, close-up, doesn't resolve at all. So the images are combinations of thwarted speech and thwarted architecture – or

FIGURE 55 *Alan Sondheim,* Tora, *2012. Virtual avatar and architecture.*

barely-interpretable speech and almost impossible-to-negotiate architecture. I also wanted to blend avatar and environment so that the two meld into each other, as if both were alive, both dead, both deconstructed.[4]

Observe the close relationship between performance, portraiture, and architectural space—all three being redefined, all three interdependent. Let us leave it there, as a platform for reflection.

CHAPTER ELEVEN

Performative engagement— Dance with projective images

One of the many artistic revolutions in the twentieth century occurred in modern dance, whose relationship to *narrative* was transformed from that of its predecessor in classical ballet. In the earlier tradition, the audience experienced the juxtaposition of two forms: the concrete, physical performance, and the abstract story or fable, whose title the work reflected. In this type of art experience, performative style followed episodic events that framed the tale so that what was performed became subjected to two distinct but interrelated readings—one relating to the story; the other, as qualitative judgments about the performance.

However, a different interpretive stance applies to the more recent tradition of modern and postmodern performance, where no obligatory storyline needs to frame a dance. This is not to say that contemporary dance has become a non-signifying practice in a closed formal vortex. The change is less a full abandonment of underlying narrative than a redefinition of narrative itself, where, in contemporary dance, it has become a set of framing signifiers pointing less to a totally structured story than to moods or themes evoked differently in each movement of a work.

It might seem that by decoupling dance from traditional narrative, aesthetic experience has lost something crucial to itself.

But this change, which conservative criticism has leveled at modern dance on more than one occasion, can be true only if we equate *story* with *meaning*, for all performance ultimately serves as a reach for meaning. What modern choreography outside of narrative tradition has instead offered us is a frame within which experience moves from interpretation to reflection, from a structural to a subjective feeling of organization, from a focus on the material and temporal boundaries of a preexisting account to the inwardly directed impulse of self-questioning that arises in our encounter with a world relentlessly composed of momentary glimpses and little more. This interface between self and world bridges the performance with our existence; lacking a complete story but offering allusions to deeper sensations, modern dance has subtly substituted "*the* meaning" for "a *sense* of meaning" in what it brings to audiences. Transcending the matrix of a story, a modern performance now yields a much wider field of interpretive possibilities without reducing the work.

One example of that encounter with subjective meaning of non-narrative modern dance is *Blinking*, a multi-movement sextet performance choreographed by Jamie Jewett and performed by Lostwax Productions to the electronic score of R. Luke Dubois. Avoiding the overused themes of love, conquest, or mythical transformation that obsess so much narrative dance, *Blinking* works like a telescope where physiological and metaphorical actions contained in a blink expand out and, like a problem set, bring into focus five distinct contexts in which the act of blinking occurs. Action faithful to a theme but without narrative, or as I have framed it, meaning without story, is the aesthetic nucleus of its form, a view of the "open work" first championed at the outset of dance's modern rebirth by its pioneer, Isadora Duncan, who maintained that, "If I could tell you what it meant, there would be no point in dancing it." This is the openness permeating Jewett's work. We find in the first 30 seconds, for instance, a plurality of spaces, each opening onto the next: the real space of the performance stage extends cinematically onto (and into) the rear wall on which the border of a pier abutting the water's edge can be seen. In this video, a lone figure meanders aimlessly, gazing toward the water in lingering, reflective reverie. The stage and pier, while in different *metaphysical* worlds, nevertheless share the same *metaphorical* space.

In the first movement of *Blinking*, the stage is darkened for a rear video projection set in a medium-sized vestibule, where the audience's point of view is positioned, with uncanny intimacy, at the extreme close up, eye-level, of a mother whose gaze alternates between a conversation with another woman, and the play of two young boys cavorting in the room. Despite her physical closeness to the person with whom she is conversing, the mother's expression of polite but apparent distraction confirms that her attention is on the physical play of the boys, and when she briefly watches them, her gaze becomes more questioning, claiming her whole presence. We see the boys' interactions, but do not hear the adult conversation; the alluring drone of Dubois's electronic prelude fixes our gaze, not our ears, because the children are watching each other, the mother is watching them, and we are watching her, all being held in place by the music's ascending scale and rhythmic emphases directed by micro-rhythms of her eyes as she blinks.

Blinking is not strictly a work of the "dance performance" category; it cannot be framed by the conventions of formalist dance critique; *why* this is so demands a moment of contextualization. A major voice in dance criticism was that of Edwin Denby, whose own trajectory is inspired by Laban's classic *The Mastery of Movement*,[1] an essay which distills the project of dance criticism down to two propositions: the *visual*—whereby the critic must be able to observe stage action—and the *historical*—through which a recollection of observed action must be provided. These actions add up to a critical style that might be called documentary in character. But the core of works like *Blinking*, whose objective is a multiple-perspective exploration of a *process*, cannot be captured within such a form. What, for example, is the purpose of digital projections, as they appear in *Blinking*, raised to the status of a cast member responding to other dancers in real time, in a formalist discussion of narrative dance as Denby might consider? There are, in this work, technological interventions whose prominence to the experience of the piece are such that they are not secondary to the performers themselves. And yet, these *active* technical elements are clearly not in the canon of dance or stage, and so, *Blinking* cannot be fully understood within the protocols of dance criticism as it has come to us today. That method would deem a work like *Blinking* as an array of digital props cosmetically sprinkled atop a modern dance core. In that view, dance comes first, while

electronics provide a secondary layer. But that dualism would cause us to question *why* technical supports have to exist over a dance in the first place—with the inevitable implication being that the choreography is itself insufficient somehow and thus needs a flashy prosthetic.

This is not an acceptable perspective. To begin with, technology is not a cosmetic element of *Blinking*. It is a central constituent of the entire work, it is in fact a motivation for the piece from the outset. As I have argued in seeing and critiquing art under a larger engagement aesthetic, the difference between media present to a work does not mean that integration is not both the challenge and the reward for new, pluralistically expressive directions. And so, it must all be read together—the technical supports endemic to this performance are themselves part of the performance, not merely mirrors of it. As dancers move, a series of functions produces visual aspects of each moment that the audience perceives. In several instances, for example, a silhouette image of several dancers is captured, this real-time capture feeds a projection of body profiles on stage comprised of moving points connected by a thick web of lines. But this body imagery is itself juxtaposed upon and (importantly) *interwoven with* the cameo-like shapes, projections of the two young boys playing. Thus the audience sees the video projection of two bodies, and the actual presence of two performers whose bodies are in turn digitally acquired, projected on the video projection, and connected to it. And by this mutual/circular/continuous process of virtual and actual communion, it is of course evident that of six visible body shapes, only two are physically present to the audience. How then can digital technology be considered cosmetic, when, in performative scenes like this, it comprises the majority of the action?

There are two additional dimensions beyond that of live performance. One is the filmic projection, which occupies what Daniel Yacavone terms a film world,[2] and the other is the interstitial world between performers and projection, a world of reference without object, which comprises the real-time capture of bodily motion and its subsequently reprocessed projection as filmic quasi-image, an abstract expressionist element in motion. What is felt in this melding between dancer's action and the filmic setting projected against the wall is an interrogative partnership: the lack of continuous narrative in the embodied action is *not* reflected on

the projected image. There are two interpretive insinuations for the audience, which must reconcile the geometric style of the dancing with the anticipation filling the near-photographic stillness that the filmic scene presents. But *because* the image is filmic rather than photographic, it holds out the possibility to the viewer that *something* is happening or might be about to happen—in the first act of the work, for example, a state of suspension supported by music, in conjunction with the mother's confident but apprehensive gaze, as it oscillates between her friend and her children. This condition of *possibility* for action is what strongly implies a narrative context; it feels like narrative, without being *a* narrative, because it conveys meaning.

Blinking operates as one work, but in two worlds: on a cinematic screen and in the real space of live performance. This is most evident in the persistent explicitness of its system of visual reference between filmic and physical. Departing from a portrait tableau—the mother gazing at the children—the action opens out to continual cycles of reference between physical and filmic by the presence of white lines literally connecting the dots on children represented on several simultaneous planes of representation: dressed similarly as their filmic counterparts, the performers, as physical "children" also appear against the backdrop as projected digital silhouettes, as real-time, mirror-like reflections, and when the filmic children are

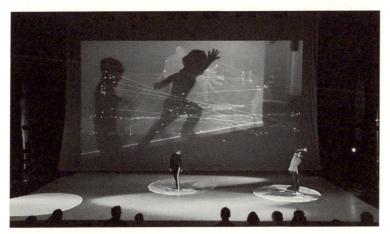

FIGURE 56 Blinking, 2009. *Jamie Jewett and R. Luke DuBois.* Performance and DVD. Detail at 08:35.

seen running back into view, the lines connecting the silhouetted shadows of the physical performers to each other weave with the projections of the filmed children. On stage, the performers stand on circled projections of the mother's eyes, circles which fill with the same connecting lines. The reference between worlds is total, and we realize that without both digital *and* physical manifestations, the work would seem strangely unbalanced.

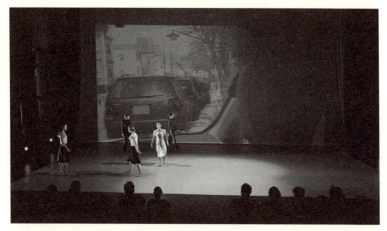

FIGURE 57 Blinking, 2009. *Jamie Jewett and R. Luke DuBois. Performance and DVD. Movement 2.*

The work's second movement evokes a different rhythmic relationship between time and objects, as in early structuralist works of filmmaker Peter Greenaway, such as the 1969 short *Intervals*. Shot in black and white, *Intervals* comprised a set of quick eye-level takes from a stationary camera capturing pedestrians on a Venice sidewalk as they walked across the frame. Each cut is timed to the audibly insistent hammering of a metronome and an alphabetic sequence so that the visual experience becomes gradually, tortuously overtaken by the temporal and hypnotic authority of sonic regularity.[3] With similar rigor, the second movement of *Blinking* focuses on the blinking lights of a parked vehicle that we see from the vantage of back seat passengers. The front seat is occupied by the mother in the first movement, and the vehicle's blink is captured by her own gaze, visually emphasized by lines connecting her eyes to the vehicle's target lights. The intervals between blinks are marked

PERFORMATIVE ENGAGEMENT 143

by the dancers assuming ritualized positions on stage as Du Bois's chime-like accompaniment evokes a reverberating metronome.

The third movement of the work recounts another blinking process—that mysterious blink when we examine ourselves in a mirror. As in the first movement, the syncopated eye blinking of the woman in the car conducts the staccato emphases of the music now, where melody and harmony have been reduced to minimal sets. Alluding to the reflective nature of the mirror gaze, two of the three dancers on stage in this movement don similar outfits and perform nearly symmetrical movements, but the pixilated outlines projected behind them, like abstract expressionist shapes, are likewise mirrored in real time on the filmic backdrop—the third dancer, dressed in nondescript white, is the presumable mirror, the act of reflection, surface without substance.

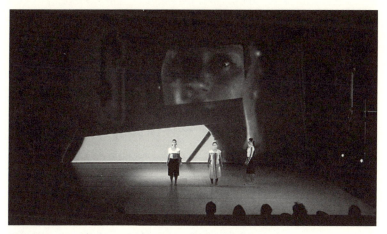

FIGURE 58 Blinking, 2009. *Jamie Jewett and R. Luke DuBois. Performance and DVD. Movement 3, detail at 19:57.*

In the fourth movement of the work, the phenomenological portrait of the blink reaches into more private territory—the extended "blink" of sleep itself. The by-now protagonist of the film world, the woman in each of the work's segments, is displayed across the entire stage backdrop in a static portrait, sleeping. This, the longest and most complex of the work's sections, is also the most literalistic, with strong reference to the dream world in the form of a sole dancer whose movements from the left wing of the

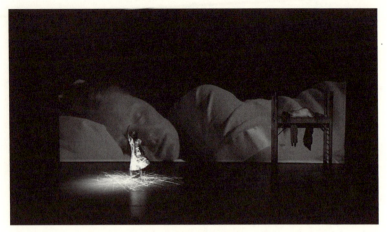

FIGURE 59 Blinking, 2009. Jamie Jewett and R. Luke DuBois. Performance and DVD. Movement 4, detail at 25:51.

stage weave to a gradual arousal and displacement of another performer sleeping atop a ladder scaffold.

Once awake, the erstwhile sleeper gets dressed and finds herself in a Neptunian domain, and beholding the water on all projected surfaces, this dancer—turned toward the rear of the stage and gazing intently at the oceanic backdrop—executes the first and only

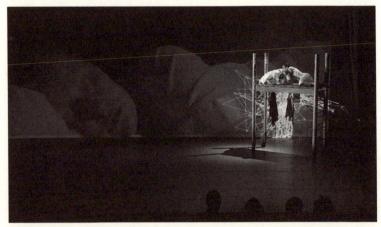

FIGURE 60 Blinking, 2009. Jamie Jewett and R. Luke DuBois. Performance and DVD. Movement 4, detail at 30:25.

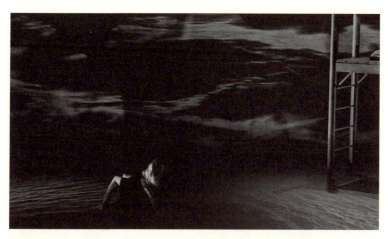

FIGURE 61 Blinking, 2009. *Jamie Jewett and R. Luke DuBois. Performance and DVD. Movement 4, detail at 36:53.*

case of *distancing* from the space of the performance; looking at the backdrop in surprise, the performer is now mirroring not the film world, but that of the audience itself.

In *Blinking*, the ambiguous tension between two action worlds—physical and virtual—presents the audience with a challenge. It must integrate both worlds into a single aesthetic experience. The nonliteral direction of the choreography on one hand and the absence of narrative in the film on the other create an intentional space in which a conceptual spirit is inescapable. But this is not new; it is for Alwin Nikolais the choreographic level where "dance is bigger than boy meets girl" (Edwards). His comment, that one should "let motion pass through space like a prism" is a tag line for *Blinking*, whose spatiality is the prism for its filmic world's action. And the tenuous roots of this prism are prolifically present in Nikolais's own choreography. His use of reflective surfaces, for example, is playfully performed in *Gallery* (1978) where every dancer appears to move about a darkened stage riding a handheld wheel, as if on a unicycle. And, in *Intrados* (1987), Nikolais presented, with the temple-like sound of gongs and hisses, a streamlined stage of six dancers whose nearly immobile and economical energy is anchored by two metal hoops around whose arches two other dancers execute a progression of framing motions that seem to direct

the ensuing stage action.⁴ The defining theme of this nonliteral approach, evident in *Blinking*, is not the presence of technology. It is the service of performative objects whose dramatic power is enhanced under low lighting. Nikolais's abandonment of narratival parameters was for him a point of pride. In the 1985 documentary

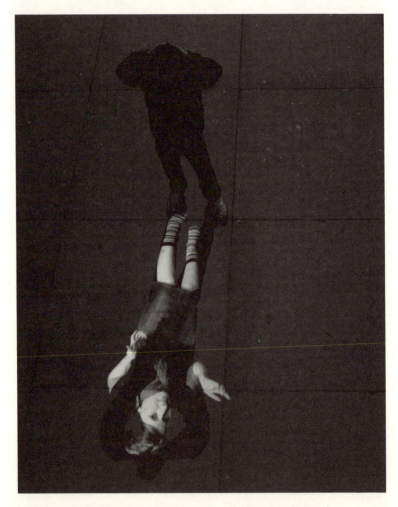

FIGURE 62 *Rafael Lozano-Hemmer,* Under Scan, *Relational Architecture 11, 2008. Trafalgar Square, London, UK. Photo by: Antimodular Research.*

Nik and Murray: The Dances of Alwin Nikolais and Murray Louis,[5] Nikolais claimed that he "destroyed realism," something he accomplished by boosting the visual dimension of dance with materials and techniques that dance as a pure form had not adopted before. And to the extent that new material enters the stage, its relationship to performance elevates from a supporting role to one in which it comprises a functional part of the performance. This shift did not come without critical risk; seen only as a case of dance rather than multimodal performance, Nikolais's work became vulnerable to attacks of "sensationalism" over form.[6] But the motion capture *in* the same space as a human body, which operates as a central constituent of *Blinking*, emerges in electronic art, not the world of dance. One parallel is Rafael Lozano-Hemmer's *Under Scan*, a work, first realized in 2005, that flooded space with an array of bright lights so that the strong shadows of passersby on the floor became backdrops to video segments greeting, gesturing, or provoking them.

FIGURE 63 *Rafael Lozano-Hemmer,* Under Scan, Relational Architecture 11, *2006. Castle Wharf, Nottingham, UK. Photo by: Antimodular Research.*

In this work, a computerized surveillance system with 14 video projectors and their servers drives a selection of pre-recorded movies through intensely bright projection. The movies portray individuals looking directly at the lens (hence the viewer), and provocations and gestures that are visible only in exact alignment with a viewer's shadow on the floor—such alignment is anticipated by the system's ability to track the motion of viewers and guess their next position in space. Any of the thousand or so pre-recorded video portraits, which are scaled and rotated to match the size and axial position of the viewer vis-à-vis the projector, can appear and will maintain eye contact as long as a viewer's body provides the shadow under which the portrait can "exist." When the viewer leaves, the portrait's attention wanders away, and the image fades out. Thus, the filmic is also sculptural, infusing the work with a séance-like aura, as if one plane of reality were being evoking by another. But every seven minutes the tracking mechanism has a chance to portray itself, when its visual reference system appears as a set of grids washing over the entire plaza.

Grids were of course the primary pattern influencing design in the twentieth century. The grid, as I have discussed in Chapter 5, was the flag of modernism, of the ideal, and of the collective. In the hands of De Stijl and Theo van Doesburg, and later those of Piet Mondrian, the grid held out the promise of harmonious unity after the horrors of World War I. The pure democracy of its form, in which every element is equal to every other, specifically disavows the prominence of groups or local differences. The grid was the opposite of the ornament in that it was created to *not* elicit an individual response, but rather to focus the eye on and dispose the mind toward totality. But *that* is also where the grid failed: it never connected to the individual soul, and as a program of any kind, was lifeless from the start. Despite its impressive purity and focus, De Stijl was politically irrelevant; and when it was adopted within Minimalism a half century later, that later movement, too, was faulted for its aloof disengagement from individual presence or perception.[7] But in electronic art, the grid makes sense not as an ideal structure above human presence, as it does for example, in Sol LeWitt's lattices, but as *the* entry point for use, something evident in *Under Scan*'s revelation of the grid as its tracking and processing roadmap. In earlier art, the grid is a fence between art and viewer; in electronic art, it is a necessity for engagement.

Andrew Neumann transposes the grid, Anne Spalter radializes it, Lozano-Hemmer maps it through sculptural projection. These are all performances in different degrees of engagement between art and its electronic support. Jewett's and DuBois's work, anchored in dance, electronic music, and visual computation, also extends the grid such that what constitutes a "performance" crosses a divide between virtual and actual. It is an empirical dialogue defined around conceptual choreography. This term, emphasizing the orchestration of movement, does not mean *dance*. I refer to a supercategory of movement expression through nonliteral dance, but dance does not address itself to what happens in its projective background, presented through a filmic plane. This quasi-autonomous filmic world makes *Blinking* more than a dance work. It extends modern dance into a post-narrative dialogue with a filmic world and a performative bridge through real-time shapes that generate several kinds of engagement from one space-time continuum.

CHAPTER TWELVE

Engagement as performed intimacy—Depicting part-object desire, visually

In the visual arts, the domain of emotional attachment has always implied at least two ways of presenting and viewing artworks. One operates in the role of mirror, the other of prism, or kaleidoscope. The first, evincing the general concern with all that is socially constructed and sanctioned in any historical epoch, is the archive of works that reflect less Platonic instantiations of Love than the societally accepted portfolio of what can, in the profound space of longing, be respectfully enunciated, displayed and enacted. This of course is the world of high art, expression in the parameters of the sublime that we take, for example in a German context, from Goethe, Schiller, or Rilke. The second domain for affective realism is less prominent. It documents the nightside of emotional intensity, the fire of longing unconstrained by and unresponsive to moral structure. Far from finding expression in starkest terms, this second realm of emotional characterization has a rather protracted development in the work of artists and movements that saw no need to reflect social mores, but rather to refract, distort, and even effigy them as hypocritical restraints on an otherwise essential human spirit whose *Sturm und Drang*, to recall one version of it, merits nothing less than the vindication of its suffering and alienation in the full light of a new artistic day. It was in literature that Stendhal,

Baudelaire, and Mallarmé found a means for such refraction, a language of expression that promoted itself from the mimesis of ritual feeling to the antagonistic refutation of the stagnant "ritualized," of the implicit in all that is unspoken, all that is culture.

It is with the end of high art's authority and its absorption by/into popular culture that the first domain of emotional expression is gradually replaced by the second. And while popular art incubates within its own environment in the form of full-fledged media that include among others the radio program, the television show, and the comic book, the venues of high art—the museum, the gallery, and the academic publication—encounter a new tension in the attempt to accommodate the "low" within the "high." Of course, the fit is ultimately incommensurable; high art, we know since Kant, revolves on distance, which is to say, ineluctability through notions of taste, while low art is about closeness, or the reach for immediacy through performance. The art of distance can afford to be mediated by costume, ritual and language that traverses all of a culture's history. The art of immediacy derives impact by jettisoning all the signs of historical determination; they play no role in the depths of true personal longing.

And so this distance-immediacy dialectic becomes taken up as a principal problem for artists whose optic lies on the tangent of the morally or socially acceptable. The moral problem might include treatments of sexuality that have been eschewed by the High Art ethic. The compass of social problems might point, among other places, to the nodes of inner experience that, when documented "up close and personal," transgress the traditional function of art as a framework for appreciative abstraction. The array of recent examples of each is an almost unbroken string since at least the 1960s, even assuming we ignore the work of Dada artists five decades earlier.

At one end, corresponding to reactions to moral code, several techniques have been used as gambits on the distance-immediacy polarity. Since the distance of sublime appreciation remains central to high art, it cannot be circumvented. But since the immediacy of popular art's freedoms offers relevance and expressive latitude, it remains too seductive, it cannot be overlooked. One recurrent solution, stylistic obfuscation, tackles the handling of the visually explicit; the image that is too salacious or extreme becomes manipulated into near-unrecognizability through compound methods of aesthetic degradation.[1]

FIGURE 64 Robert Heinecken, From the Series Are You Rea, Be An Angel, 1966. 9 7/8 × 8″. *Silver gelatin print and pencil. Courtesy of Rhona Hoffman Gallery and The Robert Heinecken Trust.*

Robert Heinecken, trained as a printmaker and working as a photographer, had a fascination with this approach, exposing the subject through cross-montage and negative overlays that retain both aesthetic distance, through the suggestive character of the images, and aesthetic immediacy, through the evidence, on

sustained view, of a more seamy source of the material itself. Not surprisingly, much of his practice could at the end of his life be characterized as occupying a resolutely contrary position, even among photographers. As we read in Heinecken's *New York Times* obituary, the artist's "hybrid integration of photographs with other mediums was a rebuke to the aesthetics of conventional photography adhered to by the major art photographers of the day. But it had much in common with the approach of Robert Rauschenberg, the unclassifiable artist whose graphic work of the late 1950's and early 60's freely mingled paint, sculpture, printmaking and photography. Like Mr. Rauschenberg, Mr. Heinecken doted on random effects and chance juxtapositions, joining a lineage in the arts that went from John Cage back to European Surrealism and Dadaism."[2] Consider the connection just made there. It emphasizes a lineage with major artists of the last century, and links them all as practitioners of unclassifiable mystery, implying that, as artists approach and engage the sources of human desire and consciousness, they mix multiple media and images, causing the historical and institutional record to become more confused by their work. The impact of this is all the more evident when we imagine what a wide-ranging set of practices and concerns the term "conventional photography" had come to embrace by the 1980s. Heinecken's *Mansmag* of 1969, a starkly colored superimposition of offset lithographs in the form of a booklet, recalls the impact of Warhol's *Disaster* series, but with sensuality rather than death at its thematic center.

The artistic breach of moral code through convolution of image proves relevant to artists who questioned and contravened social codes as well. In video, the first social code to be broken was the fourth wall, destroying high art's rule of aesthetic distance by having the artist address the viewer directly. Vito Acconci's video work during the 1970s adopted this as a signature technique, with the insistence of intimacy reinforced by the extreme close-up of the artist. Few of the many relevant instances in Acconci's oeuvre were as salient as *Centers*, a 1971 performance in which the artist's iconic stress on the inclusion of the viewer into the work is conveyed by the unadorned, sustained act of pointing. A year after the work was completed, Acconci described the action as "Pointing at my own image on the video monitor: my attempt is to keep my finger constantly in the center of the screen—I keep narrowing my

focus into my finger. The result turns the activity around: a pointing away from myself, at an outside viewer." It was this mise-en-scène that Rosalind Krauss saw not merely as a framing device but as the very structure of the video medium, yet one whose aesthetics was seen as of a narcissistic kind. "As we look at the artist sighting along his outstretched arm and forefinger toward the center of the screen we are watching," she writes, "what we see is a sustained tautology: a line of sight that begins at Acconci's plane of vision and ends at the eyes of his projected double."[3] In an argument where one kind of finger pointing underscores the basis for another, she indicts the medium for an abstract kind of narcissism, that is, not as mere self-aggrandizement but as a production logic that folds onto itself.

This tautology is the portal unifying the distance of high art with the immediacy of popular art when video and later photography assume a new kind of subject in performance—the artist

FIGURE 65 *Vito Acconci,* Centers, *1971. Video, b/w, silent, 20 min. Courtesy of the artist.*

himself or herself in self-revelation. Here, in this novel fount of expressive enthusiasm, the affordances of a new medium—video—meet the boundless potentials for exploration of a new kind of subject—the artist-as-subject—in a scheme of practice where both are completely open, entirely flexible, and responsive to new directions. This is not the artist's self-portrait of Rembrandt or van Gogh—it is not an opportunity for the encapsulation of painterly technique. Rather, this expressive direction, emerging from but transcending the recursive terms of tautology, centers rather on the problems of medium-analysis, self-analysis, and, as mentioned at the outset, code-analysis (the social code). Thus we can make sense of Pippilotti Rist's bond with the medium as not only melding the inner landscape of artist and medium, but *through* the medium's own techniques, as something that provokes from a gaze on either figure or ground but never on both. Here, the medium itself is the ground, and the contingency of the artist's being is its figure. The artist can, through this channel of articulation, say what could never be said before, as if two messages were conflated into one, in one, documenting the intimacy of lovemaking on one hand through the distance of medium destruction of the other, as in Carolee Schneemann's intensely revealing short film, *Fuses*, a work of passionate self-narration, akin to a dream sculpture, commemorating her physical relationship with James Tenney. The togetherness caught in the film is, as if to remind us of its momentary nature, blended with the artifacts of the film's own destruction through various means. The impossibility of absorbing one story without the other answers in the affirmative a question that Schneemann presumably posed in one of her notebooks "How can I have authority as both an image and an image-maker?"[4] Perhaps not *authority* but *authorship*.

Painting, sculpture, and photography, too, were blended in the work of Hannah Wilke and other artists whose feminist voices engaged in potent self-exploration. The juncture of all these media pointed to a new use of medium and new meaning to the idea of "assemblage." Extensions of this lineage are evident in the work of Lana Z. Caplan, whose work has explored a range of practices that fall under what should by now be called *biographical media*. As part of a series of music videos called *The Break-up Album*, the first, *After you've gone*, realizes a *triple* media overlay as an object of attention through song, performance, and artist. In

the tradition of the conceptual technique of explicit intimacy, Caplan, in synchronized doubled montage, sings inaudibly to a second synchronization with the playback of the eponymous song composed by Henry Creamer and Turner Layton and recorded by Bessie Smith. The song's roots are located in the historical birth of popular culture, not high art, in 1918 as was first performed by Al Jolson, and subsequently recorded by an astonishing parade of luminaries, including Louis Armstrong, Ella Fitzgerald, Frank Sinatra, Judy Garland, Marion Harris, Bessie Smith, Sophie Tucker, Benny Goodman, Lionel Hampton, the legendary Quintette du Hot Club de France, Cal Tjader, Johnny Hartman, and Shirley MacLaine, among others. Thus, Caplan's adoption of this song invokes an emotional pedigree of sorts, the domain of attachment for which love lost finds many expressions. The appropriation, however, is not of the song but of a Bessie Smith recording, itself *recoded* to the performance of the artist's lips in extreme close-up, and, as if recalling the aesthetic tautology that Krauss finds within video's logic, Caplan appears not once but twice, layered in the signature avant-garde kaleidoscopic over-placement, repetition and

FIGURE 66 *Lana Z. Caplan*, After You've Gone, *2008. Video.*

non-scenery, and close-up of lips we find interspersed throughout Léger and Antheil's 1924 classic *Ballet Mecanique*. Caplan's overlay also recalls Alice Prin (a.k.a. Kiki of Montparnasse), the protagonist of the earlier performance whom Man Ray often photographed.

Acconci's line of persuasive "reasoning" with the viewer, insufficiently explored, is taken up in Caplan's second video, *lovefool*, with the artist posed off-center in neurotic high pitch and Cyndi Lauper regalia, uttering directives like "Love me. You don't have to love, just say you love me." As the "Love me" command repeats, gradually being mouthed through more insistent and grotesque mannerism, and the sentiment it could evoke is snuffed out, the work is an interrogation of what underlies the emotion itself when obsession, one of its principal ingredients, comes to dominate the relationship. The perception of insistence for intimacy fosters an equivalent sense of distance, each destroying what becomes obvious in its absence: the caring that fuels love itself. Such is the supplication that the artist sings, or lip-syncs, to the Cardigans' hit single *lovefool*; the plea for deception that is evident in the lyrics'

FIGURE 67 *Lana Z Caplan,* Lovefool, *2008. Video.*

refrain ("Love me love me / say that you love me / fool me fool me / go on and fool me") is emphasized by Caplan's acting of a jilted lover whose self-pity takes on a demeanor that is at once tenuous, defiant, anxious, and disinterested.

The kind of artistic engagement that Krauss found problematic in early video appears to have sustained itself, exploiting new directions. Her designation of its aesthetics as centering on narcissism is the product of a literal or iconic reading, something too closely anchored to the retinal effect, and therefore a partial characterization of its larger project, which is much more indexical, and more aptly termed a broad sounding of emotional indeterminacy. Thus Rist's work in the 1990s has moved into the more stoically Finnish self-absorption that characterizes the metaphysically enigmatic work of Eija-Liisa Ahtila, whose own interrogation of how filmic imagination oversteps the physical world and vice versa can be understood in resonance with the work of Joan Jonas. For her part, Jonas's interests in symmetries of representation have assumed literal implementations in, for example, the mirror view of her 1972 *Left Side Right Side*, work that connects to much of Dan Graham's own reflective phenomenology. But in both Jonas and Graham, the affective state of the performer, powered by autistically robotic refusal, is inescapably magnetic—how can this be ignored? And for Caplan, a hybrid of directions reflects the assumption of the medium as an adjunct to human sentiment. For as arrows in the quiver of shattered relationships, these works contribute to a video series entitled *Refrain (The Break-up Album)* in reference to its meaning in both popular culture, as in the "top ten breakups" of the Stephen Frears film *High Fidelity* starring John Cusack as the romantically inept music lover, and across a lineage connecting artists whose experiential romance with the video medium mediates romantic experience through art.

CHAPTER THIRTEEN

Engagement as post-literary mechanism, an historical argument

We know from the histories of literature, architecture, and the visual arts, that important chapters and debates in each discipline have centered on notions of the "better" or "ideal" work of art as defined by the prevailing social norms of each age. At its heart, the underlying premise of aesthetic arguments reduces to questions of *form* as the criterion around which aesthetic differences are to be settled. Enveloped unarguably as we now are in a paradigmatic time of expression whose process and production are nearly simultaneous, as the architecture of new media affords us, the intimacy of medium with form raises concerns about how inconsistently, in light of its importance, we have been willing to explore the meaning of form itself for artistic implication.

One culprit of this inconsistency is the duality of implication that associates in the name of form; it appears simultaneously as a noun, to characterize the phenomenal appearance of a genre—as in poetic form—and synonymously as an adjective—the formal properties of the sculptural. These uses seem homologous, identical, equated with each other in the semantic intent to which they address themselves. And the terminological ubiquity of these words suggests that we have found in them something both sweepingly abstract and comforting in their adequacy as signifiers

that connect author with reader in commonly shared meaning. We might have learned by now that terms with these features, abstraction and comfort of reference, are like the word "God," ubiquitous not because everyone understands them equally but, rather the opposite, because they are taken in entirely idiosyncratic, subjective, personal, individualized, and therefore *unequal* ways, such that the philosophical distinction between sense and reference that we take as beginning with Gottlob Frege is relevant to these misunderstandings.

One salient example of the asymmetry of expression between sense and reference as consequential to form came up in a recent discussion I had with one of my second-year MFA students about the structure of her sculptural work. In this Digital+Media department, all students explore the synthesis of new media—not necessarily digital—with traditional media—sculpture, film, photography. My student's work involved the use of a chemically denatured conflux of tear gas and pepper spray—two weaponized gases typically used in the social extreme of the "political demonstration," that moment of engagement beyond the orderly one of the "rally," when an otherwise conforming public becomes agitated into the role of "demonstrators" and police, too, become polarized into the mode of military response signified by their black uniforms, shields, masks, and riot gear. In the context of the student's project, the problem was how to use this gaseous transformation in a statement that would also physically involve the work's viewer. Her principal idea was to create a booth that the visitor would enter, but beyond that, no other possibilities suggested themselves. I made several suggestions, responding to the need for closing the phenomenological gap between the two very disparate worlds of a political confrontation on one hand and the anesthetized confines of a gallery setting on the other. But to the artist, these all seemed too obvious, perhaps too didactic, and perhaps they were, so after two hours of visual hypothesis, we adjourned without resolution. The problem here lay in how the polemical force of the medium—its natural use makes *sense* only in a law enforcement context—could not be brought into association, could not be *referenced* from within the gallery's very abstracted world of demonstration. The work is one whose form, as it stood, overflowed with sense but was devoid of reference. And for the potential in a work of art's aesthetic contemplation

to become one of sublime transformation, both some feeling of sense and of reference must be experienced, however inchoately. The abyss that threatened the integrity of this work, the condition that maintained it in a contingent and still-disintegrated (non-integrated) state was decided entirely by the *form* of the work. For perhaps the installation, as a traversable glass box, was too formally indeterminate to permit the sense-reference gap to be closed through any line of associative inference. But it was brilliantly original in engagement.[5]

Of course, this is not the same as asserting that the sense and reference of a work must point to the same discursive space. To be sure, this distance is already an unavoidable byproduct of the interpretive ambiguity that we regularly encounter—to hear the name of Duchamp as a canonical instance of reference, for example, is to open dialogue to several new senses, to include the country and zeitgeist of the artist; the man and the prominence of his family; and the origins of conceptual expression in art. But Duchamp intuitively grasped the sense-reference problem almost too well, for the readymade makes exactly the case I am speaking of, namely, something in whose aesthetic ontology, reference undermines, refutes, and contradicts sense. By extension, that which has been called "technoculture" participates in this sense-reference dissonance, for which reason it has been called "Anti-Aesthetic," as we know from arguments presented by Habermas, Baudrillard, Jameson, Krauss and others in Hal Foster's eponymous book. Nor was this condition one of confusion only for popular culture—the enlightened aficionado, too, was now lost at sea in this procession of divergent signifiers, so that Habermas, in Foster's work, would observe that "Bourgeois art had two expectations of the audiences. On the one hand, the layman who enjoyed art should educate himself to become an expert. On the other hand, he should also behave as a competent consumer who uses art and relates aesthetic experiences to his own life problems. This second, and seemingly harmless, manner of experiencing art has lost its radical implications exactly because it had a confused relation to the attitude of being an expert and a professional."[6]

That neither expectation has blossomed from the potential to the real has led some (albeit in varying degrees of satisfaction)—Arthur Danto, Donald Kuspit, Suzi Gablik—to read the postmodern condition as synonymous with an end of art, in a post-dialectical

reprise of Hegel's argument three centuries earlier. This rupture is, of course, only the break of sense from reference transposed to a larger scope, for *sense* here is history itself, and *reference*, of course, is its anchored optic in the world of art, whose conventions, once sacrosanct, have been superseded by a turn from the past, so that the "present," the "anti-aesthetic," and the "ahistorical" mean the same.

While to the visual arts historian, the two centuries that have marked that gradual dissolution of painting's compositional tradition, most frequently chronicled as the abandonment of figuration and subsequent embrace of impressionist, abstract, and contemporary directions may seem a notably sudden period of aesthetic revolution, we know that a more temporally compressed and ubiquitously evident schism around the question of form has, in roughly half that time, come much further. I am speaking about both the radicalization of literature and poetry as free forms in the noun sense and, by dramatic opposition, the formal retention of that manifested marking of the word on the page that is the concern of typography, where form operates entirely as an adjective.

What, in the past twenty years, have been doubtlessly very inspiring discussions on the fanciful flight of textual organization and structure in digital media, specifically how speculations about how the literary has become mechanized through new experiences for reading rooted in the earliest hypertext systems and extending out to the most contemporary projects, has scarcely been tempered by the equally dramatic contrast, one which we must now read as refusal, of typography's immobility from essentially the same formal concerns that print has adopted since Gutenberg's time, and even long before that. For in this case, the marvel that was movable type relied on the mechanical galley; its flexible frame could operate as a press plate only by the process of compression on two axes of force, even though the consequence of only one of those has been contemplated by formal criticism and expressive freedom. The more famous of these forces is, of course, the vertical compression of the press's inked platen onto the paper, resulting in the printed page that has given us the basis for all distributed knowledge prior to the dominance of the electronic network. Since in print, this compression produces the impression, it therefore produces the content. Much less frequently discussed is the other

force, a *lateral* compression, under which the page elements were assembled into a single place by squeezing them together into the galley proof, tightened with vice grips into a rectangular enclosure and then positioned under the press for subsequent inking and vertical compression.

That textuality became in every sense a system, not merely for the organization of elements in place but for keeping such elements, as social entities would be in the polis, in a state of order, is evident from the exalted status that the printed word was allowed to occupy in the architectural and sculptural domains, where it was to be placed above everything foundational like columns and plinths and below the most privileged entities of consideration, like deities and leaders. The column of Trajan in Rome operates as a testament not merely to an emperor but to the function of text as the medium for logical historicism of the emperors' two victories in the epic campaigns against the rival Dacians, mirrored in the process of writing itself—all documented on a frieze that, rather than appearing traditionally in the middle as a singular layer supporting the cornice, is instead a full scroll of text over 600 feet in length in bas relief that rotates spirally upward to culminate at the pedestal where the sculptural portrait of Trajan proper could be said to begin. There is but one view of Trajan at the top but 23 rotations of the historical text; this work is both about the status of one mortal and the memorializing power of the word. Modern typeface designations, including the *Italic*, *Antiqua*, and *Roman*, confirm how the typographic roots of two millennia remain within contemporary textual conventions, even if many were reconfigured, *reformed*, if you like, with the *cursiva humanistica* of the Renaissance. To be sure, that the field of typography has not moved far from its historical fidelity to this past—the flare at the end of a letter terminal that is known as the serif comes to us from ancient Rome, with today's principal decisions being whether it should be Adnate (flowing with curvature from its connecting element) or Abrupt—or from its fealty to conservatively geometrical order *as* visual organization is a problem we shall consider below.

Speaking conceptually of the second compression in the mechanical production of text, it would have been fair to call the typesetter a sculptor, since in the medium of molten metals both employed exactly the same process. This would not surprise

anyone who understood Gutenberg's vocation as a goldsmith, a commercial sculptor. In the same way as the sculptor, creating typically in bronze, would have employed an empty cast, injecting or pouring into it the hot metallic medium to harden and materialize into the form of the final work, the typesetter injects molten metal into a type mold that becomes the inkable plate, the *block*, in the printing industry. This block, whether used for pouring and manufacture of a hot plate, or composited manually into galleys, as was the practice much earlier, is what I am pointing to in the more obscure but no less influential compression, because whether as a matrix for the pourable plate, or as an ad hoc galley set, the elemental form of text as we continue to see today in its symmetrical organization is an accident of process rather than a nod to optimal readership. In the principal system for mechanical typesetting, the Linotype, *sorts*—letters and symbols, spacers, and slugs—are selected from a storage unit and dropped into place to create lines of type. As the writer must select from the words of a language, the typesetter, too, executes a retrieval task for composing text, the galley being the stage where the lateral compression happens; it is not the birth of the page, but rather its structure as a matrix.

Why we have not separated the printed composition's rectilinear organization as (once) determined by the physical constraints of the galley's frame from the conceptual, aesthetic organization of the page is perhaps due to the lingering, if retrograde, connection not to printing but to typography that this latter profession maintains to that simplifying archetype. The lingering traditionalism of typographic form is almost too evident in Hans Rudolf Bosshard's recent and lavishly detailed *The Typographic Grid*, in which gridded page elements restrict and reflect the tenets of page design in a manner that might resemble façade studies done in architectural studios from the OMA back to that of Mies van der Rohe.

In this company too, is Willi Kunz's *Grid Systems in Graphic Design/Raster Systeme Fur Die Visuele Gestaltung*, in which text is often rendered into window-like frames conflating its symbolic literacy to the constraint of simple form.

As these examples only begin to illustrate, the predominance of geometrically primitivistic visual organization in which type, which is to say *text in print*, has remained subsumed, has needed an aesthetic outlet for the stultification of its reductionist organizing

principles. Kunz's work can be read, both literally and phenomenally, as the overlay of a presumably interesting visual form over a more constrained textual one. And if we eradicate text altogether, many design books have no issue with treating the first of these two elements autonomously, suggesting a visual aesthetic entirely of its own making. In Kimberly Elam's *Grid Systems: Principles of Organizing Type*, for example, text has been greeked out altogether, reduced to gray blocks. This practice, typical of graphic design tomes, argues for structure as entirely distinct from the content it is (supposed to) nurture, and again returns us to an incomplete aesthetic of sense without reference. "(Type) Form follows (Page) Form," as the typographic principle might read.

Where and how in the logic of design deliberations, it remains to be asked, does this breakdown, this schism, this unquestioned rupture between visual form and literary form take place? And how does the textual revert back to the rectilinear constraints of the galley proof when that structure has become so superseded by the freedom that visual form in design is formulating? Wolfgang Weingart's *My Way to Typography* showed an illustrative example. Telling of his early interest in the letter *M*, Weingart focused on the formal properties of this letter to those gradually intense deconstructive levels that begin to see it more as a symbol, and then as a glyph, than as a textual component as it is distilled away from its literary context. In a sequence of diagrams redolent with the kind of open enthusiasm that we know from children's wonder in playing with letters, Weingart rotated a chain of inchoate contortions on a circus of *M*'s whose acrobatic stretches morph from the typographic into something like a Futurist poster study.

And yet, once played out to near-Dadaist proportion, the deformations of the letter collapse, inexplicably, back down into symmetric primitives, for even the addition of a third dimension in Weingart's adoption of the letter study into a modular cube makes evident the seeming immutability of typography's need to return to the ordered simplicity of a matrix or a grid.

From across the table of contents, the newspaper galley, the book index, and significantly distinct contexts, the presence of the word is bound to the substantive notion of form as an object with definite, limited, and regular boundaries. Excepting the fringes of poetic experimentation, there exists no literary genre in the West whose textual organization has successfully escaped this constraint.

Not surprisingly, then, electronic literature's extension on that history has directed itself on the adjectival version of form—forms for reading, which is to say, form as process descriptive of a particular post-literary encounter. And that encounter depends on mechanisms that undermine and negate the linearity of the gridded reading, a problem that shall be explored in the next chapter.

CHAPTER FOURTEEN

Engagement as post-literary mechanism, from exposition to reflexivity

Pattern	Character	Purpose
Exposition	Propositional Logic	Establishment of Order
Transgression	Impulse to Freedom	Escape from Structure
Reflexivity	Perceptual Circularity	Indexical Self-Reference

The schematization you see here is a speculation on the move from mechanism to reception that some electronic works have been fostering.

For some time now, I've been looking at the problem of what seems anything like a distinguishing ontology for digital media art and literature. It seems grandiosely Romantic, and not a little naïve, to expect that from such a proclamation an objective set of markers might emerge such that our feeling for a contingent abstraction like the aesthetic and literary through the electronic can articulate distinctly from artistic impulses, processes, and products in supports that are not electronically mediated. This question extends the inquiry of aesthetic ontology that new expressive traditions ask themselves from time to time. As a case of art—that is, as aesthetic material—film's own ontological ground was explored by a long procession of deep thinking compressed into less than seven decades, to include the writings of Eisenstein, Kracauer, Arnheim, Bazin, Godard, Truffaut, Rivette, Rohmer, Mulvey, and

others. By invoking the name of ontology it ought to be clear, then, that I am referring to theory, not criticism; Kracauer is theory; Pauline Kael is criticism. Theory's importance can be gauged by its influence on criticism; criticism's importance lies in its effect on the public, to whom it addresses itself. Theory's audience is different; it listens and speaks to the broadest swath of history. Criticism is more constrained to (and by) specific works and topical trends. Criticism cannot address areas that are central to philosophy but which theory can graze because of its connection to the structural foundations of the philosophical.

To further clarify terms here, critique is philosophy, as we know from the title of many a great treatise, while criticism is the act of "hovering-over" a critique with indirect probes but lacking a rigorous framework. One of these post-critical concerns is the question of ontology. Reminding ourselves in the twentieth century of a much older lineage of inquiry, we know—perhaps most recently from Heidegger—that ontology is not theory, it is an *interrogation of essence*. Framing the question of new-media art and literature as an interrogation of this kind impels us to think in less ideologically constrained terms, and while ideas of an "essence" may be both naïve and elusive, the notion of process seems much closer to what we might be seeking. For if we imagine anything like a "discipline" of digital aesthetics and poetics at this historical moment, we are soon caught by the care with which electronically mediated creative expression has been chronicled both as process and as result. In digital art, the result, as a visual product, has been the *materia prima*, whereas in electronic literature, it is the process that has enjoyed greater exposition. Its discursive space is populated as much by objects of expression as by writerly documents of its functionality.

It is the latter of these lines of effort that has enabled electronic literature to begin its successful path toward legitimization within the academy. Some of the humanities have become *digital* humanities by—perhaps temporarily—coming to the engineering paradigm and looking empirically at what comprises mechanisms for organizing memes of principally linguistic expression. In varying degrees, the aestheticization of these mechanisms has reflected the language of information systems and has not avoided showing the computational character of works of electronic literature. That books have emerged with titles like N. Katherine

Hayles's *Writing Machines* suggests that the discourse of industry has become embedded into that of poetics, aesthetics, and creative expression. This synthesis of tongues is largely responsible for our ability as critics to speak of textual fluidity and poetic process in an objective manner unlike ever before, and has bestowed a degree of stability to concepts and observations that a discipline needs. Freud followed the same pattern in the establishment of psychoanalysis, adopting metaphors like "pressure" and "sublimation" from the language of mechanical engineering for a new poetics of subconscious motivation.

I am of course not claiming that electronic art and literature harbor scientific ambitions, but rather that they now reflect a structural foundation that was lacking before major contributions to the idea of an aesthetic or poetic framework emerged, even while *computational* explanations of poiesis were there from the beginning. Responding to a need for objective discussion of texts and games, Espen Aarseth's *Cybertext* in the late 1990s exerted the same formalist impact on digital theory that Northrop Frye's *Anatomy of Criticism* had on literary theory half a century earlier. Such was Frye's objectivist call that not until almost ten years later, with Barthes's idea of the writerly text, Derrida's deconstruction and Iser's work on reader-response does attention turn back again to complex phenomenologies of literary reception, away from the objectivist centrality of structural relations as functional constituents of a literary work.

From Exposition

I mention all of this so as to acknowledge this return from mechanism to subjectivism as the central experience of the text in this discussion. However, is isn't *human* subjectivism that I want to discuss here, but rather that of the text or art machine, so the discussion is not about a full return, but rather a helical recurrence, a critical flyover, based neither on structural/medium nor reader-reception terms, but on those of a third path, unique to electronic art and literature, which come into view when we can feel a work escaping its own expressive plane in favor of a recursive observation of its own process, that is, in what we might imagine a

mirror phenomenology. What is the demonstrable evidence of this subjectivity? It is the work's aesthetic when it operates in tension with its own frame, its own Dasein, its being-there present to us as an automatic apparatus but one that is powered by a move toward the transcendence of its own framed representation, exposing reflective qualities that resemble those of human engagement itself, which they prompt.

Interested in suggesting something beyond language, beyond representation, I am invoking the impression of a mirror so as to speak of the *being* of a particular genus in some very familiar examples of electronic art and literature. So the process in question is not presentation but rather the escape from presentation, where trajectories or acts of perception, understood as a line traced from the object to the viewer, open out onto something different, where the work additionally behaves as its own viewer or reader. That is, the work assumes and performs the position of its Other, the vantage that we have historically occupied.

In order to effect this move, the work of art or literature must transcend the conventional conditions of its own medium as a structure of exhibition—that is, the conditions of mere presentation that I encapsulate with the first Exposition state in the opening diagram. To operate while suggesting a sense of itself, it would bring us to contemplate how it could be effecting something of its own contemplation. But why the *transcendence* of its own medium-hood? In order to operate, to show, to illustrate, to demonstrate and to convey its own reading, a work must invert the structure provided by its medium so as to become a passive listener, reader, or beholder, and in so doing, is no longer operating through an original transmissive function, it is *refuting* that function by becoming the Other, the target of itself.

Perhaps we could say that such mirroring exists here in a limited form of Lacan's view of the child's first consciousness of individuation. There, the specular image, the *image spéculaire*, refers both to the simultaneous appearance of the body on a reflective surface and to the reflective act that the child experiences in seeing this second image, this "little other." The mirroring act gradually extends from something limited to a physical medium to what is performed by humans interacting with the child, where the child can see his or her actions mirrored in those of the adult in gestural play. By implication, we can take Lacan's argument to imply a

further milestone in the development of social cognition as the exactitude of this interaction gives way to looser forms of dialogue and relationship, enabling the child to move from the expectation of strict reflection to one of unrestricted response as the primary means of engagement with the world. This amplification of the mirror process is what permits, without overwhelming confusion, the emergence of behavior outside of the expectation frame of the *habitus*, the environment as an always-there arrangement of phenomena. That is, with the appearance of the Other, the regularities of the observable field begin to perform differently but have not yet become understood as entirely self-aware or self-observing, the Other is still an other, and the notion of a *projection* whose source is what is doing the looking is not yet established, even though a rustle of deviance in the framework of the image is already evident. This is the realm of reality as the performative apparatus and in electronic textuality, it is that to which the poem *For All Seasons* conforms.

Transgression: Mueller's *For All Seasons*

A case of this transcendence is the secondary use of letters and words as nontextual objects, thus denying their literary function as tokens of language, as we see in Andreas Mueller's familiar *For*

FIGURE 68 *Andreas Mueller,* For All Seasons, *2004. Software. Fall panel as text.*

All Seasons, where a quartet of prose pages establishes, by way of exposition, some memory embedded in the author's experience during each season of the year. In each case, the linguistic system becomes subject to breakdown, the electronic medium showing its characteristic dynamism in allowing the text's words to be participants in a transcendence from language and escape from the structure of textual reading, out into a figurative evocation of the recalled memory in question.

The metamorphosis from text to function is evident in each of the four seasons that Mueller chronicles. In each he offers a personal account; for the Fall narrative for instance, reference is made to autumn leaves caught in a wind vortex—the story's *punctum*—so that the text animates into the whirlwind itself:

FIGURE 69 *Andreas Mueller,* For All Seasons, *2004. Software. Fall panel as image.*

And a three-dimensional version of this is illustrated in augmented reality chapbooks like Amaranth Borsuk's, which are both authored (for text) and programmed (for code). As Borsuk explains, the "digital pop-up book"

> integrates the artist's book and e-poetry traditions to examine the conventions by which we know an object as a book. The

pages of the book contain no text, only square markers that, when displayed before the reader's webcam, activate a series of animations mapped to the surface of the page. Because the animations move with the book, they appear to inhabit "real" three-dimensional space. However, the resulting poems do not exist on either page or screen, but rather in an augmented reality where the user sees herself holding, and interacting with, the text.[7]

FIGURE 70 *Amaranth Borsuk and Brad Bouse,* Between Page and Screen, *2012. Software. Photo: Brad Bouse. Image courtesy of the artists.*

But is playful rupture in this text's formal transcendence—no doubt a literary purist might balk at this flouting of print's function—the sum of what we experience in these works? After all, it ends—as concept and process—as it began: as a case of transcendence, as an inverting departure from nullified image within a formal text to nullified text within a formal image, yet one without return or resolution using those same terms of form, image, or space. The escape from one form into the emergence of another is articulated through extra-textual principles germane to story but unrelated to print—for Mueller, fish gliding through streams, the pull of gravity on falling snow, and the turbulent vortices of windstorms—or

in virtual ones—for Borsuk, the conversion of the literary into the quasi-sculptural/quasi-photographic/quasi-filmic—and in their modification of our reading from a poetic to aesthetic one, and our relationship to the text from a lexical to a visual one. So although textuality recedes and imagery emerges, the transition is purely surface-level and retinal, if clever. The integrity of the narrative is reinforced by this translation of form because the electronic medium is equidistant from either form, text or image. Its intimacy is only with the modality of dynamic change and translation. But that very closeness to processes of alteration is what allows us to imagine it as a medium for reflection, for altering the position of the instrument itself from something invisible or transparent to something self-indicative.

Reflexivity: The Readers Project

Works that appear to behave with mirror-like reflexivity like the simpler cases above cannot simply choose to do so, they must first establish themselves with the same attention to structure that static representative works possess. This foundation, which conveys a kind of propositional logic or order as a first step, is necessary as a basis for the subsequent refutation through which the work exercises any perceptible transcendence, what I call an impulse to freedom from the strictures not of its form but its function *as* a representative object, as named by the second stage here. This transcendence is often the final destination for much electronic art and literature; it finds its ontological fulfillment in the breakdown of the order, logic, or structure that was first exposed. But only when the work makes itself part of the solipsistic process of its own being can it express as icon and index simultaneously.

And this connects back to the world of Andrew Neumann, for example, in whose series of Industrial Wall Panels there hangs an unsettling symmetry of perception locked in the structured work that allows us to observe it observing itself and showing us both its presentation and representation in a single field of view. We might moreover observe that the process of self-observation is a transparent mark or index into its own logic and flow of operation. This

is crucial to the notion of a machine-level subjectivity; we must see it having a feeling for itself as an organism.

As we saw earlier, Neumann's panels convey reflexive impulses in sculpture. For a case of reflexivity in electronic literature that is equally centrifugal, there is the compound plurality of autonomous textual readings known as *The Readers Project*. Horizontally landscaped across two pages with ample margins, this work appears at first sight to operate as a conventional text for a conventional reading. Soon, however, notice is taken of the fact that the text, already in sublimated grey against its white backdrop, is itself in some flux, it isn't moving but it isn't stable. We might notice that between the plane of its presentation and that of our viewerly observation is an intermediate layer or process that affects this transparency. What is being altered is evidence of what is being performed; as the work exists principally not to present texts but to present readings, and offers us both.

The chromatic shapes that traverse over the text are readers—machines that, like human readers, possess specific behaviors aligned around the selection of words that conforms to an order of meaning. What *The Readers Project* documents is the distance between the method of reading and that of meaning-making that for us is one and the same. But the distinction is worth contemplating, for lexical scanning is dependent only on the regular presence of

FIGURE 71 *John Cayley and Daniel Howe*, The Readers Project *(screen capture)*. © 2010 John Cayley.

text, but to make meaning, a departure from that foundation is necessary, and this is the basis of all subjective reading. What *The Readers Project* makes strange is what to us is so familiar, and this strangeness, with its aesthetic logic, is based on the fact that each of the readers here, shown in its own color, operates according to its own trajectory, the rules of which are unique to each reader programmed in software.

Following the acrostic tradition explored by Jackson Mac Low, John Cage, and other explorers of structural transgression through axial reordering, the first reader, a Mesostic, selects words for reading when these possess a letter comprising a pre-intended word. The reader *wants* to predetermine what it reads by creating words from letters cutting across other words, as shown in the highlighted uppercase element. Seen separately, the reader is a

FIGURE 72 The Readers Project, *partial view of output from a mesostic reading, 2010. The words "ITS OVER ITS DONE" are spelt out within the generated text marked by capitalization within the horizontal bodies of each word.*

selection system intended to reflect the creation of a word not in any of the words it reads, and therefore its notion of "reading" refers rather to concordance, a process of revealing word patterns constructed perpendicularly to actual texts.

This is not the only reading process; there are others. Two are noteworthy. There is a nearest-neighbor reader whose proclivity is to move toward the right and downward, selecting words that fit any natural language trigram found to be frequently present in Google search retrievals performed in real time. This process, associative at a local level, is led by a Markov chain of terms

FIGURE 73 The Readers Project, *partial view of output from a nearest-neighbor reading, 2010.*

capable of being "distracted" by lexical encounters with any term's leading neighbors. The product of this reading resembles a meandering search for the "correct phrase" that is a common experience to all speakers and writers.

A third reader may also move in the opposite, perhaps entirely counterintuitive direction—left and up, holding in memory the last two words it has read and seeking phrasal connections with any neighbors which may contain such collocating terms. This reflects an entirely stream-of-consciousness reading *against* the conventions of Western text, exercised directionally but by implication in an ontological way against the narratival offers of text's continuities.

FIGURE 74 The Readers Project, *partial view of a collocation reading*, 2010.

If earlier on J. Hillis Miller read deconstruction as "not a dismantling of the structure of a text, but a demonstration that it has already dismantled itself. Its apparently-solid ground is no rock, but thin air"[8] it was perhaps fitting to use this very dismantling as the basis for reflexivity in a word that reads itself, posing the question not of what a text is, but what it can be when the medium realizes its own subjectivity. This domain of subjectivity is vastly broader and more influential than might be imagined, it is evident in horizons, like Wittgenstein's early logic, far from the world of thought as structured centrally by individual perception. That is, at first, and because it emerges from the most acerbic corner of modern analytic philosophy, Wittgenstein's *Tractatus*: has something to say about formal logic, which is to say, the denial of subjective readings. Except, of course, that his movements within the structure of logic are entirely from *within* that body, not from the removed position of logic's pedigree of declarative otherness. So when he observes that "The internal relation which orders a series is equivalent to the operation by which one term arises from another" (5.23) he describes not action from the margins but from the core of motivation, which is to say, the possibility of acquaintance with conditions of truth from within, where the order exists not as form but as cause of form, cause of meaning. And that is a phenomenological compression that likewise comprises the truth conditions of text as a world of propositions and of image pictures, even if they mutually appear to cancel one another out.

CHAPTER FIFTEEN

Engagement as comparative communication— Formalisms of digital text

The practice of writing, always in flux, has over the last two decades been especially influenced by the emergence of digital innovations in new text genres—email messages, newsgroup postings, and weblogs. Many of the compositional practices of conventional (that is, *print-intended*) writing—the sense of a linear structure comprising a beginning, middle, and end, for example—can be said to be in crisis in the new medium. Digital genres have traded many such notions of form for the more convenient parameters offered by a tool or genre. Length is one of the attributes in greatest deviation—the *essay* or *chapter* is practically non-existent in a medium that by nature emphasizes instead the assertion of, and reaction to, specific, closely circumscribed *points*, rather than larger-scale *topics*. There are, to be sure, such compound structures in digital writing, the canonical example being the case of discussion list *threads*—sequences of messages that form a conversation around a question-and-answer or declaration-and-response form. There is also the *blog*, the online equivalent of a diary, with journal entries posted in reverse chronological order. But in both cases, the constituent posts comprising each of these forms function

as discrete, condensed, focused statements, and not as the colorful, scenery-creating experiences familiar to us in the notion of *chapter* from the world of print. These forms exemplify an anatomical truth of digital writing: at its core it is *point-based* rather than *topic-based*. Further justifying our view of the basic semantic unit as the *point* are the extreme forms that promote it: media formats and software exclusively dedicated to creating and organizing and displaying *points*: the presentation package, the idea processor, and the semantic drawing system. We might also note, in contrast, that no software exists exclusively for topic-making.[1]

For a culture whose millennia have been given with consistent rigor to the improvement of communicative competence—starting, not least, with the educational requirement that young Classical Greeks master the five-point *techné* of rhetoric—any new-fangled deviation from this progressive path toward communicative erudition is bound to have some noticeable impact. In particular, the displacement of topic-driven thinking by point-driven media introduces a special economy of language that reduces the archetypal expressive unit, the *sentence*, to an almost irrelevant and archaic artifact rarely seen in these new forms. Point-driven writing, whether manifest in drawing, diagram, or bullet list, desires to emphasize *process* and to communicate some kind of *how* concerning what is presented, and through its insistent visuality, renders the written form almost unnecessary. Not surprisingly, this alteration has attracted the attention of critics from diverse perspectives. There are some for whom the historically evolved forms of textual expression fulfill conditions of understanding that are not attainable merely with points, glyphs, or graphs, and others for whom the comparison between topical and point-driven media is not necessary, for each is its own class of communicative tool. Edward Tufte, who interestingly enough comes from a statistical rather than a literary background, finds these non-manuscript forms incapable of natural exposition and rich development of ideas.[2] For him, presentation software, with its characteristic cascade of bullet points, garish mastheads with oversized, condescendingly obvious graphics, and distracting animations typical of its "texts" amounts to a jarring, disconcerting experience lacking not only in depth but also in all that "comes across" in the fullness of ample expression. An interpretation comes from David Byrne, who, as visual artist, begins with parody, with "making fun of the

FIGURE 75 David Byrne, Sea of Possibilities, 2003. Digital image. Courtesy Pace/MacGill Gallery.

iconography of PowerPoint"[3] and redirects the medium into its own kind of expressive genre unrelated to any historically determined textual function. Utilizing the tools of the tool, such as its ability to render arrows, for aesthetic production in its own right, he subsumes the domain of text to that of image.

Two differing understandings—one pragmatic, one aesthetic—of the same phenomenon, now set the foundation for what has developed between the semi-textual and the orthodox-textual: the space of the neo-textual where oral and textual, and semi-improvised emerged, and we see a new kind of *conversational writing* be born in the form of blogs, emails, and other aleatory genres. Traditional textual practices, in the essay or novel, for instance, are perhaps six centuries old; the semi-textual is as old as the algorithmic or process diagram; its prominence emerges in the twentieth century. But conversational writing has no direct ancestor, except for the personal diary, which, however, never took the sprawling, sometimes fragmented, form common today. The term is not entirely new, however, a version of it—"conversational literacy"—appeared in one meta-analysis of oral and mediated

communication. Its author was the first to notice that lying entirely neither in print-based nor orally based genres, mediated communication synthesizes from both and "has characteristics typically assigned to both 'oral' and 'literate' ends of the continuum."[4] I found this interesting, worth exploring.

I'm not entering a literature review on the *philosophy* of differences between oral and written communication. I'm interested in exploring how those two expressive modalities compare with online modes of communication as possibly different levels of communicative engagement. We already know that speaking and writing are complementary in regard to informality and consequence: to consider the conditions of speech is to accept evanescent, improvisatory modes of expression projected literally into the air. Everything more or less spontaneous in this sense is captured within the notion of the *utterance*. But to produce writing is to engage in preparatory organizational work and editing prior to "committing" expression to a surface. Predominantly, to speak is to interact with another active speaker; to write is to interact with a passive medium. We could take these practices as two ends of a spectrum, and see in electronic writing a middle ground with sufficient latitude to behave arbitrarily *as* each of these. Here, any resemblance to print text emerges from the common lexical nature of both: words uniformly arranged on a visual medium. But the digital medium is unstable and fleeting; its textual operations do not enforce or constrain structural organization, prewriting, or detailed editing into fixed form. In conventional writing, the author generally writes to make a point. But in digital *conversational writing* online authors may pursue another purpose, its style reflects its social network, it is about participating.

This is neither literary nor a visual observation. It points to how a nexus of language is superimposed on a populace, a two-dimensional grid of continuous interaction harking back to the quaint notion of virtual community, by which Howard Rheingold meant the displacement of presence by expression, when, pondering both the breadth of collective contact and the demand for using language in the absence of material presence to assist in those relationships, he remarks that people in virtual communities "do just about everything people do in real life, but we leave our bodies behind." That is, in such contexts, communication and behavior are co-symbolic, not mutually exclusive.

We might conclude from this that the more one looks at conversational writing, the less it resembles traditional text, in purpose or structure. The speed and quantity of messages (again, emphasizing points rather than topics) compels a new grasp of its medium-specific functions, assertions that in research have been observed (consider Ferris's "computer users often treat electronic writing as an oral medium: communication is often fragmented, computer-mediated communication is used for phatic communion, and formulaic devices have arisen"[5] or Murray's classification of such writing as comprising a "language of action"[6]).

With the amount of speculation on the characteristics of digital conversational writing, one would expect a somewhat proportional body of observational data to support or refute theoretical claims, but this has not materialized. Considering that the operational nature and environment of digital text leads transparently to its archival— which is what the innumerable server logs and search engine indexes do—the paucity of systematic studies of data and material produced within and through the digital medium is surprising. "And it is not entirely clear what useful inferences can be drawn from much of what does exist, certainly stylistic knowledge — knowledge of what and how authors are creating online, and how the conventions adopted and evolving in their medium compare with those long established in the world of print — does not appear to be the focus of such analyses. One would, for instance, like to observe whether stylistic practices in digital media conform to conventional modes of print-based writing: is there consensus on the length of sentences between both conventional and conversational writing?" If conversational writing derives attributes from orality (Ferris's observation that "electronic writing is characterized by the use of oral conventions over traditional conventions, of argument over exposition, and of group thinking over individual thinking" is representative of this belief (Ferris, 2002)), how significant and present are these in any digital corpus, such as an online discussion group, or a library of similar communications documents? This suggests a spectrum of communicative modes ranging from most to least "formal" along lexical and semantic criteria defined next.

Let us assume, with general consensus, that print-oriented or traditional writing stands in structural contrast with oral communication—this point has been navigated throughout an entire literature and, as mentioned earlier, a relatively early informative meta-analysis

FIGURE 76 *Spectrum of oral-literal communicative modes*

(Janzen-Wilde's) assembled relevant conclusions for comparative media, between literacy and facilitated communication:[7]

Table 1. Characteristics of "orality" and their relationship to facilitated communication

Characteristics of "Orality"	Source[8]	Associated with facilitated communication?
Used to regulate social interactions	Westby, 1985; Hildyard & Hidi, 1985; Chafe, 1985	Yes
Topic usually here and now	Westby; Rubin, 1987	?
Familiar words; repetitive syntax and ideas	Westby; Rubin	?
Intonation and non-verbal cues important for cohesion and conveying meaning	Westby; Tannen, 1985; Hildyard & Hidi; Wallach, 1990	No
Usually has fragmented quality	Chafe; Redeker, 1984	?
Rapid rate contributes to dysfluencies	Chafe	No
Usual lack of permanence	Chafe	depends on device
Listeners often give immediate feedback	Redeker; Rubin	Yes

Table 2. Characteristics of "literacy" and their relationship to facilitated communication

Characteristics of "Literacy"	Source[9]	Associated with facilitated communication?
Slow, deliberate process because of mechanical constraints	Chafe, 1985; Rubin, 1987	Yes
No need to worry about keeping the listener's attention	Chafe	No
Often abstract or unfamiliar topics	Westby, 1985	?
Concise use of syntax and ideas	Westby	?
Cohesion based on linguistic markers	Westby; Tannen, 1985	?
Can be polished and perfected before it is read	Hildyard & Hidi, 1985; Chafe; Redeker, 1984; Rubin, 1987	Yes and no
Integrated quality	Chafe; Redeker; Westby; Rubin	?
Usually detached spatially and temporally from readers	Chafe; Redeker; Westby; Rubin	Yes and no
Visually permanent	Chafe; Redeker; Rubin	depends on device

Janzen-Wilde concludes that "characteristics of orality which are common in facilitated communication include its use in regulating social interactions and the opportunity for the listeners/communication partners to give immediate feedback to the speaker," in this sense, conversational writing is most unlike its traditional

predecessor. Today, emails and blogs are the everyday examples of conversational writing. Content and genre present problems for comparative media work, any conclusions deduced from textual analysis must only reflect *structural features* of the medium, such as specific conventions and communicative practices, rather than *content features* of it. The importance of structural inference can be illustrated in a simple example. Let us imagine a (flawed) comparison of print versus orality by means of examining five works of each. Our sample from print media, in other words, would comprise five novels and our oral sample, five transcripts transcribed from legal cases argued in a court of law. This assessment, after lexico-statistical analysis, would lead us to infer almost inescapably that print media are more "romantic" and that orality, on the other hand, is more "factual." This error of inference would reflect the nature of the samples utilized for each medium, not any features inherent in how the medium is used. In seeking to establish objective differences in communicative practices between media, therefore, we must choose criteria that are independent of special content-level features such as "factuality" or "romance," for factuality is an intrinsic monopoly of any medium. So if we compare media on strictly *structural* features that may emerge from communicative practices within them, we could choose three simple ones: sentence length, pronoun usage, and lexical density.

If, as some research in the Characteristics of Literacy table claims, written text possesses unique structural characteristics, concise use of syntax and ideas and cohesion based on linguistic markers, then the basic measure by which to compare communicative differences between text, orality, and conversational writing should be the length of sentences in each medium: if the belief is that oral media are more "rambling" and free than print-based media, we should find longer sentences from the former. Intuitively, it is reasonable to surmise that the length of sentences in one medium or genre might be radically different than those in another; why should they be the same? We will analyze this later.

Similarly, a second criterion, *relative pronoun usage*, is also worth exploring across media. Measuring the extent of pronoun usage across different media would indicate the degree to which persons are "close to the text" by way of direct reference, and

may justify answering the question of whether one medium is in general more *impersonal* than another. Again, the instinctive hypothesis might be that orality is more informal and therefore more "personal" or intimate than text, and that pronoun usage in blogs and emails lies ostensibly somewhere between both. This is intriguing, but it is worth cautioning ourselves that pronoun usage may belong more to specific kind of content than to the intrinsic structure of how communication in media takes place. Nevertheless, given this instinctive hypothesis and caveat, comparative statistics on pronoun usage are presented here without firm conclusion, should they prove helpful for future linguistic investigations in new media.

Finally, *lexical density*, the opposite of redundancy in language, is an indicator, in a text, of the percentage of words that are unique within it; the lower the density, the greater the verbal redundancy and therefore the presumed ease of comprehension. The formula for calculating the lexical density D for any text is simple: $D = (U/N) * 100$ where U is the number of unique words in a text sample, and N is its total word count. Lexical density is more than a statistical number; it confirms a central principle from information theory that the amount of redundancy in a message boosts its comprehension. Let us imagine that you want to learn a dialectical kind of Spanish, Cuban street argot, one word at a time. Today's word is *astilla*, a noun which translates to *splinter*, although the slang means something completely different. With a single utterance, you might or might not guess the slang term's denotation, "Use *astilla* for dinner." The lexical density of this utterance is 100%, each of its words is unique. But in a new phrase, "Use *astilla* for dinner. Use *astilla* for payment" there are 5 out of 8 unique words. Its lower (63%) lexical density reflects the possibility that the redundancy in this text potentially amplifies its comprehension, and you now have some feasible ideas as to the slang meaning of *astilla*. My next phrase, "Use *astilla* for dinner, use *astilla* for payment, use *astilla* for purchases" now presents only 6 unique words out of 12, a 50% lexical density, and this increased redundancy can support your growing conjecture that *astilla* means money.

In this sense, comparative measures of lexical density can corroborate or disprove the claim that orality emphasizes familiar words as well as repetitive syntax and ideas,[10] and based on those

research claims, we would expect to find lower lexical density in oral data than in print, and the density of online texts would presumably lie between both.

With three simple criteria, we can attempt to determine whether, structurally, it is possible to find higher-level qualities of online conversational writing that contrast with orality and written text. The data for such an investigation should range across each of the four communicative modes in question, including sentence samples from print text, emails, blogs, and transcripts of spoken occasions. Scanning software could be designed for a number of purposes, including automatic retrieval of emails from a public database, retrieval of blog postings with archival in text-only form, and to gather statistical measures from each corpus. In the area of print, there is a half millennium of source material to choose from, but oral practices of today cannot compare to texts older than about a century. Subsequently, the works of the chosen corpus, though small, should comprise a roughly equal number of short stories from classic literature and combine it with modern stories in a new medium, like an online magazine.[11] We might choose a few thousand sentences for analysis from each of four modes: print, oral communication, emails, and blogs. The oral sources would include transcripts of political debates, television talk shows, and one radio documentary interview.[12] The email samples should come from a large email archive that is public, thus avoiding privacy concerns.

All of this is in place for an *empirical* conversation about engagement across communicative modes. The email corpus mined in this analysis was made public as a result of a U.S. federal criminal investigation, and consists of the text of 619,446 email messages from the Enron Corporation.[13] Numerous analyses have been made of this corpus, the most systematic being that from the University of Massachusetts.[14] The source of blogs is taken from 30 sequential postings in each of 61 random blogs (1830 unique postings with 8726 sentences). Overall, a comparable number of sentences from emails (9875), blogs (8780), debates (8748), and texts (8600) was analyzed.[15]

There is much theory on blogging, but few empirical studies exist of semantics or stylistic composition in blogs (or emails), and methodological problems are epidemic. One of the larger studies, by Herring et al, analyzed 203 blogs but reached conclusions

based on the reported number of sentences detected (3260) and words collected (42930)—given the number of blogs examined, this study cannot have scanned more than the first page of each blog, for in my study of 61 blogs, a scanning program requested 30 blog postings from each, for a total of 8726 sentences and 94433 words—a far larger amount of data from fewer than one-third the blogs in Herring's study.[16] In all, the statistics are based on 522 individual postings. My analysis found the average number of words per post to be 303, not similar to Herring's 210. We did, however agree on the average number of words per sentence; I found 15, Herring 16.

Herring et al. counted the paragraphs in their blog corpus, but I find this measure somewhat problematic in the blog genre. A paragraph, in the realm of conventional print, is a group of one of more sentences separated by one or more empty lines. However, paragraphs operate differently in web genres, where, rather than being used to separate groups of ideas in the same text, paragraph breaks introduce whole new ideas or micro texts. Similarly, the paragraph—or a set of empty lines, to be precise—is overloaded in blog style, being the default marker between blog posts, the separator between texts and graphic elements, the break between a text and an inserted quote, and a mere cosmetic device where inserting white space adds visual balance to existing text blocks. None of these uses is related to the original purpose of the paragraph. A much more difficult problem is that of quoted phrases in blogs. Herring's count presents the methodological complication that no single definition was given for what constitutes a quoted phrase. They provide two separate counts, quoted sentences/fragments and quoted words per sentence but do not state how quotes were counted, for, in blog style, there are at least three ways to quote. One is by inserting the desired text within quotes—the conventional way. Another is by inserting a block of quoted text, for which an HTML tag specifically exists. The third is not to include the text at all, but rather to link to it. This makes questionable the statistical measure presented there, the number of "quoted words per sentence," which they find to be 7.6—an almost impossible number if we accept their 13.2 "words per sentence" measure, as it would mean that over half of everything written is in quotes. Possible, but unlikely.

In an initial examination of 500 emails and 500 posts on random blogs, the pattern of sentence length for each genre is quite similar:

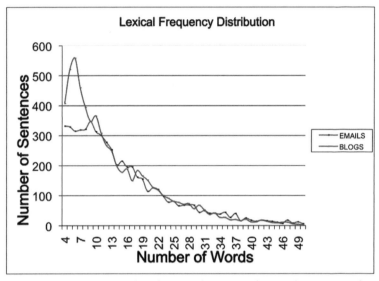

FIGURE 77 *Frequency distribution of sentences by word count, emails and blogs*

If, even taking into consideration the wide disparities in style across all possible authors, significant stylistic differences are found with the distribution of sentence length in other genres, these could be attributed to the structure of the genre, and its writing practices, which for the most part lack interventions such as word count limit, editorship, and revision, all of which would influence its average length of sentence.

If we overlay sentence length (grouped in ranges of 5 words), in all communicative modes a single graphical frequency distribution, we find the first significant difference between text and conversational writing.

Table 3. Relative distribution, sentence length ranges, by genre

Range	Emails	Blogs	Text	Debate
1–5	37.6%	29.7%	14.1%	19.2%
6–10	24.2%	21.6%	11.5%	28.2%
11–15	19.3%	16.1%	14.8%	20.1%
16–20	14.4%	13%	18.9%	15.1%
21–25	7.9%	7.7%	15.1%	7.3%
26–30	2.5%	5.4%	8.9%	3.2%
31–35	3%	2.8%	6.8%	2.8%
36–40	1.7%	1.4%	4.3%	1.6%

From this table we can ask whether significant relationships hold between sentence lengths across media modes. A regression analysis of emails and blogs shows a strong (98.5%) correlation between them ($p < 0.05$):

Table 4. Regression analysis of sentence length ranges—emails and blogs

Regression Statistics	
Multiple R	0.992762
R Square	0.985578
Adjusted R Square	0.983174
Standard Error	1.648615
Observations	8

	df	SS	MS	F	Significance F
Regression	1	1114.4473	1114.4473	410.03478	0.00
Residual	6	16.307602	2.7179337		
Total	7	1130.755			

Likewise, blogs and spoken text share a tight 75.4% correlation ($p < 0.05$) in length:

Table 5. Regression analysis of sentence length ranges—blogs and speech

Regression Statistics	
Multiple R	0.868533
R Square	0.75435
Adjusted R Square	0.713408
Standard Error	5.283954
Observations	8

	df	SS	MS	F	Significance F
Regression	1	514.4277	514.4277	18.42495	0.005135
Residual	6	167.521	27.92017		
Total	7	681.9488			

And the correlation between email and spoken data is significantly high (70.7%, $p < 0.05$):

Table 6. Regression analysis of sentence length ranges—email and speech

Regression Statistics	
Multiple R	0.84133
R Square	0.707836
Adjusted R Square	0.659142
Standard Error	7.42031
Observations	8

	df	SS	MS	F	Significance F
Regression	1	514.4277	800.389	14.5364	0.008836
Residual	6	330.366	55.061		
Total	7	1130.755			

These analyses demonstrate significant similarity in sentence length across oral and conversational writing modes. Conversely, and as expected, there is a low (28.4%) correlation of sentence length between email and written text; we may conclude that sentences in these two modes are not of typically similar lengths:

Table 7. Regression analysis of sentence length ranges—email and texts

Regression Statistics	
Multiple R	0.532924
R Square	0.284008
Adjusted R Square	0.164676
Standard Error	11.616156
Observations	8

	df	SS	MS	F	Significance F
Regression	1	321.144	321.144	2.37998	0.173840504
Residual	6	809.610	134.935		
Total	7	1130.755			

In summary, this shows, at the conventions of sentence length, how much closer emails and blogs are to spoken genres than to written texts.

One structural point about blog stylistics bears consideration: the notion of *sentence* must be somewhat redefined in this genre, which gives equal importance both to the "traditional" declarative sentence and the caption, which is not a sentence but a verbal adjunct to reinforce an associated idea or a graphic. Thus, what appear under normal grammatical conditions to be nonsensical fragments like "Rewards of some hard digging" or "gander mountain credit card" emphasize the dependence of text on other non-textual elements in order to substantiate meaning. This has become standard practice in blog writing. Typically, the fragment-caption will be a sentence missing either the verb, e.g. "Lots of diggers," "Myself with a very good find," "picture of beetle bug" or the subject, e.g. "Screening ore."

The results of sentence length, which show conversational writing to be of similar length as oral utterances, does not carry in the area of pronoun usage, as Figure 78 shows.

The frequency slope shows that text employs more pronouns than blogs or email samples, and approximates only speech in frequency of use. This runs against the generally accepted polarity of orality versus literacy, with conversational writing synthesizing elements of both. The formula for determining pronoun usage is simply the percentage of words in a corpus that are pronouns. No doubt, a larger corpus is necessary to determine this more authoritatively, and we might keep in mind that some text genres are bound to have more pronouns than others. In the present case, the text corpus was comprised entirely of fiction works, but if we used scientific monographs, the resulting pronoun usage would

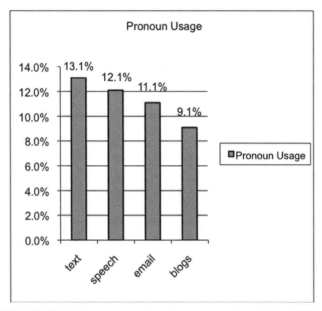

FIGURE 78 *Relative pronoun usage in text, speech, email, and blog sample*

differ greatly. Nonetheless, as a starting point for discussion, these results invite certain speculation. In particular, we might infer that blogs are more "impersonal" than email, and both are less personal than speech, which is as we might expect, since speech is more improvisatory; and email is easier to compose than blogs. In the Enron sample, many emails were of a highly personal nature whose appropriateness in a blog format may not be evident. Further research should statistically probe the comparative degree of personal reference in blogs and emails.

The final measure of potential communicative differences, lexical density, shows the differences divided into three groups—Speech (6%); Blogs (9%) and Emails (10.7%); and Texts (17.2%). It is accepted that text has a higher lexical density than speech, and, in support of my hypothesis, blogs and emails lie between both.

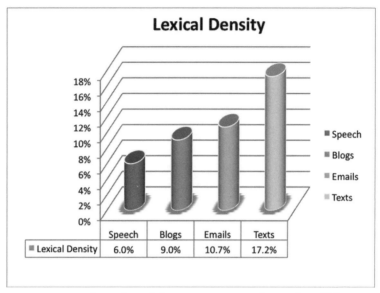

FIGURE 79 *Relative lexical density in text, speech, email, and blog samples*

This analysis of four distinct communicative modes—speech, blogs, emails, and printed text (as fiction works)—exposes sufficiently significant differences in sentence length, pronoun usage, and lexical density between them as to support the assertion that blogs and emails, which I am calling instances of *conversational writing*, conform to stylistic and structural characteristics somewhere between speech and print. This may suggest that usage of different communicative media appears to respond to fundamental differences between them, with the most marked contrast being observed in sentence length and the least, for usage of pronouns. We might say that sentence length is the most *structural* of our three metrics, and pronoun usage the most *stylistic*, with lexical density somewhere between both. In that the observed differences were largest in the structural variables of observation, further research should examine similarly structural variables in corpus samples across these or similar communicative media.

CHAPTER SIXTEEN

Engagement across shifting beliefs: Shamanism, Turing, and ELIZA

I close with a final addition to the tensions explored throughout this book, those between formalism and anti-formalism, between representation and meaning, between object and process, and between contemplation and judgment. All tensions exist not merely because they represent oppositions, but because they do so in a way that allows them to be compared in the first place. And as the basis of all comparison is some kind of language—visual, auditory, or symbolic, language on some level is at the heart of each of these. Not all languages are formalistic, not all are exact, and not all can be understood universally. Art is one of the languages which has been undergoing continual expansion, and now impels us to think and feel differently about the way it is made, the means through which it is presented, and the possibilities by which it should be experienced. It is asking us to engage in new forms of interaction with it, electronic or otherwise. It seems to be embodying a kind of knowledge at the edges of rational perception, and the mystery of its interpretation is, of course, that, while figurative (as with photography) it points not to the world, but to how we perceive. It is therefore a signifier to our own sensibilities, always present, but rarely obvious to us. The widest possible chasm between the formal and anti-formal is in our midst, in the concept of "information as

intelligence" around which contemporary society has gambled its foundations, on the one hand, and a different sense of knowing, or intuition, to include the aesthetic and the nebulous, on the other.[1] For me, this takes on the character of a final tension, between the superformal aspects of computational intelligence, up against the mystical dimension, which my own culture accepts—each has a particularly relevant place in aesthetic understanding. To relate a personal experience with the second, I begin with a background on the first.

Every so often, scholarship returns to the intractable problem of human dialogic interaction with systems designed with capabilities for patterned response. Several ontic questions persist—are such systems truly *intelligent*? And if not, what of the insightful behavior which they stimulate, not to say *awaken*, of the users who interact with them? These systems came about as experiments in artificial intelligence revolving around three primary areas of research interest: strategies for knowledge representation, problems in understanding natural language, and methods for search optimization. All research was empirical; software was created and tested in accordance with comparative benchmarks appropriate to each of these problem spaces. The outcome of each of these lines of effort led to thinking whose echoing influence we might call small or large.

In knowledge representation, for example, the large problem was that of dynamically mapping schemas in a logically stable framework, while the smaller work involved the creation of semantic networks, frames and scripts, and production systems. All three of these methodologies had remarkable impact on research thinking of the 1970s and 1980s. And all are dead today. Likewise, in natural language work, the big problem of parsing engendered the smaller approaches to it involving the investigation of grammars (formal, transformational, systemic, and case grammars); systems to demonstrate real-time machine and natural-language translation (e.g. LUNAR, SHRDLU, MARGIE, LIFER); and state-based parsing solutions like augmented transition networks, and systems like the General Syntactic Processor. In search, too, the big problem was optimization against enormously large symbol spaces, whose smaller problems involved now-defunct research on state-space search, game-tree search, and proving machines like the General Problem Solver, David Gelernter's geometric theorem-prover; STRIPS and many others.

It might be obvious that the "large" in each research area was the lasting question—proof perhaps that many of them remained unsolved—and the "small" was a compartmented decomposition of it into a hypothesis framework which would be the target of a particular kind of software program. It was the inability for this separation to become unified, a chasm in which big problems were never resolved by small programs, that led to the extinction of much of the artificial intelligence era. But the few species that survived did so as pedagogy, as examples of the philosophical, or ethical, conundrums that obtain when non-instrumental questions are so intimately addressed by machine-level cognitive processing. MYCIN, for example, the expert system whose rule base would prompt physicians with a series of incrementally specific questions on a patient's presenting symptomatology and generate both a diagnosis and the rationale for the reasoning, was never widely accepted, unable to conquer another problem space, relating to less transparent questions of professional discomfort and liability at the implication of having a program render a medical verdict and treatment instructions. Even after output latency improved so that the time-delay in producing a diagnosis was reduced to several minutes, MYCIN, like CADUCEUS and INTERNIST-I (and unlike systems like DxPlain that produce analysis rather than diagnosis), was quietly swept under the production rug, never used in a clinical setting, despite systematically outperforming human professionals in diagnostic questionnaires.

Lastingly discussed today, but in a discipline distinct from computer science, in which it was created, or psychology, whose practice it reflected, is another of the survivors of AI lore—ELIZA. This program, which impersonates a Rogerian psychotherapist, performs a real-time dialogue with a user, who plays the presumed role of neurotic.

One of the unique and insufficiently discussed realities of this program is how the user complies—or not—with the implicit instigation to "become" a patient. Two worlds simultaneously claim the user's speech-as-writing: in one, what is typed belongs to a curious "tester" of the system's ability to understand and respond, to function in a conversation; in another, the utterances are forced into another discourse as they become interpreted within the scope of a greater malady which ELIZA persists in exploring. There is communication but not dialogue, which, with Bakhtin, we feel

presupposes the position of both speakers in one and the same, not different, discursive worlds. The first is the intersubjective world of communicative competence that Habermas has problematized, as I have mentioned earlier in this book; the second, institutionalizing and projective of a pathogenic paradigm, is that of Michel Foucault.

In its place in multiple intellectual lineages, ELIZA is more than an empirical probe for implementing and studying automatic conversation. Two additional ramifications persist, one involving the foundations of the literary (as beyond the linguistic), the other the foundations of being (as beyond simulation). In the first, Noah Wardrip-Fruin has brought ELIZA into dialogue with story-construction systems, particularly James Meehan's 1976 work with *Tale-Spin*, whose interactive output is not diagnostically constraining banter but rather questions about the world which constitute the basis for a new real-time work of fiction.[2] The second, in which dialogic intelligence is bound up with being—or rather the idea of identity as locating one's condition in multiple comparative worlds—is one that I experienced firsthand in early life.

The experience in question relates, improbably enough, to a very specific moment in my youth in Cuba. A young girl, around the same seven years of age as myself at the time, took sick in a house party that my family was attending. One of the visitors, a tall Watusi, assumed control, demanding silence and dimmed lights. Shaking a petite bag of rattling pebbles, he gesticulated around the girl in a commanding exertion of energy, whereupon, returning to Occidental reality, he recomposed himself and declared the girl cured. Arising, she briskly ran to the rear of the house where we children were playing; everything resumed as before.

To everyone witnessing this, analysis seemed unnecessary, Cuban culture always accepted the workings of obscure causes on faith. But I was left with a *why* that transcended any possible *how*, as it had been shortly before witnessing this therapeutic intervention that I had been the target of a rather different one. A few months earlier, my parents noticed a persistent lump near my umbilical area, and brought me to Havana's central hospital emergency room, where an aunt who coincidentally was the duty nurse that day was preparing the operating room for another patient. Suspecting symptoms of

something ominous, she summoned doctors to my torso, who ordered me rushed to the operating room for emergency surgery. Several hours later, I regained consciousness to the hovering voices of my aunt, my parents and the surgeon, clarifying the attack of an virulent, Ebola-like staphylococcal infection that had been about to fatally enter my bloodstream. So when at the party, the girl had, like a phoenix, risen perkily, the imprint of Western medicine—my twenty stitches—forced the question of why I couldn't have had *that* mystical intervention, rather than that of Western-style surgery.

Decades later, I recall this event as the example of transformation through opacity; the inexplicability of ritual shrouded in the enactment of a healing act was proof of intervention. In the space of the miraculous there is no room for explanation: the performance, by itself, suffices. The logos of Western medicine, on the other hand, depends on a transparent kind of visibility: description, prediction, explanation. Its enemy *is* murkiness; no intervention is legitimate without explanation of method. Opacity is the wall separating the dialectic of miracle against that of mechanism, the sense of meaning versus the structure of language.

There is another domain in which the same tension plays out, concerning itself with the study of *intelligence*. In the frequent but miraculous performances of learning and deduction that entail human understanding, the shaman is the *Every-person* whose adaptation to cognitive challenges is both normal and extraordinary—and as opaque as the shaman's rite. Learning, of course, is always the greatest mystery. It is with some irony then, that, as with medical interventions, there exist in the context of intelligent behavior performance conditions that are recurring and highly formulaic. And these recurrences have produced opportunities for mimicking intelligent behavior in computers through a tradition of experiments in which the challenge is to design the proper recipe capable of straddling the distance between the opaque miracles of understanding and the transparent mechanisms of language. Historically, two cases stand out. One of these, proposed as a *Gedanken*, was theoretical computer science's greatest unrealized challenge, and the other, as its inverse, emerged as an actual computer program performing a quasi-farcical play on the opacity of intelligence and our desire for connecting with an Other

through the miracle of understanding, even when that Other is a mechanism.

The first example, a theoretical challenge to understanding, was posed by Alan Turing in 1950, near the end of a brief but astonishing life whose professional vector contributed vital chapters to the histories of computer science, artificial intelligence, and mathematics. The miracle under Turing's scrutiny was framed by the question, "Can a machine communicate like a human being?", whose underlying problem is whether such processing can ever be *indistinguishable* from human processing, perhaps locked in powerful opacities similar to those concealed by the "black box" of the brain. To that end, Turing imagined an imitation game consisting of three rooms: room A houses a computer capable of communicating using natural human language, room B accommodates a human being, as does room C, whose inhabitant serves as prompter and judge in the game. The computer and human respondents in rooms A and B would engage in ostensibly convincing dialogue with the judge, who cannot see which of the two locutors is the human one, but who, able to converse openly with each, must attempt to spot the computer. If, pondering the conversation, the judge cannot distinguish which of the two participants is the machine, the machinery will have passed the Turing Test. This test is not intended to establish objective definitions of intelligence, but to mark the point of sufficiently flexible processing at which the expressive difference between machine and human cannot be made with certainty. We might note that there is no need to identify *how* the machine constructs responses. The point is rather whether it can generate communication sufficiently intelligent so as to deceive human understanding, be it akin to the form of shaman, inspired by the forces of an unseen causality, or of physician, guided by the transparencies of scientific method.

Until recently, all computer learning followed the latter, procedural model. A set of instructions, explicitly ordered into a software program, was run by a system whose behavior conforms entirely to the logic of the source code, the computer's recipe. And while by now, computer science has developed modes of machine learning through neural networks, whose complex webs of triggering associations agglomerate learning in a manner that is self-organizing and opaque to analytic breakdown, there is one program from the dawn

of artificial intelligence's golden age, designed roughly 15 years after Turing's challenge, that explored the minimal feasibility conditions for the Turing Test. Evocatively named ELIZA,[3] the program's ploy was the presumed encapsulation of specific human characteristics, much as Pygmalion's statue, whose femininity seemed so flawless that he fell in love with it. If Ovid's poem, recounting that "Art hid with art, so well perform'd the cheat/It caught the carver with his own deceit," might have produced the earliest reference to an aesthetic Turing Test that history knows, ELIZA was the most trivial yet transparent case of impersonation in dialogue.

Presenting a teletype interface in which a user answers prompts generated by the system, ELIZA was configured as a Socratic therapist using the Rogerian technique of posing open-ended questions to probe for moments of Cathexis and then selectively steering the patient's attention. Even if it could arguably approximate a psychotherapeutic Turing Test, how could such a system be programmed in software? ELIZA's method, exploiting the fact that intelligence is *assumed* to resemble understanding, focused on creating the illusion of understanding by drawing from a minimal recipe of syntactic patterns that transformed user input to construct a convincing response. When ELIZA's rules match words and word groups from the user-patient's statements, a transformation of the matched input produces a response. One such transformation involved first person to second person conversions, so the user typing, "It's obvious that you must be bored of me by now" would surprisingly encounter, "What makes you think I am bored of you?". This riposte was produced by the decomposition template (0 YOU 0 ME) where the first 0 matches anything until the word "YOU," and the next 0 again captures everything until the word "ME." Applying the four components of the template matches the input as follows:

FIGURE 80 *Rule 1.*

This rule is in turn matched to another: (WHAT MAKES YOU THINK I 3 YOU), in which 3 represents the words matching the

third element of the prior rule ("must be bored of"), permitting ELIZA to transform the user's input into the seemingly conscious reply

Pattern: (WHAT MAKES YOU THINK I 3 YOU)

RESPONSE: WHAT MAKES YOU THINK I MUST BE BORED OF YOU

FIGURE 81 *Rule 2.*

In another kind of transformation rule ELIZA exchanged specific words for categories within which they can be classified. Thus, if a user mentions the word "sister," ELIZA, retrieving the *family* category, would then ask, "Tell me more about your family." Similarly, words like *depression* promote up to *feeling*, so that if the user complains, "I am often depressed," ELIZA counters with, "Tell me more about your feelings." The illusion within what Weizenbaum called the "overwhelmingly psychological orientation" of the pseudo-therapeutic context to which it was meant to be compared, was absorbing.

However, none of ELIZA's transformations actually preserved knowledge; the program only manipulated linguistic markers via single-sentence interaction. One of the therapist's strengths is managing some memory of a patient's statements. ELIZA, however, discards every input after its transformation into response. It thus has no notion of therapy through the logic of discourse, the perception of consistency, or contradiction, across a span of utterances.[4] Even so, with prescient anticipation of the fervor that the program would provoke in the coming decades, Joseph Weizenbaum, its author/creator, was careful from the outset to present the anatomy of ELIZA exclusively as a collection of processing statements amalgamated into a recipe for a specific encounter in discourse, by whose destruction of opacity in the explanation of its method, he was desirous to "rob ELIZA of the aura of magic to which its application to psychological subject matter has to some extent contributed."[5] For ELIZA, as for the physician and the shaman, exchange of signs frames an encounter that turns on transformation rules, but in converting opacity into transparency, the visible evidence of these rules eradicates their power so that "once a particular program is unmasked, once its

inner workings are explained in language sufficiently plain to induce understanding, its magic crumbles away; it stands revealed as a mere collection of procedures, each quite comprehensible."[6]

Lest, then, we interpret the notion of "transformation" too "opti-mystically," it is worth noting that continual allusion to divergences between the transformation of conceptual structures, like machine-based conversation, against the opposite of transformation, the *stasis* of institutional structures which utilize those machines was not lost on Weizenbaum, who much later suspected that

> if it had not been for the computer, if the computer had not been invented, what would the banks have had to do? They might have had to decentralize, or they might have had to regionalize in some way. In other words, it might have been necessary to introduce a social invention, as opposed to the technical invention.
>
> What the coming of the computer did, "just in time," was to make it unnecessary to create social inventions, to change the system in any way. So in that sense, the computer has acted as fundamentally a conservative force, a force which kept power or even solidified power where is already existed.[7]

Given the constraints against hopes for meaningful understanding that ELIZA demonstrated, we could read this as a proclamation of how the virtual symbolic provides a field for encounters involving recipe-like transformations not of knowledge, but rather of doubt itself. But that, in all its meditative engagement, is where new art begins.

APPENDIX

Selected and Annotated Fragments of ELIZA Script Source Code

Comments on source code functionality appear in italic prior to the source code.

"Sorry" mentioned in the patient's input:

(SORRY ((0) (PLEASE DON'T APOLOGIZE)

(APOLOGIES ARE NOT NECESSARY) (WHAT FEELINGS DO YOU HAVE WHEN YOU APOLOGIZE) (I'VE TOLD YOU THAT APOLOGIES ARE NOT REQUIRED)))

Transformation rule REMEMBER 5 collects into item 4 everything after the patient's mention of the word "remember":

(REMEMBER 5

((0 YOU REMEMBER 0) (DO YOU OFTEN THINK OF 4)

(DOES THINKING OF 4 BRING ANYTHING ELSE TO MIND

(WHAT ELSE DO YOU REMEMBER)

(WHY DO YOU REMEMBER 4 JUST NOW)

(WHAT IN THE PRESENT SITUATION REMINDS YOU OF 4)

(WHAT IS THE CONNECTION BETWEEN ME AND 4))

Any mention of "dream" is responded to with a general prompt for the patient's own interpretation:

(DREAM 3 ((0) (WHAT DOES THAT DREAM SUGGEST TO YOU)

(DO YOU DREAM OFTEN) (WHAT PERSONS APPEAR IN YOUR DREAMS)

(DON'T YOU BELIEVE THAT DREAM HAS SOMETHING TO DO WITH

YOUR PROBLEM)

...

))

nothing matched, prompt for more:

(NONE ((0) (I AM NOT SURE I UNDERSTAND YOU FULLY)

(PLEASE GO ON)

(WHAT DOES THAT SUGGEST TO YOU)

(DO YOU FEEL STRONGLY ABOUT DISCUSSING SUCH THINGS)))

Seize on tentative statements:

(PERHAPS ((0) (YOU DON'T SEEM QUITE CERTAIN)

(WHY THE UNCERTAIN TONE)

(CAN'T YOU BE MORE POSITIVE)

(YOU AREN'T SURE) (DON'T YOU KNOW)))

(MAYBE (-PERHAPS))

Mention of computers is another loaded term:

(COMPUTER 50 ((0) (DO COMPUTERS WORRY YOU)

(WHY DO YOU MENTION COMPUTERS) (WHAT DO YOU THINK MACHINES

HAVE TO DO WITH YOUR PROBLEM) (DON'T YOU THINK COMPUTERS CAN

HELP PEOPLE) (WHAT ABOUT MACHINES WORRIES YOU) (WHAT

DO YOU THINK ABOUT MACHINES)))

Echo patient's statement by inverting first-person into second-person:

(AM—ARE ((0 ARE YOU 0) (DO YOU BELIEVE YOU ARE 4)

(WHAT WOULD IT MEAN IF YOU WERE 4) (=WHAT))

((0) (WHY DO YOU SAY 'AM') (I DON'T UNDERSTAND THAT)))

(ARE ((0 ARE I 0)

(WHY ARE YOU INTERESTED IN WHETHER I AM 4 OR NOT)

(WOULD YOU PREFER IF I WEREN'T 4) (PERHAPS I AM 4 IN YOUR

FANTASIES) (DO YOU SOMETIMES THINK I AM A) J-WHAT))

((0 ARE 0) (DID YOU THINK THEY MIGHT NOT BE 3)

(WOULD YOU LIKE IT IF THEY WERE NOT 3) (WHAT IF THEY WERE NOT 3)

(POSSIBLY THEY ARE 3)))

NOTES

Chapter 1

1 Richard Serra, quoted in Vilis R. Inde, *Art in the Courtroom* (Westport, Conn.: Praeger, 1998), 59.
2 See Margit Rosen, "A Record of Decisions: Envisioning Computer Art," in *Charles Csuri: Beyond Boundaries, 1963—Present*, ed. Janice M. Glowski (Columbus, OH: College of the Arts, Ohio State University and ACM SIGGRAPH, 2006), 43.

Chapter 2

1 Maurice Merleau-Ponty, *Phenomenology of Perception*, trans. Colin Smith, 1995 edn. (Routledge and Kegan Paul, 1945/1962), 309.
2 This work has been extensively explored in several texts on electronic art. I provide a treatment of its uniqueness through several different moments in Francisco J. Ricardo, "Reading the Discursive Spaces of 'Text Rain', Transmodally," in *Literary Art in Digital Performance: Case Studies and Critical Positions*, ed. Francisco J. Ricardo (New York: Continuum, 2009).
3 Much of the latter half of Lev Manovich's *The Language of New Media* argues that the cinematic metaphor is ideal for understanding new media. The presence of other dimensions of new media art, like the performative, as well as locative/architectural/spatial kinds of art that we will examine later in this book, allows for cinematic metaphors, but seems to argue for an expanded way to understand many unique encounters with new-media art.
4 Henri Bergson, *Matter and Memory*, trans. Nancy Margaret Paul and W. Scott Palmer (London: George Allen and Unwin, 1911), 169.
5 Ibid., 196.

6 Ibid., 210.
7 Piaget sees learning as a function of these two operations: "The filtering or modification of the input is called assimilation; the modification of internal schemes to fit reality is called accommodation." Jean Piaget, *The Psychology of the Child* (New York: Basic Books, Inc., 2000/1969), 6.
8 Bergson, *Matter and Memory*, 87.
9 Consider Caro's *Lock* (1962), where two parallel rectangular frames of painted steel embrace together through a perpendicular beam rising above them as if shepherded together by a parental agency. The act of parallel positioning sustains the sense of stability between any two or more objects at rest so situated. However, in *Lock*, there is another axis at which the two frames diverge. One of these two parallel panels lays flat, while at one end, its adjacent neighbor rises at an incline, kineticizing the dialectic of implied rest versus implied motion. The implication of motion is inescapable. That both panels are laterally anchored by an authoritative *I* beam intersecting them once again reinforces the impression of support on rails, a sense that is even more palpable in later works like *Prairie* (1967) and *Ordnance* (1972).
10 Emphasis on this choice is the fact that much of Neumann's earlier work, such as his *Wind Tunnel Series*, was swathed in a wholly industrialistic metallism about which there was no such question of contrast or incommensurability of material.
11 Rosalind Krauss, "Video: The Aesthetics of Narcissism," *October*, no. 1, Spring (1976): 52.
12 Ibid.: 53.

Chapter 5

1 Rosalind Krauss, "Grids," *October*, no. 9 (1979).
2 Ibid.
3 The connection between this tradition and electronic literature was one of the strands explored in my most recent book, Francisco J. Ricardo, ed., *Literary Art in Digital Performance: Case Studies in New Media Art and Criticism* (New York: Continuum, 2009).
4 Personal communication, 21 August, 2012.
5 Ibid.
6 In some cases, manual intervention included small changes, such as

ink type. Henry had first applied color fills over the machine-created works with regular pens, but after 1962, he adopted indian inks in technical tube pens, realizing that pens could fade when exposed to sunlight. This change is reflected in the captions for works, which indicate "biro" or "indian ink" in hand-embellishment descriptors.

7 Henry's daughter, Elaine O'Hanrahan, witnessed his drawing operations: "I well recall him adjusting the machine several times during the image creation process. It was indeed a source of constant fascination for both myself and my father as we watched the images emerge on paper, especially since the machines were not precision controlled instruments but relied in part on a 'mechanics of chance'. This meant my father had only general, overall control and the final image was something of a surprise. These machines were not pre-programmed." Personal communication, 29 July 2012.

Chapter 6

1 Francisco J. Ricardo, "Until Something Else: A Theoretical Introduction," in *Cyberculture and New Media*, ed. Francisco J. Ricardo (Amsterdam and New York, NY: Rodopi, 2009).

2 Stanley Cavell, *The World Viewed* (Cambridge, MA: Harvard University Press, 1971), 38.

3 Henry Jenkins, *Games, the New Lively Art* (2000 [cited]); available from http://web.mit.edu/cms/People/henry3/GamesNewLively.html

4 As writes one designer against a popular myth: "Designers are creative souls with the freedom to make worlds: Er ... Nope." (http://www.gamasutra.com/blogs/AnthonyHartJones/20091127/3664/Game_Designer_As_A_Dream_Job.php).

5 Gilbert Seldes, *The Seven Lively Arts* (New York: Sagmore Press, 1957 [1924]), 3.

6 Ibid., 7.

7 Steven Poole, *Trigger Happy: Videogames and the Entertainment Revolution* (http://stevenpoole.net, 2000), 388–9.

8 See http://pentametron.com

Chapter 7

1. The virtual galleries *Virtual Gallerie, Image Armada, Scenecaster/3D Scene* as described in (http://www.technologyinthearts.org/wp-content/uploads/2009/10/VirtualGallerySoftwareReview2009.pdf) turn on the premise that screen space can be converted into gallery real estate without loss of the aesthetic experience that comes from a physical visit. The premise is heightened by the presence of wall space on the computer screen; whether it makes a positive, functional contribution to the browsing experience is another matter. A simpler, more web-like system, http://www.seditionart.com/, de-emphasizes the gallery look and focuses on well-known artists.

Chapter 8

1. In the roughly ten-year trajectory that includes *The Concept of Criticism in German Romanticism, Goethe's 'Elective Affinities', The Origin of German Tragic Drama, Little History of Photography*, and most importantly *Surrealism: The Last Snapshot of the European Intelligentsia*, we can read the decade preceding *The Work of Art in the Age of Mechanical Reproduction* as a foundation period for Benjamin's aesthetic philosophy, honing a criticism firmly committed to the idea of some unitary truth in the work of art.
2. Alan Sondheim, ed., *Individuals: Post-Movement Art in America* (New York: E. P. Dutton, 1977).
3. Dick Higgins, "Statement on Intermedia," in *Dé-Coll/Age(Décollage)*6*, ed. Wolf Vostell (Frankfurt and New York: Typos Verlag/Something Else Press, 1967).
4. Christian Nold, East Paris Emotion Map (Paris: http://www.paris.emotionmap.net/info.htm, 2008).
5. For updates on the work's auction price, see http://atooltodeceiveandslaughter.com/
6. Personal communication, 1 August 2012.

Chapter 9

1. The examples here conform to the notion of *public sphere* that Habermas first outlined, since the social sphere is a function of the

public sphere. See Jürgen Habermas, *The Structural Transformation of the Public Sphere: An Inquiry into a Category of Bourgeois Society* (Cambridge: Polity, 1962 (trans. 1989)).

2 Mikhail Bakhtin, "Form of Time and Chronotope in the Novel," in *The Dialogic Imagination: Four Essays*, ed. Michael Holquist (Austin: University of Texas Press, 1981).

3 Habermas, *The Structural Transformation of the Public Sphere: An Inquiry into a Category of Bourgeois Society*.

4 See Peter Hohendahl and Patricia Russian, "Jürgen Habermas: 'the Public Sphere' (1964)," *New German Critique* 3, Autumn, 1974.

5 Richard Serra, "Selected Statements Arguing in Support of Tilted Arc," in *Richard Serra's "Tilted Arc"*, ed. Clara Weyergraf-Serra and Martha Buskirk (Eindhoven: Eindhoven, 1988).

6 Follow the argument in Richard Serra., "Art and Censorship," *Critical Inquiry* 17, no. 3 (Spring, 1991).

7 Hilton Kramer, "Is Art above the Laws of Decency?," *New York Times*, 2 July 1989.

8 The work is diligently described and documented at http://34n118w.net

9 Hight's critical essays can be found at www.jeremyhight.info

Chapter 10

1 The comprehensive extent of this program is evident all throughout Barthes's second phase: Roland Barthes, *Elements of Semiology*, [1st American edn (New York: Hill and Wang, 1968), Roland Barthes, *Système De La Mode* (Paris: Éditions du Seuil, 1967). Roland Barthes, *The Fashion System*, 1st edn. (New York: Hill and Wang, 1983), Roland Barthes, *L'empire Des Signes* (Genève: Skira, 1980), Roland Barthes, *S/Z*, trans. Richard Miller (New York: Farrar, Straus and Giroux, Inc., 1974 [1970]).

2 Kostas Terzidis, *Algorithmic Architecture* (Amsterdam: Elsevier, Ltd., 2006), 88.

3 Diane Ghirardo, "The Architecture of Deceit," *The Yale Architectural Journal* 21 (1984): 110–15.

4 Personal communication, 2 August 2012.

Chapter 11

1 Rudolf Von Laban and Lisa Ullmann, *Mastery of Movement* (Hightstown, NJ: Princeton Book Company, Publishers, 1988 [1950]).

2 For a theoretical exposition of this concept, see Daniel Yacavone, "Towards a Theory of Film Worlds," *Film-Philosophy* 12, no. 2 (2008).

3 In this and other experiments, Greenaway participates in the aesthetics of structural film, uninterested in narrative, and entirely focused on the condition of moving from an image to a state of perception. See Paula Willoquet-Maricondi, *Peter Greenaway's Postmodern/Poststructuralist Cinema* (Lanham, MD: The Scarecrow Press, Inc., 2008).

4 As a bridge to the ontology of a new technological aesthetics, Nikolais was one of the first choreographers to refer to his performers as "figures" rather than dancers, "a term belonging to the realm of sculpture and the iconography of cultural objects," leading directly to the essence of his particular style: "the possibilities that technology could bring to the theater." Marcia B. Siegel, "Artisans of Space," in *The Returns of Alwin Nikolais: Bodies, Boundaries and the Dance Canon*, ed. Claudia Gitelman and Randy Martin (Hanover, CT: Wesleyan University Press, 2007), 62.

5 *Nik and Murray: The Dances of Alwin Nikolais and Murray Louis.* 1985. Available from Michael Blackwood Productions, Inc. 6 West 18th Street, Suite 2B New York, NY 10011.

6 One critic says of Nikolais, "The films of his work recall my problems with what little I saw of it onstage: the visual sensationalism develops no depth or complexity as poetic imagery or as drama." Alastair Macaulay, "A Kinetic Innovator, Plumbing the Surreal," *New York Times*, 28 January 2010.

7 Of course, the principal critique was the essay "Art and Objecthood," whose argument expands on its title's conjunction ("and") in considering these two poles. Michael Fried, "Art and Objecthood," in *Minimal Art: A Critical Anthology*, ed. Gregory Battcock (New York: E. P. Dutton & Co., Inc., 1968).

Chapter 12

1 This, with a plurality of layered media, for example, is evident in the work of Lyn Winter.
2 Andy Grundberg, "Robert Heinecken, Artist Who Juxtaposed Photographs, Is Dead at 74," *The New York Times*, 22 May 2006.
3 Krauss, "Video: The Aesthetics of Narcissism."
4 Nancy Princenthal, "The Arrogance of Pleasure—Body Art, Carolee Schneemann, New Museum of Contemporary Art, New York, New York," *Art in America* 1997.
5 The artist is Laura Alesci.
6 Jürgen Habermas, "Modernity Versus Postmodernity," in *The Anti-Aesthetic: Essays on Postmodern Culture*, ed. Hal Foster (New York: The New Press, 2002), 275.
7 Amaranth Borsuk and Brad Bouse, *Between Page and Screen* (Los Angeles: Siglio Press, 2012). See also http://www.amaranthborsuk.com/projects
8 J. Hillis Miller, "Stevens' Rock and Criticism as Cure," *Georgia Review*, no. 30 (1976): 34.

Chapter 15

1 One could mention the case of outlining software as the clear exception. This class of software offers, after all, the swift and ready capacity for promoting, demoting and reordering items, from lines to entire paragraphs. It would seem the perfect topic processor were it not for the fact that what is moved is being arranged merely graphically, not semantically; the software applies no rules for identifying, relating, or maintaining coherence among the topics in the user's text. All manipulation is purely visual, none of it topical. It would "work" just as well with pages of gibberish text.
2 Edward Tufte, *The Cognitive Style of Powerpoint* (Cheshire, Connecticut: Graphics Press, 2003).
3 David Byrne, *E.E.E.I (Envisioning Emotional Epistemological Information)* (Göttingen, Germany: Steidl Publishing, 2003).
4 Lori Janzen-Wilde, "Oral and Literate Characteristics of Facilitated Communication," *Facilitated Communication Digest* 1993, no. 2.

5 S. P. Ferris, "Writing Electronically: The Effects of Computers on Traditional Writing," *Journal of Electronic Publishing* 8 (2002).
6 D. E. Murray, "Literacy at Work: Medium of Communication as Choice" (paper presented at the American Association of Applied Linguistics, Seattle, WA, 1985).
7 Faced with the computing phenomenon as a social and pedagogical challenge, it was in the late 1980s that education took a deep interest in the problem of comparative communication in electronic and conventional forms. The research was both humanistic in scope, and applied empirical methods from social sciences. Rarely has a moment in research been so open and so comprehensive in analysis of data across expressive modalities. Since then, the state of communication research has narrowed significantly. Here, I return to those initial forays for this broad inquiry on expressive engagement.
8 W. L. Chafe, "Linguistic Differences Produced by Differences between Speaking and Writing," in *Literacy, Language and Learning: The Nature and Consequences of Reading and Writing*, ed. N. Torrance, D. R. Olson and A. Hildyard (Cambridge: Cambridge University Press, 1985), A. Hildyard and S. Hidi, "Oral-Written Differences in the Production and Recall of Narratives," in *Literacy, Language and Learning: The Nature and Consequence of Reading and Writing*, D. R. Olson, N. Torrance and A. Hildyard (eds) (Cambridge: Cambridge University Press, 1985), G. Redeker, "On Difference between Spoken and Written Language," *Discourse Processes* 7 (1984), D. L. Rubin, "Divergence and Convergence between Oral and Written Communication," *Topics in Language Disorders* 7 (1987), G. Wallach, "Magic Buries Celtics: Looking for Broader Interpretations of Language Learning and Literacy," *Topics in Language Disorders* 10 (1990), C. E. Westby, "Learning to Talk – Talking to Learn: Oral-Literate Language Differences," in *Communication Skills and Classroom Success: Therapy Methodologies for Language Learning Disabled Students*, ed. C. S. Simon (San Diego: College-Hill Press, 1985).
9 As above, and also Deborah Tannen, "Relative Focus on Involvement in Oral and Written Discourse," in *Literacy, Language and Learning: The Nature and Consequence of Reading and Writing*, N. Torrance, D. R. Olson, and A. Hildyard (eds) (Cambridge: Cambridge University Press, 1985).
10 Westby, "Learning to Talk – Talking to Learn: Oral-Literate Language Differences."
11 See Appendix B.

12 See Appendix A.
13 A sample of that corpus is used in my analysis. B. Klimt and Y. Yang, "Introducing the Enron Corpus" (paper presented at the CEAS 2005, The Second Conference on Email and Anti-Spam, Stanford University, Stanford, CA, 21–22 July 2005).
14 H. Bekkerman, *Document Classification on Enron Email Dataset* (2005 [cited 20 May 2005]); available from http://www.cs.umass.edu/~ronb/enron_dataset.html
15 This study avoids mining data of proprietary social media systems like Facebook.
16 S. C. Herring, L. A. Scheidt, S. Bonus and E. Wright, "Bridging the Gap: A Genre Analysis of Weblogs" (paper presented at the 37th Annual Hawaii International Conference on System Sciences (HICSS'04), 2004).

Chapter 16

1 The project of new-media artists like Alan Sondheim engages with how the conditions of art have transcended conventional understanding. This consciousness emerges from a profound epistemological commitment, highly developed aesthetic understanding, and firm grasp of the paradigms of information science. Sondheim has championed this awareness for four decades; see, for example, Sondheim, ed., *Individuals: Post-Movement Art in America*.
2 This line of reasoning is explored in Noah Wardrip-Fruin, *Expressive Processing: Digital Fictions, Computer Games, and Software Studies* (Cambridge: MIT Press, 2009). My earlier thoughts on this were published in Marisa Jahn, Candice Hopkins and Berin Golonu (eds), *Recipes for an Encounter* (New York: Western Front, and Pond: Art, Activism, and Ideas, 2009).
3 As all computer scientists know, the program was named after Eliza Doolittle, the deprived girl with Cockney accent and working-class mannerisms in George Bernard Shaw's 1913 *Pygmalion*. The play is itself an adaptation of the myth of Pygmalion and the Statue from Ovid's narrative poem, *Metamorphoses*.
4 This was left as a goal for a possible "augmented ELIZA program" that itself was never built.
5 Joseph Weizenbaum, "Eliza: A Computer Program for the Study of

Natural Language Communication between Man and Machine," *Communications of the ACM* 9, no. 1 (1996): 45.

6 Ibid.: 36.

7 Diana ben-Aaron, "Weizenbaum Examines Computers and Society," *The Tech*, 9 April 1985.

A version of Chapter 15 appeared in *Cyberculture and New Media*, edited by Francisco J. Ricardo, Amsterdam: Rodopi, 2009, and a version of Chapter 16 appeared in *Recipes for an Encounter*, edited by M. Jahn, C. Hopkins, and B. Golonu, Vancouver: Western Front, 2009.

BIBLIOGRAPHY

Bakhtin, Mikhail. "Form of Time and Chronotope in the Novel." In *The Dialogic Imagination: Four Essays*, Michael Holquist (ed.), 84–258. Austin: University of Texas Press, 1981.
Barthes, Roland. *Elements of Semiology*. [1st American edn. New York: Hill and Wang, 1968.
—*The Fashion System*. 1st edn. New York: Hill and Wang, 1983.
—*L'empire Des Signes*. Genève: Skira, 1980.
—*S/Z*. Translated by Richard Miller. New York: Farrar, Straus and Giroux, Inc., 1974 [1970].
—*Système De La Mode*. Paris: Éditions du Seuil, 1967.
Bekkerman, H. *Document Classification on Enron Email Dataset*, 2005 [cited 20 May 2005]. Available from http://www.cs.umass.edu/~ronb/enron_dataset.html
ben-Aaron, Diana. "Weizenbaum Examines Computers and Society." *The Tech*, 9 April 1985, 2.
Benjamin, Walter. "The Work of Art in the Age of Mechanical Reproduction." In *Illuminations: Essays and Reflections*, Hannah Arendt (ed.). New York: Schocken, 1969, 220, 221, 238, 239.
Bergson, Henri. *Matter and Memory*. Translated by Nancy Margaret Paul and W. Scott Palmer. London: George Allen and Unwin, 1911.
Borsuk, Amaranth, and Brad Bouse. *Between Page and Screen*. Los Angeles: Siglio Press, 2012.
Byrne, David. *E.E.E.I. (Envisioning Emotional Epistemological Information)*. Göttingen, Germany: Steidl Publishing, 2003.
Cavell, Stanley. *The World Viewed*. Cambridge, MA: Harvard University Press, 1971.
Chafe, W. L. "Linguistic Differences Produced by Differences between Speaking and Writing." In *Literacy, Language and Learning: The Nature and Consequences of Reading and Writing*, N. Torrance, D. R. Olson, and A. Hildyard (eds). Cambridge: Cambridge University Press, 1985.
Julie Edwards, in *movement + media + music + text*. URL: http://coreproject.wordpress.com/author/coreproject/page/6/. Accessed 7 March 2013.

Ferris, S. P. "Writing Electronically: The Effects of Computers on Traditional Writing." *Journal of Electronic Publishing* 8 (2002).
Fried, Michael. "Art and Objecthood." In *Minimal Art: A Critical Anthology*, Gregory Battcock (ed.). New York: E. P. Dutton & Co., Inc., 1968.
Ghirardo, Diane. "The Architecture of Deceit." *The Yale Architectural Journal* 21 (1984): 110–15.
Grundberg, Andy. "Robert Heinecken, Artist Who Juxtaposed Photographs, Is Dead at 74." *The New York Times*, 22 May 2006.
Habermas, Jürgen. "Modernity Versus Postmodernity." In *The Anti-Aesthetic: Essays on Postmodern Culture*, Hal Foster (ed.). New York: The New Press, 2002.
—*The Structural Transformation of the Public Sphere: An Inquiry into a Category of Bourgeois Society*. Cambridge: Polity, 1962 (trans. 1989).
Herring, S. C., L. A. Scheidt, S. Bonus and E. Wright, "Bridging the Gap: A Genre Analysis of Weblogs." Paper presented at the 37th Annual Hawaii International Conference on System Sciences (HICSS'04) 2004.
Higgins, Dick. "Statement on Intermedia." In *Dé-Coll/Age (Décollage)* * 6, Wolf Vostell (ed.). Frankfurt/New York: Typos Verlag/Something Else Press, 1967.
Hildyard, A., and S. Hidi. "Oral-Written Differences in the Production and Recall of Narratives." In *Literacy, Language and Learning: The Nature and Consequence of Reading and Writing*, D. R. Olson, N. Torrance, and A. Hildyard (eds), 285–306. Cambridge: Cambridge University Press, 1985.
Hohendahl, Peter, and Patricia Russian. "Jürgen Habermas: 'the Public Sphere' (1964)." *New German Critique* 3, Autumn, 1974: 45–8.
Jahn, Marisa, Candice Hopkins, and Berin Golonu, (eds) *Recipes for an Encounter*. New York: Western Front, and Pond: Art, Activism, and Ideas, 2009.
Janzen-Wilde, Lori. "Oral and Literate Characteristics of Facilitated Communication." *Facilitated Communication Digest* 1993, no. 2.
Jenkins, Henry. *Games, the New Lively Art*, 2000. Available from http://web.mit.edu/cms/People/henry3/GamesNewLively.html
Kramer, Hilton. "Is Art above the Laws of Decency?" *New York Times*, 2 July 1989.
Krauss, Rosalind. "Grids." *October*, no. 9 (1979).
—"Video: The Aesthetics of Narcissism." *October*, no. 1, Spring (1976).
Laban, Rudolf Von, and Lisa Ullmann. *Mastery of Movement*. Hightstown, NJ: Princeton Book Company, Publishers, 1988 [1950].
Macaulay, Alastair. "A Kinetic Innovator, Plumbing the Surreal." *New York Times*, 28 January 2010.

Merleau-Ponty, Maurice. *Phenomenology of Perception*. Translated by Colin Smith. 1995 edn: Routledge and Kegan Paul, 1945/1962.
Miller, J. Hillis. "Stevens' Rock and Criticism as Cure." *Georgia Review*, no. 30 (1976).
Murray, D. E. "Literacy at Work: Medium of Communication as Choice." Paper presented at the American Association of Applied Linguistics, Seattle, WA 1985.
Piaget, Jean. *The Psychology of the Child*. New York: Basic Books, Inc., 2000/1969.
Poole, Steven. *Trigger Happy:Videogames and the Entertainment Revolution*: http://stevenpoole.net, 2000.
Princenthal, Nancy. "The Arrogance of Pleasure – Body Art, Carolee Schneemann, New Museum of Contemporary Art, New York, New York." *Art in America* 1997.
Redeker, G. "On Difference between Spoken and Written Language." *Discourse Processes* 7 (1984): 43–55.
Ricardo, Francisco J. "Reading the Discursive Spaces of 'Text Rain', Transmodally." In *Literary Art in Digital Performance: Case Studies and Critical Positions*, Francisco J. Ricardo (ed.). New York: Continuum, 2009a.
—"Until Something Else: A Theoretical Introduction." In *Cyberculture and New Media*, Francisco J. Ricardo (ed.), 1–22. Amsterdam and New York, NY: Rodopi, 2009b.
—ed. *Literary Art in Digital Performance: Case Studies in New Media Art and Criticism*. New York: Continuum, 2009c.
Rosen, Margit. "A Record of Decisions: Envisioning Computer Art." In *Charles Csuri: Beyond Boundaries, 1963–Present*, Janice M. Glowski (ed.). Columbus, OH: College of the Arts, Ohio State University and ACM SIGGRAPH, 2006.
Rubin, D. L. "Divergence and Convergence between Oral and Written Communication." *Topics in Language Disorders* 7 (1987): 1–18.
Seldes, Gilbert. *The Seven Lively Arts*. New York: Sagmore Press, 1957 [1924].
Serra, Richard. "Selected Statements Arguing in Support of Tilted Arc." In *Richard Serra's "Tilted Arc"*, Clara Weyergraf-Serra and Martha Buskirk (eds). Eindhoven: Eindhoven, 1988.
—"Art and Censorship." *Critical Inquiry* 17, no. 3 (Spring, 1991).
Siegel, Marcia B. "Artisans of Space." In *The Returns of Alwin Nikolais: Bodies, Boundaries and the Dance Canon*, Claudia Gitelman and Randy Martin (eds), 53–63. Hanover, CT: Wesleyan University Press, 2007.
Sondheim, Alan, ed. *Individuals: Post-Movement Art in America*. New York: E. P. Dutton, 1977.

Tannen, Deborah. "Relative Focus on Involvement in Oral and Written Discourse." In *Literacy, Language and Learning: The Nature and Consequence of Reading and Writing*, N. Torrance, D. R. Olson and A. Hildyard (eds). Cambridge: Cambridge University Press, 1985.

Terzidis, Kostas. *Algorithmic Architecture*. Amsterdam: Elsevier, Ltd., 2006.

Tufte, Edward. *The Cognitive Style of Powerpoint*. Cheshire, Connecticut: Graphics Press, 2003.

Wallach, G. "Magic Buries Celtics: Looking for Broader Interpretations of Language Learning and Literacy." *Topics in Language Disorders* 10 (1990): 63–80.

Wardrip-Fruin, Noah. *Expressive Processing: Digital Fictions, Computer Games, and Software Studies*. Cambridge: MIT Press, 2009.

Weizenbaum, Joseph. "Eliza: A Computer Program for the Study of Natural Language Communication between Man and Machine." *Communications of the ACM* 9, no. 1 (1996): 36–45.

Westby, C. E. "Learning to Talk – Talking to Learn: Oral-Literate Language Differences." In *Communication Skills and Classroom Success: Therapy Methodologies for Language-Learning Disabled Students*, C. S. Simon (ed.). San Diego: College-Hill Press, 1985.

Willoquet-Maricondi, Paula. *Peter Greenaway's Postmodern/ Poststructuralist Cinema*. Lanham, MD: The Scarecrow Press, Inc, 2008.

Yacavone, Daniel. "Towards a Theory of Film Worlds." *Film-Philosophy* 12, no. 2 (2008): 83–108.

Yang, Y., and B. Klimt. "Introducing the Enron Corpus." Paper presented at the CEAS 2005, The Second Conference on Email and Anti-Spam, Stanford University, Stanford, CA, 21–22 July, 2005.

INDEX

Aarseth, Espen 171
abandonment 5, 22, 40, 57, 91, 137, 146, 164
absence 6, 16, 57, 99, 102, 125, 133, 145, 158, 186
absorption 40, 152
abstractions 7–8, 10, 28, 37, 45, 54, 58–61, 63, 65, 67–8, 71, 77, 82, 94, 116, 124–5, 127, 132, 137, 140, 143, 152, 155, 161–2, 164, 169, 189
Acconci, Vito 47, 109–10, 154–5, 158
ACM 215, 224, 228
active-matrix 20
Activism 223, 226
Adorno, Theodor 123
Aesthetic 1–2, 4–6, 8–10, 12–13, 15, 18–19, 22–3, 27–8, 38, 40–3, 46–7, 49–52, 54–5, 67, 73–5, 79, 81–2, 84, 92–3, 98–101, 103, 105, 108, 111, 114–16, 121, 125–6, 128, 132, 134, 137–8, 140, 145, 152–5, 157, 159, 161–4, 166–7, 169–72, 176, 178, 185, 202, 207, 216, 218, 220–1, 223, 226
Africa 105, 108
afterimage 52
agitprop 94
Ahtila, Eija-Liisa 159
AI 203
Alesci, Laura 221
Algorists 61
algorithms 58, 85, 94, 102–3, 111–12, 185, 219, 228
algotecture, see Terzidis 131
anti-aesthetic 40, 221, 226
anti-formalism 201
anti-portraits 50
antimodular 147
antisubjective 18
aphorisms 71
API 45
apologias 76
apparatus 40, 75, 173
appearance 2, 12, 20, 94, 103, 132, 161, 173
arbitrariness 186
arc 8–9, 124–7, 219, 227
arch-commercial 83
archaic 8, 77, 92, 184
archetype 3, 15, 36, 58, 61, 65, 166
architecture 2, 40, 53, 57, 68, 79, 89, 113–16, 121–3, 128–35, 146–7, 161, 165–6, 219, 226, 228
archive 16, 63–4, 84, 151, 192
Arduino 100
arguments 7, 12, 40, 75, 83, 92–3, 111, 124–5, 131, 155, 161, 163–4, 172, 187, 220
Arnheim, Rudolf 169
art 1–15, 19–20, 29–32, 38–41, 43–7, 49, 51, 53–5, 57–61, 63–7, 73–7, 79–85, 87, 92–5, 97, 99–103, 105, 108–9, 111, 113, 115, 122–8, 137, 140, 147–9, 151–2, 154–5, 157, 159, 161, 163–4, 169–72, 176, 201, 207, 209, 215–21, 223, 227
art-as-ritual 40
art-collecting 101
art making 81
art-political 127
art-prophylactic 127
art-viewing 9
ARTFORUM 9

INDEX

arthood 5, 10, 76, 101
artifacts 156, 184
artisanal 74
artist 4–9, 12, 14, 22–3, 26, 29–30, 32–3, 38, 40, 42–7, 49–52, 54–5, 58–61, 63–5, 67–8, 70, 74–7, 79–84, 87, 92–3, 96, 100–2, 105, 108–10, 114–15, 117–22, 124–7, 137, 151–2, 154–6, 158–9, 161–3, 169, 175, 184, 218, 221, 223, 226
artwork 20, 39, 47, 81, 88, 102, 108
assemblages 12, 23, 46, 68, 74, 81, 165, 188
association 10, 29–31, 39–40, 42, 55, 91, 130, 161–3, 179, 222, 227
asymmetry 54, 88, 115, 131, 162
asynchronous 21
attention 35, 37, 49, 58, 63, 68, 108, 121, 139, 148, 156, 171, 176, 184, 189, 207
auction 73, 75, 83, 100–2, 123, 218
audience 5, 7, 35, 41, 43, 54–5, 75, 82, 96, 99, 103, 105, 108, 137–8, 140–1, 145, 163, 170
auditorium 93
augmentation 2, 54–5, 70, 102, 126, 174–5, 202
aural/auditory 30, 37–8, 42, 49–50, 52, 91–5, 102, 105, 111, 148, 201, 208
authenticity 93, 95, 100
author/authorship 1, 61, 76, 97, 156, 162, 186–7, 194, 208
authority 73, 75, 114, 142, 152, 156
automatic 172, 192, 204
autonomously 2, 22–3, 28, 83, 88, 101, 127, 167, 177
avant-garde 77, 123–6, 157
avatars 135
awareness 16, 18, 108, 121–2, 125, 223

backdrops 14, 23–4, 26, 108, 115, 127, 141, 143, 145, 147, 177
background 14, 134, 149, 184, 202
Baigell, Matthew 9
Bakhtin, Mikhai 114, 203, 219, 225

balance 16, 38, 79, 81, 124, 193
ballet 23, 137, 158
balloons 63
balustrades 23
Barthes, Roland 129, 171, 219, 225
Baudelaire, Charles 74–5, 152, 169
beam 23–4, 66, 216
before-after *see* time 14
behavior 14, 38, 109, 172–3, 177, 186, 202, 206
being-there 172
Benjamin, Walter 39–43, 91–3, 95–6, 100–2, 218
Bergson, Henri 16, 18, 20, 215–16, 225
Berlin 112
Blinking 138–47, 149
blocks 53, 166–7, 193
blog 123, 183, 185, 190–6, 200
body 13–15, 17, 42, 65, 101, 109, 134, 140, 147–8, 172, 178, 181, 186–7, 220, 227
Bois, Yve-Alain 143
book 1, 3, 9–10, 12, 32, 61, 79, 82, 101, 124, 152, 154, 163, 167, 170, 174–5, 201, 204, 215–16, 220, 227
Boomerang 42
Borsuk, Amaranth 2, 174–6, 221, 225
Bosshard, Hans Rudolph 166
Bourgeois Society 219, 226
Byrne, David 184–5, 221, 225

Cage, John 154, 178
Calder, Alexander 14
camera 4, 20, 23, 25–8, 42, 53, 142
Caplan, Lana Z 159
captions 88, 127, 198, 217
Cardigans 158
Caro, Anthony 22–4, 26
Cartesian 68, 129
cascade 114, 184
catapults 59, 61, 114
category 1, 5, 10, 30, 43, 46, 54, 74, 82, 84, 114, 134, 139, 208, 219, 226
Cathexis 207
causality 6, 140, 154, 181, 204, 206

INDEX

Cavell, Stanley 74–5, 217, 225
Cayley, John 2, 177
censorship 125–6, 219, 227
center/centrality 4, 7, 23, 30, 42–3, 50, 55, 58, 80, 108–9, 115, 121, 154–6, 161, 171, 181
centrifugal 177
chasm 201, 203
choreography 138, 140, 145, 149, 220
chronotope 114, 127, 219, 225
cinema 13, 16, 28, 41, 68, 95, 141, 215, 220, 228
circularity 12–13, 15, 52, 54, 58, 63, 65, 67–70, 121, 142, 169
city 49–50, 52, 71, 85, 112, 121
closeness 36, 52, 109, 134, 139, 152, 154, 157–8, 176
co-optation 42, 49, 79, 103, 109
codes 84, 152, 154, 156, 174, 206, 211
cognitive 20, 203, 205, 221, 228
coherence 20, 26–7, 221
cohesion 15, 190
collage 6, 33, 50
collapse 42, 47, 83, 167
collectivity 16, 31, 41, 46, 50, 59–63, 78, 80, 87–8, 97, 103, 105, 111, 113, 122, 148, 186, 209
collectors 7, 81–2, 87, 102
color 14, 44, 50, 87, 154, 178, 184, 217
coltan 108
columbite-tantalite 108
combines 81
comedy 108, 127, 152
commerce 10, 74–6, 81, 83, 101–2, 166
communicative 184, 186–8, 190, 192, 194, 199–200, 204, 224, 228
complexity 10–12, 30, 34, 36, 43, 57, 65, 74–5, 102, 115, 123, 143, 171, 206, 220
compositional 34, 36, 58, 79, 96, 164, 183, 192
compound 94, 114, 152, 177, 183
computational 79, 149, 170–1, 202
computing 6, 9–10, 15, 44, 59, 64–6, 73, 75–6, 79, 81–3, 96, 102, 114, 116, 148, 187, 203, 205–6, 209, 213, 215, 218, 222–5, 228
concentration 40
concept 3, 6, 9, 13, 17, 21, 23, 76–7, 81, 83, 93, 95, 101–2, 108–9, 111, 114, 123, 129, 145, 149, 157, 163, 165–6, 171, 175, 201, 209, 218, 220
concreteness 28, 30, 57, 61, 116, 137
conditions 20, 30, 39–40, 42–3, 53, 67, 81–3, 93, 101, 111, 116, 123–4, 130–1, 133, 141, 163, 172, 181, 184, 186, 198, 204–5, 220, 223
Congo 108
connections 1, 3, 6, 36, 41, 53, 67, 100, 108, 112, 154, 166, 170, 180, 211, 216
connotations 6, 88, 131
consciousness 74, 108, 123, 125–6, 133, 154, 172, 205, 208, 223
consensus 54, 187
consequences 23, 73, 123, 164, 186, 222, 227
constraints 22, 37, 68, 76, 83–4, 123, 131–3, 166–7, 170, 186, 189, 204, 209
constructions 4, 8–9, 13, 20, 22, 39, 55, 103, 115, 124, 130, 132–3, 151, 179, 204
contemplation 3, 10, 12–13, 18, 31, 39–42, 47, 71, 91, 109, 162, 164, 172, 177, 201
contemporary 1, 4, 6–7, 9, 13, 24, 30, 43, 54–5, 58, 64, 67, 75, 77, 79, 82, 84, 94, 103, 123, 125–6, 131, 137, 164–5, 202, 221, 227
content 12, 14–16, 50, 164, 167, 191
contexts 4–5, 13, 27, 30–1, 43, 54, 61, 77, 88, 104–5, 122, 127, 129, 138–9, 141, 151, 162, 167, 186, 205, 208
contingent 47, 53, 156, 163, 169
contradictions 34, 75, 100, 125, 163, 208
contrasts 16, 22, 26–7, 31, 40, 75–6,

INDEX

95, 108, 111, 114, 129–30, 133, 164, 184, 187, 192, 200, 216
control 39, 76, 81, 83, 105, 126, 204, 217
conventional 5, 8, 10–11, 45–6, 49, 52–5, 59, 127, 131, 154, 172, 177, 183, 186–7, 193, 223
convergence 5, 13, 20, 23, 222, 227
conversation 28–32, 77, 84, 139, 192, 203–4, 206, 209
Copenhagen 122
core 14, 60, 100, 112, 139, 181, 184
corpus 187, 192–3, 198, 200, 223, 228
correlation 12, 197
courses 7, 15, 18, 20, 40–41, 43, 46, 58, 61, 64, 73, 92–3, 115, 124, 126, 130, 140, 148, 151–2, 163–4, 171, 181, 201, 205, 220
creation 3, 5, 7, 21, 32, 44, 75, 82–3, 92–4, 111, 113, 129, 131, 166, 178–9, 184, 187, 202, 207, 217
creativity 1, 3, 6, 58, 61, 63, 67, 76–7, 83–4, 92–5, 99, 102, 111, 130, 170–1, 217
criterion 1, 7, 47, 79, 132–3, 161, 187, 190, 192
critique 2–3, 6–12, 20, 30, 38–9, 41, 43–7, 57–8, 73, 75–6, 79, 82–3, 87–8, 91, 94–5, 105, 115, 122–6, 130, 132, 138–40, 147, 164, 170–1, 184, 215–16, 218–21, 227
crits 43
Csuri, Charles 9, 77, 79, 215, 227
Cuba 204
cubes 100–1, 167
Cubism 54
culmination 67, 92, 108
culture 1, 3–5, 32, 75–7, 82, 111–12, 129, 152, 157, 159, 184, 202, 204, 220–1, 226
curator 7–8, 49, 73, 87–8, 100
Cusack, John 159
Cyberculture 217, 224, 227
Cybernetic 67
cyberspace 131
Cybertext 171

Dada 152, 154
dance 2, 5, 36, 43, 65, 105, 137–141, 143–5, 147, 149, 220, 227
Dasein 172
data 77, 187, 192–3, 196, 223
database 192
dataset 223, 225
dead 97, 99, 135, 202, 221, 226
deconstruction 135, 171, 181
decoupling 137
deformations 167
degradation 152
degrees 83, 149, 163, 170–1, 190, 199
deities 165
delay 42
delegation 111
denial 10, 19, 37, 58, 75, 95
denotation 191
density 190–2, 200
departure 3, 7, 12, 47, 52–3, 61, 66, 94, 175, 178
depth 2, 17, 22–4, 26, 74, 116, 152, 184, 220
description 9, 12, 14, 22, 37, 42, 45, 55, 74, 79, 88, 109, 115, 127, 154, 168, 181, 205, 219
desecration 92
design 1, 3, 57, 61, 83, 89, 103, 116, 121, 129–30, 132–3, 148, 166–7, 205
designation 12, 159, 165
designer 50, 76–7, 83, 116, 192, 202, 207, 217
desire 81, 151, 154, 184, 205, 208
destruction 8, 46, 114, 124–6, 154, 156, 158, 208
detail 9, 15, 28, 35, 44, 57, 95, 99, 141, 143–5, 166, 186
development 12, 41, 74–5, 129, 131, 173, 184
device 11, 75, 86, 93, 95, 97, 111, 155, 187–9, 193
diagnosis 203
diagram 17–18, 20, 105, 133, 172, 185
dialectical 40, 123, 152, 191, 205, 216
dialogue 29, 31–2, 41, 50, 101,

INDEX

126–7, 149, 163, 173, 203–4, 207
Dialtones 96
digital 6, 9, 13, 19, 38, 43–4, 59, 63, 65, 67, 70, 76–7, 79, 82–4, 88, 111–12, 139–42, 164, 169–71, 183–7, 215–16, 223, 228
dimensions 11, 14, 38, 47, 57, 61, 65, 87, 114, 121, 126, 133, 140, 147, 167, 202, 215
discipline 124, 130, 133, 161, 171, 203
discourse 83, 87, 122–3, 126, 163, 170–1, 203–4, 208, 215, 222, 227
displacement 94, 131, 144, 184, 186
distance 23–4, 34, 36, 38, 40, 42, 75, 93, 105, 114, 152–6, 158, 163, 177, 205
distinct 16, 22, 25, 31, 37–8, 50, 54, 76, 112, 114, 122, 137–8, 167, 200, 203
distortion 11, 34, 36, 116, 125–6, 134
distraction 40–2, 139, 184
distribution 2, 5, 82, 91, 94–7, 99, 102–3, 105, 111–12, 121, 164, 195
documentation 36, 39, 49, 97, 102, 139, 147, 151–2, 156, 165, 170, 177, 187, 192, 219, 223, 225
Doesburg, Theo van 148
domain 132, 144, 151–2, 157, 181, 185, 205
doppelganger 123
doubt 46, 108, 126, 130, 175, 198, 209
drawing 9, 17, 58–60, 62, 65–7, 78–80, 93, 132, 184, 207, 217
dream 33–4, 41–2, 53, 92, 100, 143, 156, 212
dualism 50, 55, 130, 140, 161
DuBois, Luke 2, 138, 145
Duchamp, Marcel 8, 58, 64, 68, 73–4, 163
Duncan, Isadora 138
DVD 53, 145

e-poetry 174
Eastmond, Evelyn 44–7, 127

educational 5, 74, 83, 184, 222
Eisenman, Peter 116
electrokinetics 27
electronics 1–2, 5–6, 9–13, 15, 17, 19–21, 23, 25, 27–8, 38, 43, 45–6, 59–60, 63–5, 79, 82–4, 92, 95–6, 102–4, 108, 111, 113, 115, 117–22, 128, 138–40, 147–9, 164, 168–74, 176–7, 186–7, 201, 215–16, 222, 225
elements 16, 20, 22–7, 33, 79, 93, 102–3, 111, 130, 134, 139–40, 148, 165–7, 178, 193, 198, 208, 219, 225
elevation 7, 83, 147
ELIZA 201, 203–4, 207–9, 211, 223
email 192, 196–200, 223, 225, 228
embedding 4, 19–20, 40, 101, 114, 128, 171, 174
embellishment 66–7, 78
embodiment 32, 100, 132
embrace 12, 18, 49, 58, 87, 108, 154, 164, 216
emergency 3, 32, 46, 173, 175, 183, 205
emotional 34–5, 97–9, 151–2, 157–9, 218, 221, 225
emperor 165
empiricism 122, 126, 133, 149, 170, 192, 202, 204, 222
encapsulation 13, 156, 172, 207
encounters 1, 7, 9–10, 19–20, 46, 68, 83, 100, 125, 138, 168, 180, 207–9, 215, 223–4, 226
encroachment 123
Engagement 1–14, 16, 18, 20, 22–24, 26, 28, 30, 32, 34, 36–8, 40, 42–7, 49–55, 58, 60–2, 64–71, 73–4, 76, 78, 80, 82, 84, 86–8, 92–6, 98, 100, 102–6, 108–30, 132, 134, 138–40, 142–4, 146, 148–9, 151–9, 161–4, 166, 168–70, 172–4, 176, 178, 180, 183–4, 186, 188, 190, 192, 194, 196, 198, 200–9, 222
enigma 35, 159
Enron 192, 199, 223, 225, 228
entertainment 3, 5, 74–7, 217, 227

entropy 111
environmental 8, 125–6, 133–5, 152, 173, 187
Epistemological 221, 223, 225
escape 42, 132, 172, 175
Escher 68
ESP 41
ethic 129, 152
ethical 203
evident 3, 5, 12–13, 19, 21, 23, 26, 33, 37–8, 61, 79, 88, 92, 102, 109, 111–12, 114–15, 130–1, 140–1, 146, 148, 153–4, 156, 158, 164–7, 172–4, 177, 181, 199, 208, 219, 221
evocative 30, 63, 174
evolutionary 57, 71, 75–6, 88, 94
exclusive 49, 93, 127, 186
existence 3, 5, 20, 28, 32, 54–5, 57, 76, 80, 92–3, 111–12, 127, 138, 140, 167, 172, 175, 177, 181, 184, 187, 192–3, 201, 205
expansive/expansion 3–4, 8–9, 14, 58, 121–4, 201, 215
expectation 163, 173, 197
experiential 1–3, 5–9, 11–13, 15–16, 18–20, 22, 24, 30, 37–40, 42–3, 45–7, 50, 52, 54–5, 76, 79, 82, 88, 93–7, 99–101, 105, 108, 114–16, 131, 137–9, 142, 145, 152, 159, 163–4, 171–2, 174–5, 180, 184, 201–2, 204, 218
experimentation 6, 51, 134, 167, 202, 205, 220
expert 163, 203
expression 7–8, 74, 84, 112, 126–7, 139, 149, 151–2, 161–3, 170–1, 184, 186
Expressionism 8, 37, 61, 67, 94, 140, 143
extension 39, 47, 58, 92, 102, 123, 125, 133, 138, 149, 163, 168–9, 172
external 13, 101, 108, 114
extinction 7, 203
extra-textual 175

fabrication 19, 39, 130

Facebook 123, 223
factuality 190
familiar 4, 31–3, 55, 105, 108, 125, 172–3, 178, 184, 188, 191
familiarity 31, 49
FANTASIES 213
fascination 49, 153, 217
fashion 3–5, 129, 219, 225
fashionable 77
fashions 23
feedback 18, 42, 189
feeling 1, 108, 208, 211
femininity 156, 207
fictions 223, 228
film 5, 74, 220, 228
Film-Philosophy 220, 228
focus 2, 10, 18, 50, 138, 148, 155, 167, 184, 187, 207, 220, 222, 227
form 1, 3–10, 12, 16–17, 20, 22, 26, 28–9, 37, 39–40, 42–3, 47, 51, 53, 55, 57–9, 61, 63, 67–9, 71, 74–7, 82, 84, 88, 92, 94, 97, 99, 102, 108, 111, 114, 116, 121, 127, 129–33, 137–9, 143, 147–8, 152, 154, 161–4, 166–8, 172–3, 175–6, 181, 183–6, 192, 201, 206, 222
formal 9, 18–20, 22–3, 26, 46, 124–5, 137, 161, 164, 167, 175, 181, 202
formalisms 58, 68, 125, 139, 171, 183, 201
foundation 94, 108, 111, 171, 176, 178, 185, 218
Fountain 73
fragmentation 42, 50, 68, 185, 187–8, 198, 211
frames 4, 13, 47, 51, 59, 61–2, 80, 100, 112, 116, 130, 137–9, 166, 172, 202, 206, 208, 216
framework 10, 18, 114, 124, 130, 152, 170–1, 173, 203
France 157
Frasca, Gonzalo 83
Frears, Stephen 159
freedom 81, 87, 111, 125, 164, 167, 176, 217

INDEX

Frege, Gottlob 162
frequency 194, 198
Freud, Sigmund 41, 171
Fried, Michael 46, 220, 225
Frye, Northrop 171
fugue 68
fulcrum 15
functionalism 4, 11, 20, 23, 26, 35,
 40, 46, 50, 52, 55, 81, 83, 88,
 99, 101, 111, 115–16, 122, 124,
 127, 129–34, 147, 152, 165,
 170–4, 176, 183, 185, 203, 211,
 216, 218
functions 29, 49, 116, 124, 140, 187
Futurists 61, 167

galleries 3–4, 31–2, 50–1, 53, 65,
 73–4, 76–7, 85, 87–9, 100, 145,
 152–3, 162, 185, 218
galleys 61, 167
gamasutra 217
game 5–6, 10, 73, 75–7, 79–84, 111,
 116, 171, 202, 206, 217, 223,
 226, 228
gap 7, 41, 162–3, 223, 226
gazing 29, 31, 130, 138–9, 141–4,
 156
Gedanken 205
Gehry, Frank 129
Gelernter, David 202
generative 36, 38, 47, 58, 84, 123–4,
 131, 203, 206
generators 2, 84
genres 54, 77, 84, 89, 114, 167, 183,
 185–6, 190, 193–5, 198, 223,
 226
geographical 97, 99
geometry 13, 19, 23, 28, 31, 60,
 114, 116, 121, 127, 141, 165–6,
 202
geospatial 131
germane 53, 175
Germany 91, 221, 225
Gestaltung 166
gesture 41, 52, 113, 147–8, 172
Ghirardo, Diane 132, 219, 226
Glitter, Gary 36
glyphs 167, 184

goal 12, 80, 125–6, 223
Goethe, Johann Wolfgang von 151
Gogh, Vincent van 156
Google 44–5, 179
government 125
grammars 23, 68, 129–30, 198, 202
graphical 30, 50, 83, 154, 166–7,
 184, 193–4, 198, 221
Greenaway, Peter 142, 220, 228
Greenberg, Clement 124
grid 10, 23, 57–61, 63–4, 66–7, 114,
 148–9, 166–8, 186
grooves 52
ground 23, 88, 115–16, 156, 169,
 181, 186
group 55, 76, 96–7, 116, 126, 187,
 193, 199
Guggenheim 52
Gursky, Andreas 68

Habermas, Jürgen 122–3, 125–6, 163,
 204, 218–19, 221, 226
habitus 173
Hamlet 34, 103
hand 19, 46, 54, 58, 66–7, 78–9, 145,
 156, 162–3, 190, 202, 205
handwriting 73
happening 42, 141
Hecker, Zvi 131
Hegel, Georg Wilhelm Friedrich 164
Heidegger, Martin 170
Heinecken, Robert 153–4, 221, 226
helicopter 71
here-and-now 40
here-there 11, 23
Higgins, Dick 94, 218, 226
Hirschhorn, Thomas 53
Hirst, Damien 53
histories 5–10, 12, 30, 34, 40, 42–3,
 45–6, 54–5, 58–60, 64, 73, 75,
 79–83, 92–4, 102–3, 111, 122–3,
 125–6, 139, 151–2, 154, 157,
 161, 164–5, 168, 170, 172,
 184–5, 205–7, 218
Holt, Nancy 42–3, 47
Horkheimer, Max 123
HTML 193, 217, 223, 226
humans 3, 9, 19–20, 40–2, 114, 122,

132, 147–8, 151, 154, 159,
 171–2, 177, 202–3, 207
Husserl, Edmund 11, 13, 15
hybridity 6, 44–5, 159
hyper-consciousness 125
hyper-contemporary 126
hypertext 77, 164
hypothesis 13, 133, 162, 191, 199, 203

IBM 59, 61
iconography 185, 220
ideals 4, 24, 92, 148, 215
ideas 10, 14, 87, 101, 108, 131, 170,
 184, 188–91, 193, 223, 226
illusion 58, 116, 208
illustration 20, 28, 65, 84, 97, 109,
 121, 166, 172, 174, 190
image 2–5, 7, 10, 22, 26, 29–32, 34,
 36, 39–40, 42, 44–6, 50, 63–7,
 70–1, 96, 100, 114, 116, 140–1,
 148, 152, 154, 156, 172–6, 181,
 185, 217–18, 220
image-maker 156
image-object 114
imagery 3, 14, 31, 114, 140, 176, 220
images 3–5, 11, 17, 22, 24, 30, 32,
 34–5, 39, 53, 71, 74, 88, 99, 112,
 121, 134, 137, 153–4, 217
imagined 8–9, 43, 50, 55, 61, 92–3,
 112, 114, 127, 154, 159, 170–1,
 176, 181, 190–1, 206, 219, 225
immediate 7, 10–13, 30, 34, 42, 55,
 99, 132, 152–3, 155, 189
immersive 34, 68
immobility 164
immutability 167
immutable 59, 122
impact 65, 152, 154, 171, 184, 202
implication 12, 15, 18, 20, 30, 76,
 81, 92, 111, 140, 151, 154, 161,
 172, 180, 203, 216
importance 7–8, 27, 38–9, 41, 43, 73,
 76, 79, 82, 96, 108, 123, 140,
 161, 170, 188, 190, 198, 218
Impressionism 16, 22, 41, 64, 67,
 125, 164, 172, 216
impressions 3, 13, 16, 18, 30, 41,
 108, 164

impulses 138, 169, 177
inclusion 10, 31, 43, 67, 102, 154,
 218
incommensurability 152, 216
incomplete 50, 167
Incompleteness 55
inconspicuousness 23
indeterminacy 111, 131, 163
indexical 30, 159, 167, 169, 176
individual 10, 17–18, 60, 88, 125,
 148, 172, 181, 187, 193
inexplicability 59, 125, 167, 205
infamy 73, 124
inference 81, 87, 94, 163, 190, 199
informality 186, 191
informational 18, 39, 52, 54–5, 63,
 66, 170, 187, 191, 221, 223,
 225
ingredients 14, 46, 158
ink 59, 62, 66–7, 78, 80, 217
innovation 22, 49, 63, 183
inputs 18, 77, 84, 94, 207–8, 211,
 216
inquiry 10, 43, 79, 169–70, 219, 222,
 227
inscriptions 52, 112, 127
insinuation 38, 141
installations 6, 15, 44, 46, 65, 77,
 96, 163
instances 24, 26, 61, 80, 88, 97, 123,
 138, 140, 154, 163, 174, 185,
 187, 200
instantaneous 4, 40
instantiations 151
instinctual 18, 39, 191
institutions 3, 5, 73–4, 76, 79, 84–5,
 122, 154, 204, 209
instructions 9, 54, 103, 203, 206
instrumental 13, 46, 74, 176
instruments 52, 96, 217
integration 15, 20, 38, 43, 58, 75–6,
 81, 94, 140, 154, 174, 189
integrity 2–3, 74–5, 82–3, 88, 163,
 176
intelligence 108, 202–7
interaction 1, 16, 43, 46, 99–100,
 104, 115, 139, 172–3, 175, 186,
 188–9, 201–2, 208

INDEX

interactivity 2, 14–15, 44–6, 77, 82, 111, 128, 204
interface 52–3, 89, 138, 207
intermediate 18, 177
internet 73, 77, 100–1, 105
interpretation 7, 20, 30–32, 37, 41, 52, 54, 138, 184, 201, 203, 212, 222, 228
interrogative 140, 158–9, 170
intersubjective 204
interventions 113, 127, 139, 194, 204–5, 216
intimacy 4, 13, 19, 24, 31, 36, 38, 105, 124, 139, 151, 153–9, 161, 176, 191, 203
invention 3, 74–5, 209
inversion 3, 22, 75, 80–1, 88, 109, 127, 130, 172, 205
invisibility 18, 32, 176
iPod 33, 36
irony 22, 46, 74–5, 81, 92, 101, 205
irreplaceability 81

Jenkins, Henry 76–7, 79, 82, 217, 226
Jewett, Jamie 2, 138, 141–5, 149
Jonas, Joan 159
Judd, Donald 9, 58
judgment 2–3, 7, 10, 12–13, 18, 30, 46–7, 55, 124–5, 137, 201
Juul, Jesper 83
Juxtaposition 33, 43, 52, 116, 137, 140, 154, 221, 226

Kael, Pauline 170
kaleidoscopic 151, 157
Kanarinka 127
Kant, Immanuel 152
Kerouac, Jack 68
kinetic 16, 220, 226
kinetic-semantic 77
kineticism 13
kineticizing 216
kinetics 16, 18, 20–1, 44, 76–7, 111, 114–15, 121, 140, 177, 220
kinoprojection 41
Klimt, Gustav 223, 228
knowing 29, 202
knowledge 92, 164, 187, 201–2, 209

Knowlton, Kenneth 60, 79, 128
Kostelanetz, Richard 112
Kracauer, Siegfried 170
Krauss, Rosalind 9, 41, 57–8, 155, 157, 159, 163, 216, 221, 226
Kruger, Barbara 127
Kuspit, Donald 163

Laban 139, 220, 226
Lacan, Jacques 172
lack 5–6, 15, 40, 93, 104, 126, 138, 140, 170–1, 184, 188, 194
landscape 23, 54, 63, 91, 128, 130, 156, 177
lange-parole 130
language 2, 13–14, 23, 29, 31, 33, 47, 52, 112, 123, 129, 152, 166, 170–4, 179, 184, 186, 191, 201–2, 205–6, 209, 215, 222, 228
Language-Learning 222, 228
Larsen, Caleb 77, 100
LCD 19, 25, 28
learning 205–6, 216, 222, 228
legitimization 9–10, 31, 46, 73–5, 77, 93–4, 96, 100, 111, 170, 205
Leider, Philip 9
length 2, 7, 12, 81, 111, 165, 183, 187, 190, 194–8, 200
lens 39, 126, 148
letters 14, 61, 91, 167, 173, 178
Levin, Golan 2, 96
LeWitt, Sol 9, 58
lexical 176–7, 180, 186–7, 190–2, 200
life 4, 7, 18, 38, 41, 54, 57, 63, 68, 77, 96, 112, 123, 129, 148, 154, 163, 186, 204, 206
LightBox 45
line 12, 14, 30–1, 45–6, 52, 55, 83–4, 101, 145, 155, 158, 163, 172, 223
lineage 58, 67, 75, 154, 156, 159, 170, 204
linearity 5, 16, 18, 31, 43, 46–7, 52, 66–8, 71, 79, 116, 123, 140–2, 166, 168, 170, 183, 193, 202, 221

Linguistics 9, 14, 130, 170, 174, 189–91, 204, 208, 222, 227
Linotype 166
lip-sync 158
listener 40, 128, 172, 189
Listeners 188
listens 170
literacy 166, 185, 188, 190, 198, 222, 228
literal/literary/literature 1–2, 4, 9–12, 34, 43, 45, 61, 81–2, 84, 91, 114, 125, 133, 143, 151, 159, 161, 163–5, 167, 169–13, 175–7, 179, 181, 184, 186–7, 192, 204, 215–16, 227
lithographs 154
live-action 41
location 4, 23–4, 97, 115, 128, 131, 133, 204
locative 128, 215
logic 6, 27, 40, 50, 58, 92, 111, 114, 130, 155, 157, 165, 167, 169, 176, 178, 181, 202, 206, 208
logos 205
lost 10, 36, 43, 54, 83, 88–9, 112, 124, 137, 157, 163, 209
love 33–7, 52–3, 138, 151, 157–9, 207
lovefool 158
Lozano-Hemmer, Rafael 1, 146–7, 149
ludologists 111

Macaulay 220, 226
machine 1, 42, 60, 65–7, 74, 78, 92–3, 100, 114, 171, 177, 202, 206, 209, 213, 217, 224, 228
machine-based 209
machine-created 217
machine-generated 66
machine-level 177, 203
machine-programmed 58
magic 209
Malevich, Kasimir 58
Mallarmè, Stèphane 152
man 40, 73, 91, 158, 163, 224, 228
mandala 58, 71

Mandelbrot, Benoit 68
Mandell, Henry 61, 64
manifestos 130
manipulation 38, 113, 123, 208, 221
Mann, Steve 99
manner 20, 36, 59, 76, 93–4, 99, 163, 166, 171, 206
mannerism 158
Manovich, Lev 215
mantra 129
marble 88
marching 50
Marclay, Christian 49–53, 55
marker 1, 33, 47, 58, 60–1, 66–7, 77, 112, 142, 164, 169, 175–6, 178, 189–90, 193, 200, 206, 208
Markov 179
Marsching, Jane 127
Marx Karl 91
Marxism 92, 123
masks 162
masquerade 132
materiality 6–7, 9, 20, 22, 26–8, 30, 32–3, 52–3, 58–9, 63, 67, 81, 83, 88, 97, 99, 101, 114, 126, 131–4, 138, 147, 154, 166, 170, 186–7, 192, 216
mathematics 68, 206
matrix 2, 129, 138, 167
matter 1, 25, 35, 54, 58, 132, 208, 215–16, 218, 225
McCall, Anthony 45, 65
McLuhan, Marshall 115
meaning 2, 13, 15, 20, 29–32, 47, 52, 55, 63, 101, 103, 112, 116, 127, 138, 141, 156, 159, 161–2, 177–8, 181, 188, 191, 198, 201, 205
meaning-making 16–17, 177
mechanisms 13, 18, 21, 38, 41, 50, 65–6, 68, 74, 88, 91–2, 94, 102, 113, 148, 161, 164–6, 168–71, 189, 205–6, 218
media 1–7, 9–15, 29, 33, 37–40, 43–6, 49–50, 52–3, 55, 59–60, 63, 73, 76, 79, 81, 84, 92–5, 97, 99, 102, 111–15, 123, 128, 140, 152, 154, 156, 161, 164, 169,

184, 187–8, 190–1, 195, 200, 215–17, 221, 223–4, 227
mediation 4, 21, 88, 94, 152, 159, 169–70, 187
medium 4–5, 14, 30, 35, 38–42, 45, 47, 49–50, 52, 59, 74–7, 79, 88, 92, 102, 111–12, 115, 133, 154–6, 159, 161, 165–1, 172, 174, 176, 181, 183, 185–7, 190–2, 222, 226
membership 50, 81, 139
membrane 18, 69
memes 61, 170
memory 16–18, 20, 30–1, 33, 36, 38, 52–3, 55, 93, 156, 174, 180, 208, 211, 215–16, 225
memory-images 16
memory-making 30
Merleau-Ponty, Maurice 11–13, 215, 226
mesostic 178
messages 34, 38, 45–6, 100–1, 105, 127, 156, 183, 187, 192
meta-analysis 185, 187
meta-contribution 123
metal 27, 145, 166
metamorphosis 174, 223
metaphor 13–16, 24, 112, 115, 138, 171, 215
method 3–4, 6, 9, 12, 26, 37, 39, 79, 94, 105, 108, 134, 139, 152, 177, 192–3, 202, 205–8, 222, 228
metonymy 50
metrics 200
metronome 143
Metz, Christian 75
migration 32, 101, 109, 134
milestone 41, 173
mind 1, 16, 36, 42, 55, 58, 68, 88, 112, 123, 125, 148, 198, 211
minimalism 7–8, 18–20, 22, 26, 39, 46, 57–9, 88, 94, 100, 131, 143, 148, 207, 220, 225
miracles 206
mirror 38, 42, 58, 103, 115, 124, 140–1, 143, 145, 151, 159, 165, 172–3, 176
mise-en-scène 53, 155

misunderstandings 162
mobility 14, 32, 46, 84, 86, 95–6, 105, 108, 121
modality 16, 18, 37–8, 44, 49, 54–5, 83, 115, 124, 126, 162, 176, 186–8, 192, 194–5, 197, 206, 219, 222, 225
model 18, 20, 46, 55, 81–2, 206
modernity 6–7, 43, 45, 55, 57–8, 61, 66, 73, 77, 91–2, 102, 121, 123–5, 129, 137–9, 148–9, 165, 181, 192
modular 167
Mohr, Manfred 9, 77, 80
Molnar, Vera 60
moment 2, 4, 12–13, 15–16, 18, 20, 29, 31, 55, 69, 77, 91–5, 97, 99–100, 102–3, 105, 111–12, 115, 132–3, 138–40, 156, 162, 170, 204, 207, 215, 222
momentum 114
Mondrian, Piet 58, 148
money 73, 82, 85, 123, 127, 130, 191
monographs 198
montage 157
Montfort, Nick 2, 84, 86
morality 103, 122, 125, 129, 151–2, 154
morgues 4
morph 167
mortality 165
mother 139, 142
motion 14–16, 20, 22–3, 67–8, 71, 79, 87, 108, 116, 140, 145, 147–8, 216
motivation 55, 82, 124, 131, 140, 171, 181
motorcade 87
motors 21, 27, 65, 75, 111, 123
mount 27
mountains 57, 61, 198
movement 8, 12, 14, 16, 20–3, 39, 41, 50, 55, 58, 61, 71, 79, 105, 108–9, 124, 137–40, 142–5, 148–9, 151, 159, 165, 169, 172–3, 175, 179–81, 220–1, 226
movies *see also* film 39, 65, 74, 91, 148

MSW *see* Stublič 122
Mueller, Andreas 175
multi-movement 138
multi-perspectival 22
multidirectional 69
multiplayer 82
multiple-perspective 139
multiplicity 22, 37, 82
multipositional 24
Mulvey, Laura 169
mundane 97
museums 3–4, 10, 51–2, 63, 73, 77, 79, 87, 109–10, 152, 221, 227
music 5, 30, 36–7, 50, 52, 96, 105, 138, 141, 143, 149, 156, 159
MYCIN 203
Mylar 45
myopia 125, 130
MySpace 123
mystical 58, 63, 91, 143, 154, 201–2, 205
myth 58, 134, 138, 217, 223

n-dimensions 131
narcissism 155, 159, 216, 221, 226
narrative 27, 36–7, 41, 43, 55, 77, 94, 97, 101–2, 111–12, 114, 127–8, 137–41, 145–6, 174, 176, 180, 220, 222–3, 226
narratologists 111
nature 4, 12, 14, 17–18, 31–2, 39, 44, 95, 102, 111, 114, 143, 156, 183, 186–7, 190, 199, 222, 227
navigation 36, 50, 111, 130, 187
nearest-neighbor 179
neo-functionalist 132
neo-minimalistic 26
neo-textual 185
Neumann, Andrew 2, 13–14, 18–28, 149, 176–7, 216
neural 206
neutrality 87
new-media 60, 77, 84, 88, 92, 113, 127, 170, 215, 223
new-media-art-criticism 123
Nikolais, Alwin 145–7, 220, 227
Noguchi, Isamu 125
Noland, Kenneth 58

Nold, Christian 98–9, 218
nominalism 54
non-engagement 47
non-instrumental 203
non-integrated 163
non-involvement 133
non-local 91
non-manuscript 184
non-narrative 111, 138
non-object 83
non-physical 88
non-scenery 158
non-signifying 137
non-textual 198
nonliteral 145–6, 149
nonphysical 132, 134
normative 47, 76, 103
not-experience 125
notes 1, 21, 40, 58, 109, 184, 206, 215
nothingness 6–7, 41, 151, 212
notions 13, 15, 19–20, 31, 43, 47, 53, 58, 81, 88, 92, 99, 102, 122, 124, 131, 152, 161, 167, 170, 173, 177, 179, 183–4, 186, 198, 208–9, 218
Notzold, Paul 2, 128

obfuscation 83, 152
object 2–3, 5, 7–8, 11, 16, 20–2, 28–9, 31–2, 36, 40, 45, 50, 67–8, 81–2, 84, 88, 92, 100–1, 113–16, 140, 156, 167, 172, 174, 176, 201
objecthood 73, 81, 101, 220, 225
objective 26, 29, 35, 74, 83, 114, 123, 131, 139, 169, 171, 190, 206
observations 12–13, 17, 22, 41, 43, 68, 105, 115, 171, 177, 186–7, 195–7, 200
obsession 5, 8, 138, 158
obstacle 125
obviousness 5, 20, 27, 37, 40, 44, 50, 58, 77, 79, 102, 130, 132, 158, 162, 184, 201, 203, 207
online 100, 183, 186–7, 192
ontology 7, 14, 54, 58, 92–93, 130, 163, 169–70, 176, 180, 202, 220

INDEX 241

opacity 18, 34, 205–6, 208
open 8, 10–11, 13, 36, 42, 52, 69, 75–6, 84, 93, 113, 138, 156, 163, 167, 172, 222
oppositions 26, 28, 40, 43, 74, 100, 123, 127, 164, 201
optic 5, 11, 14, 20, 40, 75, 152, 164
optimization 130, 202
orality 185–92, 197–8, 222, 227
orchestration 149
order 2, 8, 24, 30, 47, 55, 58, 68, 105, 112, 114, 124, 126, 129, 165, 167, 169, 172, 176–7, 181, 183, 198, 206
organicity 27, 63, 93
organism 177
organization 131, 138, 164–7, 186
originality 6, 16, 32, 35, 38–39, 41, 43, 49–50, 61, 63, 65, 74, 93–6, 102–3, 111, 116, 126, 163, 172, 193, 218
ornamental 57, 66, 148
oscillations 12, 17, 22, 63, 111, 115–16, 141
others 5–6, 9, 12, 19, 32, 59–60, 79, 82, 105, 116, 124, 127, 152, 157, 163, 170, 179, 184, 198, 202
ourselves 3, 35, 143, 170, 191
output 84–5, 178–9, 204
overlays 27, 52, 54–5, 76, 114, 153, 156, 158, 167, 194

page 61, 105, 164–7, 175, 193, 221, 225
painting 4–5, 7–9, 14, 20, 24, 33–4, 37–8, 40, 46, 52, 57–9, 63, 77, 79, 88, 91, 97, 115, 124, 154, 156, 216
palette 22, 33, 44, 64
panels 20, 22–7, 33–7, 44, 70, 76, 127, 173–4, 176–7, 216
panning 28
Panofsky, Erwin 75
paper 59, 61–2, 64, 66–7, 73, 78, 80, 164, 217, 222–3, 228
parade 50, 157
paradigms 161, 170, 204, 223
parity 123

parsing 202
part-object 151
participants 97, 174, 206
participatory 38, 43, 77, 97, 103, 126–7, 163, 186, 220
passages 13, 77, 112
passengers 142
passersby 147
path 30, 58, 83, 130, 170–1, 184
patient 41, 203, 207–8, 213
patterns 15, 26, 58, 82, 114–16, 121, 148, 169, 171, 179, 194, 202, 208
pedagogy 203, 222
pedestal 165
pedestrians 7, 125, 142
pedigree 157, 181
Pentametron 77, 85
people 79–80, 97, 99, 108, 126–7, 186, 213
perceptual 2, 8, 11–14, 16–20, 22–4, 29–30, 37–8, 40, 42, 52, 55, 87, 108, 114–16, 122, 124–8, 148, 158, 169, 172, 176, 181, 201, 208, 215, 220, 226
perfection 4, 66–7, 75
performance 1–2, 41–3, 50, 52–4, 84, 93, 96, 100, 102, 104–8, 111, 113, 127–8, 134–5, 137–47, 149, 151–9, 172–3, 177, 179, 203, 205, 207, 215–16, 220, 227
Perl 84
permutations 8, 65, 97
persona 29–30, 82, 109, 123–4, 139, 207
phenomenology 3, 8, 11, 53, 71, 95, 115, 124, 143, 159, 161–2, 171–3, 181, 185, 215, 222, 226
philosophy 29, 74, 114, 123, 129–30, 162, 170, 181, 186, 203, 218
phones 32, 44–6, 84, 95–6, 108
phonograph 39, 50, 52–3, 95
photo-image 19, 29–31, 33, 38–9, 50, 106–7, 146–7, 175
photography 3, 5–6, 9, 24–5, 29–33, 35–9, 43, 49–50, 52, 65, 73–6, 79, 109, 115, 117–22, 141,

153–6, 158, 162, 201, 218, 221, 226
photorealism 67
PHP 217
phrase 44, 125, 180, 191, 193
physicality 6, 8, 13, 22–3, 26, 36, 38, 50, 59, 67, 71, 85, 88, 100–2, 108, 111, 113–14, 126, 128, 130–3, 137, 139–42, 145, 156, 159, 162, 166, 172, 218
physicians 203, 206, 208
physics 132, 134
physiology 97, 138
Piaget, Jean 216, 227
Picasso, Pablo 54
pictorial 33, 67, 74, 76–7, 115–16, 132, 181
pieces 82, 108–10, 140
pigmented 58, 61, 64
Pissarro, Camille 82
pitch 158
place 4–8, 12, 27, 30, 32, 73, 75, 84, 88, 93–4, 97, 100–1, 112, 115, 125, 139–40, 152, 165–7, 191–2, 201–2, 204
placidity 34
planes 16, 18, 20, 23, 38, 65, 114, 141, 148–9, 155, 171, 177
planks 22
plastics 53, 101
platen 57, 164, 166
platform 27, 121, 126, 135
platinum 36
Platonic 151
play 18, 23, 26, 29, 33–4, 36–7, 39, 41, 50, 52, 65, 75, 81–2, 84–5, 108, 111, 115, 139–40, 152, 167, 172, 203–5, 223
playback 36, 41, 50, 96, 100, 157
plaza 7–8, 125, 148
plea 158
pleasure 221
plexiglas 100
plinths 22, 165
plot 105
plotter 59–62, 80
ploy 207
plume-like 121

plurality 26, 50, 77, 94–5, 97, 103, 116, 138, 140, 177, 221
plywood 25, 28
poetry 2, 14, 30, 38, 61, 77, 83–4, 161, 164, 167, 170–1, 173, 175–6, 207, 220, 223
poiesis 171
point 3, 8–10, 12–13, 16–18, 20, 22–3, 26, 30–1, 40, 42–3, 49, 54, 61, 65–6, 69–70, 74, 83, 92, 94–6, 103, 116, 125, 127, 132–3, 137–40, 146, 148, 152, 154–5, 163, 166, 183–4, 186–7, 198–9, 201, 206
point-based 184
point-driven 184
polarity 3, 68, 124, 152, 162, 198
polemics 83, 92, 123–4, 162
poles 17, 28, 127, 220
police 4, 113, 162
polis 122, 165
polished 26, 189
politics 108, 113, 122–3, 125, 127, 148, 162, 192
polytonality 116
popular 4, 75–6, 124, 126, 152, 155, 157, 159, 163, 186, 217
portrayal 4, 13, 35, 37, 50, 54, 66, 71, 77, 80, 83, 99, 135, 141, 143, 148, 165
pose 27
position 8–9, 44, 52, 75, 81, 139, 143, 165, 215–16, 227
positive 2, 212, 218
possess 31–2, 73, 101–2, 178
possibility 2–3, 8, 12, 18–19, 22–3, 27, 30, 32, 41, 49, 53, 55, 58, 60, 82, 88, 92–3, 95, 97, 99, 129, 138, 141, 162, 181, 185–16, 191–4, 201, 204, 213, 220, 223
post-architecture 129, 131
post-Benjamin 111
post-critical 170
post-dialectical 163
post-grid 61
post-historical 45, 92
post-literary 161, 169
post-medium 45, 132

INDEX 243

post-movement 218, 223, 227
post-narrative 149
post-Romantic 92
post-text 3
postclassical 132
postminimal 18
postmodernity 92, 221, 226
posts 105, 183, 194
poststructuralist 220, 228
potent 156
potentials 32, 39, 52, 133, 156, 191
pourable 166
PowerPoint 185
ppg256 84, 86
practices 2, 5, 10, 41, 43–4, 49–51, 54, 77, 83–4, 87, 94, 111, 115, 122, 131, 134, 137, 154, 156, 166–7, 183, 185–7, 190, 192, 194, 198, 203
pragmatic 68, 185
presence 30–1, 33, 38, 40, 43, 101, 113–14, 141, 191, 193
presentation 7, 10, 20, 28, 32, 43, 50–1, 55, 85, 87, 103, 114, 134, 145, 149, 151, 163, 172, 176–7, 184, 191, 193, 201, 203, 207, 222–3, 228
presumption 79
primitives 167
primordial 129
principle 13, 55, 58, 71, 103, 167, 191
print 58–9, 84, 111, 153, 164, 166, 175, 184, 186–7, 190, 192–3, 200
print-based 187
print-intended 183
printing 153, 166
printmaking 43, 154
prism 145
prison 42
privacy 29–33, 35–6, 73, 123, 143
privilege 18
probes 6, 12, 170
problematic 5, 8, 23, 38, 53, 68, 75, 83, 87, 95, 102, 125–6, 131, 138, 152, 159, 162–3, 165, 168–9, 193, 202–3, 206, 212–13, 222

Probst, Barbara 39
processhood 5–10, 12, 16–18, 20, 23, 27–8, 30, 37, 39–40, 45, 55, 66, 71, 73, 75, 77, 79, 81, 83–5, 88, 94, 99–100, 113, 115, 121, 139–40, 148, 161, 164–6, 168–73, 175–7, 179, 184–5, 189, 201, 203, 206, 208, 217, 222–3, 228
procession 16, 43, 50, 58, 84, 87, 112, 163, 169
processor 184, 202, 221
proclamations 77, 169, 209
proclivity 179
production 1–6, 9, 19, 22–3, 29–30, 32, 40–1, 43–4, 52–4, 59, 63, 67, 71, 74–5, 79, 82–4, 88, 92–4, 102–3, 112, 123–4, 140, 155, 159, 161, 164–5, 170, 180, 185, 187, 202–3, 205, 207, 222, 226
program 75, 80, 84, 129, 132, 148, 152, 193, 203, 205–8, 219, 223, 228
programming 59, 95–6, 100, 174, 178, 207
progression 23, 65, 74, 114, 145
progressive 13, 17, 23, 184
project 22–3, 67, 116, 130, 139, 159, 162, 176–80, 223
projection 1, 5, 8, 14–16, 22, 24, 36, 39, 41–2, 44–5, 57, 64–5, 67–70, 77, 95, 105, 108, 113–22, 127–8, 131–2, 137, 139–44, 148–9, 155, 173, 186, 204
promotion 11, 23, 74–5, 115, 152, 221
prompt 47, 172, 203, 206–7, 212
pronoun 190–1, 200
pronouncement 132
proof 165, 167, 205
propeller-like 14
proposals/propositions 12, 68, 85, 133, 139, 169, 176, 181
proprietary 223
proscriptions 81
prose 174
prosecution 80
prosthetic 140

protagonism 35, 49, 104, 114, 143, 158
proverbial 100
provocation 22, 37–8, 99–100, 122, 126–7, 147–8, 156, 208
proximity 24, 110
proxy 125
psychology 9, 13, 55, 66, 203, 208, 216, 227
psychotherapy 203, 207
pterosaur 7
public 1, 3, 7, 9, 30–2, 40, 46, 77, 109, 113, 122–7, 162, 170, 192, 218–19, 226
publication 32
publishing 5, 83, 221–2, 225
punctum 174
pundits 125
purity 58, 63, 92, 148, 175
purposes 113, 192
pursue 186
puzzles 6
Pygmalion 207, 223

quality 2, 27, 31, 38, 43, 54, 57, 93, 102, 131, 189
quantity 187
quarters 52
questions 1, 5–6, 10, 27, 74, 88, 108, 132, 161, 183, 202–4, 207
QuickTime 65

radical 10, 13, 39, 60, 163–4, 190
radio 152, 192
range 97, 187, 197
rank 4
Rauschenberg, Robert 33, 54, 154
reader 2, 52, 79, 162, 172, 176–80, 189
reader-reception 171
reader-response 171
readership 166
reading 1–3, 5, 7, 19, 26, 31–2, 37, 49–50, 52–3, 61, 73, 76–7, 91–5, 113–14, 116, 126, 137, 140, 154, 159, 163–4, 167–8, 172, 174, 176–81, 189, 209, 218, 222, 227
readymades 8, 73, 163

real 22, 36, 41, 43, 67, 79, 84, 109, 114, 122, 124, 127, 131, 138–9, 141, 143, 163, 179, 186, 218
real-time 15, 17, 21, 27, 42–3, 77, 84–5, 91, 99, 103, 105, 140–1, 149, 204
realism 67–8, 147, 151
realization 38, 108, 131
recall/reference 20, 23, 68, 105, 154, 157–8, 174
reception 31, 41–2, 50, 53–4, 88, 111, 115, 169, 171
recognition 31–2, 38, 68, 88
recoil 132
recollection 16–17, 108
recording/recounting 16, 26, 36, 41–2, 52, 63, 93, 97, 112, 157, 207
recurrence 22, 152, 205
recursion 156, 171
reference 4, 9, 13, 16–17, 23, 29–30, 36, 44–5, 49, 53, 55, 61, 63, 66, 76, 79, 81, 84, 92, 95, 97, 113, 116, 131, 133, 140–3, 148–9, 159, 162–4, 167, 170, 172, 174, 179, 190, 199, 207, 220
reflexivity 169
refraction 44, 113, 152
refrain 159
refutation 125, 127, 132, 152, 163, 172, 176, 187
regression 198
regularity 19, 61, 116, 142, 163, 167, 177, 217
reinforcement 15, 20, 22, 88, 121, 154, 176, 198, 216
relations/relational 6, 8–9, 13, 16, 22–4, 29–33, 36, 38, 52–3, 74–6, 81–2, 87, 92, 101–2, 108, 114–15, 122–4, 127, 130–2, 135, 137, 142, 146–7, 156, 158–9, 163, 171, 173, 176, 181, 186, 188–9, 193, 195, 203–4, 221
relevance 7, 46, 77, 92, 154, 162, 188, 202
reliance 39, 42, 54, 111, 131
Rembrandt, Harmenszoon van Rijn 156

INDEX 245

rendering 16, 20, 25, 45–6, 59, 64, 116, 121, 132–3, 166, 184
repetition 13–14, 19–20, 58, 60, 157–8, 188, 191
replacement 37, 41, 55, 75, 88–9, 125, 129, 152
replica 21, 99
representation 7, 15–16, 18, 21, 30, 33, 38, 41, 49, 54, 67, 87, 122, 134, 141, 159, 172, 176, 187, 201–2, 207
reprise 164
reproduction 35, 40, 52, 54, 82–3, 91–4, 102, 105, 218
reptilian 7
research 126, 146–7, 187, 190, 192, 199–200, 202–3, 222
resemblance 1, 5, 10, 23, 30, 33, 57, 73, 80, 166, 172, 180, 186–7, 207
reserve 112
resistance 94, 100
retrieval 52, 166, 179, 192, 208
reuse 4, 132
revelation 60, 68, 71, 91, 132, 148, 156, 179, 209
Reykjavik 116
Rheingold, Howard 186
Rilke, Rainer Maria 151
ringtones 96
riot 162
rising 40, 57, 74–5, 92, 94, 116, 205, 216
Rist, Pippilotti 156, 159
robotics 27, 159
Rogerian 203, 207
Rohe Ludwig Mies van der 166
Rohmer, Eric 169
Rokeby, David 77
roles 7, 18, 22, 24, 39, 75, 80, 82, 87, 92, 96, 102–3, 114–15, 147, 151–2, 162, 203
rotation 4, 6, 9, 12, 14, 19, 40, 44, 66–70, 88, 93, 95, 101, 114, 125, 127–8, 131, 140, 148, 155, 164–5, 167, 171, 207–8, 218
Rothko, Marc 61
rotoreliefs 64, 68

Rubin, Ben 188–9, 222, 227
rupture 124, 164, 167, 175
Ryman, Robert 58

sample 1, 190–2, 198–200, 223
Samurai 63
Saussure, Ferdinand 129
Schneemann, Carolee 156, 221, 227
scholarship 43, 84, 91–3, 202
science 5, 58, 111, 171, 198, 203, 205–6, 222–3, 226
screen 14, 44, 65, 77, 88, 91, 114, 116, 141, 154–5, 175, 177, 218, 221, 225
sculpture 2, 4, 7–9, 18, 22–4, 26–7, 32, 43–5, 57, 65, 77, 88, 101, 113–16, 124–6, 134, 148–9, 154, 156, 161–2, 165–6, 177, 220
search 131, 179–80, 187, 202
Seedbed 47
Seldes, Gilbert 76–7, 217, 227
self-referentiality 5–6, 20–2, 38, 43, 53, 77, 81, 101, 123, 138, 155–6, 159, 169, 173, 176, 206
semantics 123, 130, 161, 184, 187, 192, 202, 221
sensations 13, 18, 30, 43, 138, 220
sensibility 2, 7, 55, 91, 102, 125–6, 201
sensory 2–3, 6–8, 11–14, 16–20, 22, 24, 29–30, 32, 35, 37, 40–2, 50, 52, 54–5, 63, 75, 77, 82, 88, 92–3, 102, 131, 138, 148, 156, 158, 162–5, 167, 172, 183, 186, 189, 191, 202, 205, 209, 216
sentences 43, 184, 187, 190, 192–8, 200
series 13, 18–19, 22, 33, 50–1, 63, 65, 81, 84, 97, 140, 153–4, 156, 159, 175–6, 181, 203, 216
Serra, Richard 7, 42, 124–7, 219, 227
sexuality 152
shadows 142, 148
shafts 22, 24
Shakespearean 34, 84
Shamanism 201, 205–6, 208
shapes 11, 14, 20, 50, 58, 61, 63–4, 69, 128, 140, 143, 149, 177

shifting 8, 13–14, 16, 18, 22, 44, 49, 60, 116, 147, 201
Shklovsky, Viktor 105
SHRDLU 202
SIGGRAPH 215, 227
sight 65, 155, 177
sign/signification 23, 50, 63, 73, 130, 219, 225
signals 8, 58, 65, 92, 96, 105, 108
signature 60, 154, 157
signs 129, 152, 208
silence 101, 155, 204
silhouette 142
Silkscreen 60
similarity 22, 24, 51–2, 61, 68, 84, 121, 141–3, 187, 190, 193–4, 197–8, 200, 206, 208
simulacrum 89
simulation 88–9, 116, 204
simultaneity 18, 20, 35, 41–2, 54, 61, 93–4, 96, 99, 102, 121, 141, 161, 172, 176, 203
Sinatra, Frank 157
skyscrapers 4, 58, 71
slang 191
slap-stick 77
small 1, 20, 68, 81, 99, 115, 130, 192, 202–3, 216
smell 97
SMS 2, 45–6, 105, 108, 128
social 3–4, 31, 46, 67, 92, 94, 103, 108, 122, 151–2, 154, 156, 161–2, 165, 173, 186, 188–9, 209, 218, 223
society 4, 54, 77, 92, 113, 202, 219, 226
sociology 123
Socratic 207
software 44, 84, 88–9, 173–5, 178, 184, 192, 202–3, 206–7, 221, 223, 228
solipsism 100
solitude 50, 66, 74
Solzhenitsyn, Aleksandr 82
Sondheim, Alan 94, 133–4, 218, 223, 227
song 36–7, 157
sonic 38, 142

sonnet 84
soundtracks 103, 112
Source 1, 5, 29, 84, 95, 99, 108, 122, 154, 173, 188–9, 192, 206, 211, 217
south 121
space/spatiality 2, 6–8, 11–13, 15, 17, 22, 25–6, 30–1, 33, 40–1, 43, 49, 51–2, 54–5, 59–62, 65, 68–70, 78, 80, 83, 87–9, 93–4, 99, 101, 109, 111, 113–22, 124–132, 134–5, 138, 141, 145, 147–9, 151, 163, 166, 170, 175, 185, 189, 193, 202–3, 205, 215, 218, 220, 227
Spalter, Anne 67–8, 71
span 28, 52, 115, 208
Spanish 112, 191
speaking/speech 3–4, 7, 27, 30, 37, 41–3, 47, 74–6, 81, 84, 94, 99, 103, 112, 125, 127, 129–31, 133–5, 163–5, 170–2, 180, 186, 189, 192, 196–200, 204, 222, 225, 227
spectacle 32
spectatorship 9, 22–3, 39–40, 91
spectrum 13, 28, 130, 188
specular 172
speculation 9, 127, 164, 169, 187, 199
speech-as-writing 203
speed 41, 66, 128, 187
Spellman, Naomi 128
sphere 6, 31–2, 35, 54, 83, 93, 113, 122–7, 218–19, 226
spiral 26, 131, 165
spirit 15, 30, 41, 58, 61, 93, 95, 145, 151
spirograph 65
stability 5, 13, 16, 22–3, 43, 46, 115–16, 171, 177, 202, 216
staccato 143
stage 41, 50–1, 76, 83, 96, 103, 108, 113, 138–40, 142–7, 166, 176
stasis 13, 16, 23, 209
state-based 8, 13, 16, 22, 36, 41, 97, 111, 122, 141, 159, 163, 165,

INDEX

172, 193, 202, 215, 220, 222, 227
state-space 202
statement 13, 20, 22–3, 26, 28, 35, 38, 47, 55, 81, 84, 88, 113–14, 126, 162, 184, 207–8, 212–13, 219, 227
states 12, 15, 132
static/stationary 8, 14, 16, 22, 28, 46, 71, 114, 121, 128, 142–3, 176
station 4, 121
statis 10
statistics 184, 191–3, 195–7, 199
statue 97, 99, 207, 223
status 10, 32, 53, 64, 73, 75–7, 79, 81–2, 84, 88, 93, 113, 139, 165
steel 7–8, 22, 24, 26, 53, 57, 63, 216
Stendhal 151
Stieglitz, Alfred 76
Stijl, De 8, 58, 148
still 1, 4, 7, 11, 15, 19, 37, 54, 77, 97, 132, 173
stillness 141
stimulation 37, 68
stochastic 131
Stockholder, Jessica 53
storage 85, 166
story 33, 41, 58, 63, 102–3, 111–12, 124, 128, 137–8, 156, 175, 192, 204
storyline 137
storyteller 128
strategies 113, 127, 202
stream-of-consciousness 180
street 4, 97, 103, 113, 127, 191, 220
Strickland, Stephanie 77
structure 1–2, 10, 12–15, 19–20, 26, 37–8, 41, 45, 50–2, 55, 57, 60–1, 68, 76, 102–3, 111, 114–16, 127, 129–35, 137, 142, 148, 151, 155, 162, 164, 166–7, 169–72, 174, 176, 178, 181, 183, 186–7, 190–2, 194, 198, 200, 205, 219–20, 226
Stublič, Alexander 2, 114, 122
style 6, 24, 57, 125, 137, 139, 141, 152, 186–7, 192–4, 198, 200, 220–1, 228

subconscious 55, 171
subjectivity 11, 13, 16, 18–21, 23, 29–30, 32, 35–6, 42, 50, 54, 63, 81, 93, 114, 125, 128, 130, 137–8, 153, 155, 162, 171–2, 174, 177–8, 181, 198, 208
sublimation 27, 177
sublime 4, 151–2, 163
substitution 37, 84, 130, 138
suggestion 6, 10, 12–13, 26, 31, 37, 40, 73, 88, 111, 121, 131, 153, 161–2, 167, 171–2, 187, 200, 212
supercategory 149
superformal 202
superimposition 154, 186
superior 79
Suprematism 8, 58
support 20, 27, 59, 63, 67, 88, 114, 122, 140–1, 147, 149, 165, 169, 187, 191, 199–200, 216, 219, 227
surface-level 6, 17, 27, 116, 143, 172, 175–1, 186
surgeon 205
surprise 43, 114, 145, 154, 165, 168, 184, 187, 207, 217
surrealism 154, 218, 220, 226
surrounding 8, 42
surveillance 148
survey 88
suspension 10, 19, 36, 44–5, 50, 141
sustain 7, 46, 123, 130, 154–5, 159
symbols 5, 23, 52, 57, 63, 113, 166–7, 201–2, 209
symmetry 7, 19, 58, 60, 68, 100–1, 130, 143, 159, 166–7, 176
symptomatology 203
synchrony 27, 42, 121, 129, 157
syncopation 143
synergy 129
synonym 3, 76, 84, 123, 125, 130, 161, 163
syntax 188–91, 202, 207
synthesis 11, 13, 105, 115, 162, 171, 186, 198
system 1, 4–5, 9, 11, 13, 15, 17, 19, 21, 23–5, 27, 46, 64–5, 68, 73–5,

83–4, 89, 96–7, 101, 111, 116, 128–31, 141, 148, 164–7, 170, 174, 179, 184, 187, 192, 202–4, 206–7, 209, 218–19, 223, 226
T-cross 24
table 125, 167, 188–90, 197
Tamahagane 63
taste 7, 54, 77, 152
tautology 130, 157
technical-reproduction 40, 74, 76, 78, 92–3, 139–40, 209, 217
technique 28, 32, 41, 74, 105, 147, 152, 154, 156–7, 207
technology 1, 3–6, 9, 22, 24, 38–41, 47, 57, 63, 67, 74, 76, 91–2, 94–5, 108, 111–12, 114–15, 139–40, 146, 218, 220
Tektronix 61
teleology 92, 131
telepathy 76
Telepresent 99
telescope 24, 138
Telesymphony 96
teletype 207
temporality see time 7, 12, 15–16, 18, 20, 30, 41, 83, 92–3, 99, 111, 114, 129, 138, 142, 164, 170, 189
tension 20, 23, 34, 39, 81, 108, 115–16, 145, 152, 172, 202, 205
term 6, 12–13, 21, 28–9, 42–3, 50, 52, 75–6, 87, 101, 108, 113–15, 122–3, 129, 131, 134, 140, 149, 151, 154, 156, 159, 161–2, 170–1, 175, 179–81, 185, 191, 213, 220
territory 104
Terzidis, Kostas 131, 219, 228
Text Rain 215, 227
text/texts/textuality 1–3, 10, 14–15, 33, 36–8, 44–6, 61, 63, 105, 108, 112, 127, 164–7, 171, 173–81, 183–7, 190–4, 196–200, 215, 221
Texterritory 103–8, 111
theater 4, 51, 83, 88, 124, 220

theme 23, 52, 87, 105, 116, 121, 127, 137–8, 146, 154
theorem-prover 202
theory 7, 9–10, 43, 73, 76, 79, 83, 92, 122–3, 130, 170–1, 187, 191–2, 205–6, 217, 220, 228
therapy 204, 207–8, 222, 228
thermodynamics 111
thinking 2, 8, 12, 79, 92–3, 123, 130, 169, 184, 187, 202, 211
three-dimensiona 114, 175
time 2, 7, 9, 13, 15, 18, 30–1, 39–43, 54, 58–9, 68, 73, 76–7, 79, 81, 84, 92–4, 96–7, 99–102, 105, 108, 111–12, 114, 125, 129, 139, 142–3, 161, 164, 169, 179, 191, 204, 209, 219, 225
time-delay 203
timeline 64, 83
tool 100, 185
tools 20, 47, 133, 185
topic 52, 77, 170, 183–4, 187–9, 221–2, 228
tradition 7, 37, 43, 45–7, 57, 61, 111, 116, 127, 137–8, 152, 157, 162, 164, 166, 178, 185, 187, 189, 205, 216, 222, 225
Trajan 165
trajectory 74, 83, 139, 172, 178, 218
transaction 102
transcendence 13, 23, 30, 57–9, 64, 71, 77, 95, 116, 131–2, 138, 156, 172–6, 204, 223
transcripts 190, 192
transfer 4, 28, 102, 109
transformation 1, 13, 32, 36, 39, 60, 63, 69, 88, 92, 109, 115–16, 122, 125, 128, 131, 133, 137–8, 162–3, 202, 207–9, 211, 219, 226
transgression 152, 169, 173, 178
transition 13–16, 18, 20, 22–3, 25–6, 115, 176, 202, 226
translation 27, 71, 88, 123, 176, 191
translucent 44
transmedial 112
transmission 4, 172
transmodal 215, 227

INDEX 249

transparency 176–7, 187, 203, 208
transposition 23–4, 28, 63, 68, 132, 164
trauma 66
travel 128
traverse 28, 121, 152, 163, 177
treatise 170
treatment 23, 152, 203, 215
trigger 52, 206, 217, 227
trigonometry 64
trigram 179
trope 68
truth 3, 5, 30, 36–7, 39, 47, 54–5, 74, 101, 130, 133, 138, 152, 181, 184, 218
turbulence 175
Turing, Alan 201, 207
tweets 84
TXTual Healing 128
typeface 165
typesetting 166
typography 167

ubiquity 26, 61, 84, 92, 161–2, 164
Ultrachrome 64
Underscan 147
understanding 7, 12–13, 20, 28, 30, 32, 35, 42, 54, 58, 71, 76–7, 84, 111, 115–16, 124, 131, 139, 159, 166, 172–3, 184–5, 201–3, 205–7, 209, 212–13, 215, 223
unfolding 41, 91, 93, 108, 128
uniformity 57, 60, 162, 186
uniqueness 3–5, 20, 45, 49, 54, 74, 80–2, 93–4, 101, 124, 127, 171, 178, 190–2, 203, 215
unison 116
universalsc 13, 28, 54–5, 92, 111, 201
universe 6–7, 16, 58, 87
unnatural 18
unspoken 123, 152
unstable 5, 12, 31, 46, 116, 186
urban 49, 68, 97, 99, 121, 128
urbanscapes 71
use 3, 19, 27, 36, 39, 45–47, 52, 59, 64–65, 67, 71, 113–15, 122, 124, 131–2, 145, 148, 152, 156, 162, 166, 173, 181, 187–91, 193, 198–200, 203, 223
user-patient 207
utopian 92, 132
utterances 29, 42, 127, 129–130, 186, 191, 198, 203, 208
Utterback, Camille 15, 77

vagueness 31, 33, 39, 79, 125
validity 46–7, 93, 102, 111
value 3, 32, 46, 73, 79, 81–3, 87, 101–2, 125
Vantongerloo, Georges 58
variables 8, 15, 65, 105, 111, 132, 200
varieties/variations 2, 5–6, 13–14, 54, 57, 63, 97, 111, 124
vectors 23, 63, 67, 206
vehicle 142
vellum 45
velocity 66
Venice 142
venues 42, 49, 87–8, 123, 152
verbal 191, 198
verdict 3, 10, 203
vernacular 19, 131
Verostko, Roman 62
verticality 16, 23, 66, 68, 116, 130, 165
vessel 63
video 15, 19, 21, 25, 27–8, 41–3, 45, 49, 51–2, 65, 68–70, 108, 138–40, 147–8, 154–5, 159
videogame 79, 82
view 2–3, 6–8, 10, 13–16, 19–25, 30–2, 39–40, 47, 49, 54–5, 64–5, 70, 75, 79, 87, 96, 100, 102, 104, 106–9, 114–15, 125, 127, 129, 138–9, 141–2, 148, 154–5, 158–9, 162, 165, 171–2, 176, 178–80, 184, 217, 225
viewer 2–3, 7–9, 15, 21–3, 32, 35, 38–9, 44–7, 54, 63, 74, 108–9, 124, 127, 148, 151, 177
vignette 36
virtual 43, 85, 87–9, 114, 123, 126, 131–4, 140, 149, 176, 186, 209, 218

visual/visible 1, 3–4, 8, 12–14, 18,
 20, 23–4, 26, 30, 34–41, 44,
 49–50, 58, 61, 68, 71, 79, 81,
 92, 96, 101, 112, 114–16, 121,
 131, 140–2, 147–9, 151–2, 155,
 161–2, 164–7, 170, 176, 184,
 186, 189, 193, 205, 208, 221
voice 44–5, 103, 127, 139, 156, 205
vortex 137, 175

wall 3–4, 14–15, 23, 31–2, 52, 70, 73,
 84, 87–8, 108–9, 138, 140, 154,
 176, 205, 218
war 8, 108, 148
Wardrip-Fruin, Noah 204, 223, 228
Warhol, Andy 8, 154
way 1, 3, 5, 8–9, 12–13, 16, 19, 26,
 29–30, 37–8, 40, 45, 55, 58–9,
 63, 71, 79, 85, 92, 94, 99, 101,
 109, 111, 113, 122–4, 127, 140,
 151, 162, 166–7, 173–4, 180,
 190, 193, 201, 209, 215
webcam 175
Weblogs 183, 223, 226
webs 206
Weizenbaum, Joseph 208–9, 223, 228
Weyergraf-Serra, Clara 219, 227
Whiteread, Rachel 53
Wilke, Hannah 156
Wilson, Mark 61
Winter, Lyn 32–6, 38, 47, 221
wish 29, 52, 93, 126
witness 47, 94, 204, 217
Wittgenstein, Ludwig 29, 47, 67
Woodman, Francesca 30, 39
word 6, 14, 17, 29, 36, 40, 42–4,
 47, 52, 75–6, 80–1, 84, 93, 123,
 131, 134, 161–2, 164–7, 173–4,
 177–81, 186, 188, 190–1, 193–4,
 198, 207–9, 211
works 1–4, 6–15, 18–24, 26–33,
 35–47, 49–50, 52, 54–5, 59–61,
 63, 65, 67, 75–7, 79–84, 87–9,
 91–4, 96–7, 99–103, 105, 108–9,
 111–13, 115–16, 121, 123–8,
 132–3, 137–43, 147–9, 151–2,
 154, 156, 158–9, 161–3, 165–7,
 169–72, 175–7, 186, 190, 192,
 198, 200, 202, 204, 215–22, 226
worlds 4, 6–7, 10, 19, 22, 28, 30–2,
 35, 39, 41, 46, 50, 52, 55, 67–8,
 71, 82, 87–8, 92, 96, 101–2, 113,
 116, 123–4, 131–3, 138, 140–3,
 145, 147–9, 151, 159, 162, 164,
 173, 176, 181, 184, 187, 201,
 203–4, 217, 220, 225, 228
Wray, Sheron 2, 108
writing 1, 6, 9–10, 75, 83–5, 92,
 97, 99, 111, 122, 155, 165–6,
 169–71, 180, 183–7, 189–90,
 192–4, 197–8, 200, 217, 222,
 227

XMLfile 105

Yacavone, Daniel 140, 220, 228
YouTube 108

Zajec, Edward 60
zeitgeist 163
zero-dimensional 131
zone 26, 124